tips, inspiration and instruction in all mediums

How did you paint that?

100 ways to paint
PEOPLE & FIGURES
VOLUME 1

international
artist

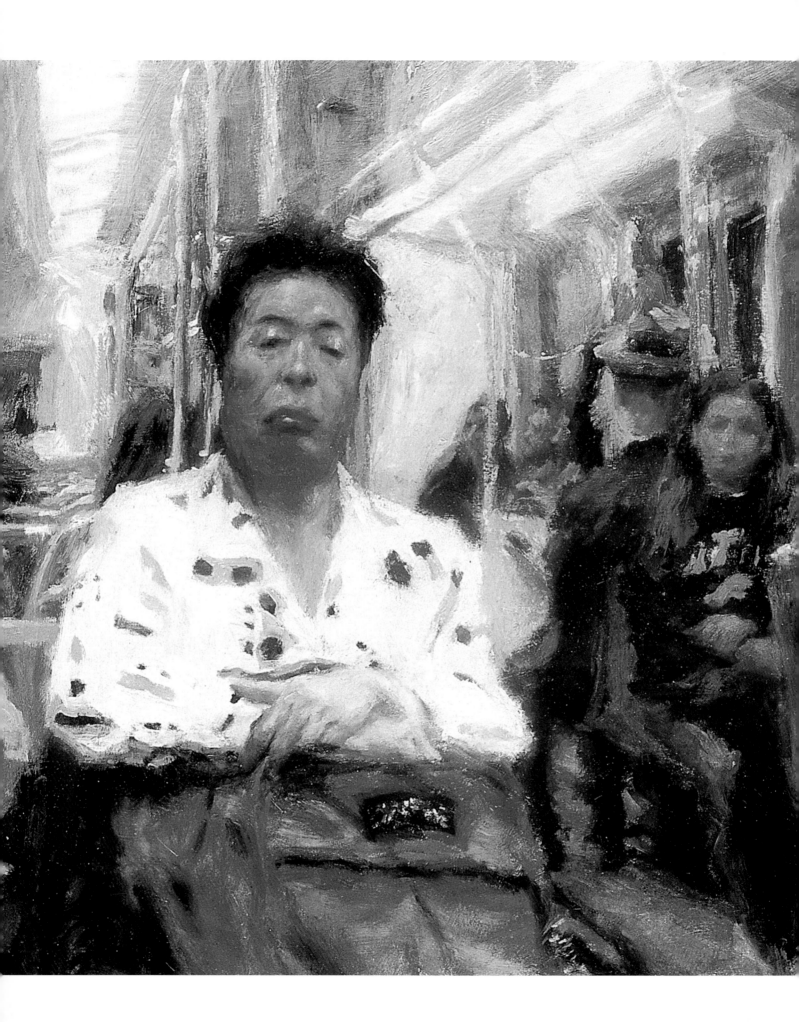

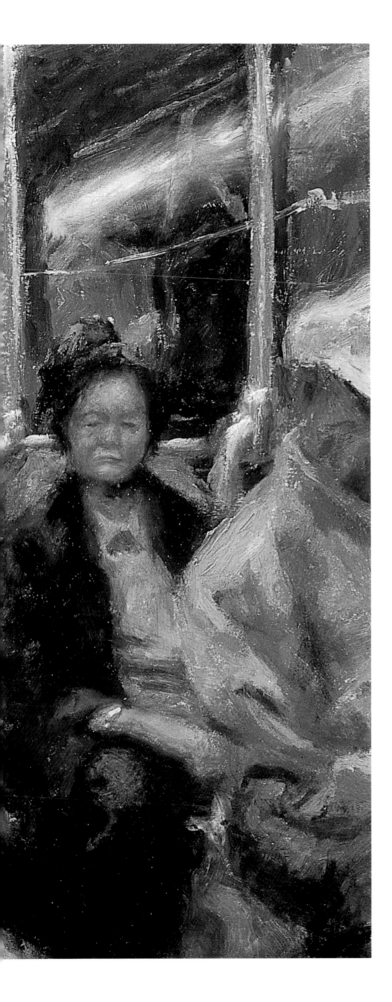

How did you paint that?

100 ways to paint

PEOPLE & FIGURES

VOLUME 1

International Artist Publishing, Inc
2775 Old Highway 40
P.O. Box 1450
Verdi, Nevada 89439

Website: www.intenationalartist.com

© International Artist 2004

Edited by Terri Dodd and Jennifer King
Designed by Vincent Miller
Typeset by Ilse Holloway, Lisa Rowsell
and Cara Herald
Editorial Assistance by Dianne Miller

ISBN 1-929834-40-3

Printed in Hong Kong
First printed in hardcover 2004
08 07 06 05 04 6 5 4 3 2 1

Distributed to the trade and art markets
in North America by:
North Light Books,
an imprint of F&W Publications, Inc
4700 East Galbraith Road
Cincinnati, OH 45236
(800) 289-0963

Oil
1, 2, 3, 5, 6, 7, 8, 10, 11, 12, 15, 16, 17, 18, 20, 21, 23, 25, 26, 29, 30, 31, 32, 34, 35, 37, 39, 40, 41, 42, 43, 44, 46, 47, 48, 49, 50, 51, 53, 55, 57, 58, 63, 64, 65, 67, 68, 71, 72, 73, 74, 75, 76, 77, 78, 83, 84, 85, 87, 88, 90, 91, 93, 94, 97, 99

Watercolor
9, 13, 19, 22, 27, 28, 33, 59, 60, 61, 62, 66, 79, 89, 92, 100

Acrylic
56, 80, 86 95,

Gouache
45

Pastel
4, 14, 24, 36, 38, 52, 54, 69, 70, 81, 82, 96, 98

Acknowledgments

International Artist Publishing Inc. would like to thank the master artists whose generosity of spirit made this book possible.

Dona Abbott 9
Marie Hélene Auclair 14
Aldo Balding 87
Jeffrey W Bass 19
Marian De Berry 22
Sandra Bos 99
Bob Brandt 94
Ryan S Brown 20
Robert Buckner 11
Jenny Buckner 21
Anne Bull 93
Scott Burdick 10
Judith Carducci 4
Lucille Carter 18
Magdalena Castañeda 17
Warren Chang 16
Chris Cheetham 96
Tiziama Ciaghi 95
C M Cooper 15
Gez Cox 92
Fletcher Crossman 86
Kevin M A Cunningham 88
Tony Duarte 81
Margaret Dyer 24
Don Ealy 25
John Ennis 26
Andy Evansen 27
Anna J Farawell 69
Vincent Fazio 67
Ginny Fletcher 90
Douglas Flynt 68
Brian Freeman 70
Karen Goins 41
Andrzej Gosik 100
Ray Harrington 85
Fu Hong 83
Shu-Ping Hsieh 42
Irena Jablonski 43
Bill James 45
Dick Jenkins 44
Alda Kaufman 33
Tom Kelly 91
Mostafa Keyhani 29
Jung Han Kim 1
J Mark Kohler 28
Mark Laguë 8
Colleen Lauter 32
Kristan Anh Le 31
Burt Levitsky 30
Dennis E Lewis 78

Catherine Lidden 82
Steve Lopes 84
Jimmy Lu 34
Susan Lyon 2
David Neil Mack 79
Mike Mahon 36
Shirley de Maio 23
Douglas Malone 37
Lee McManus 38
Judith Mroski-Gonzalez 39
Christopher Near 40
Rich Nelson 5
Devdatta D Padekar 6
Andrew Paterson 97
J Richard Plincke 89
Dennis Poirier 46
Camille Przewodek 47
Barry John Raybould 48
Cara J Reische 49
Donald Renner 50
Tae Rhea 51
Jolanda Richter 7
Candice Rivard 52
Mario Robinson 54
Patricia A Rohrbacher 53
Tom Ross 55
Paul Saindon 56
John T Salminen 13
Suzy Schultz 57
Larry Smitherman 80
Susanna Spann 59
Maurice Spector 58
Kim Stenberg 60
Paul Sullivan 61
Dashuai Sun 62
Tom Swimm 63
Nancy Tankersley 64
Joan Stevens Taylor 12
Des Thomas 98
Sheryl Thornton 66
Vilas Tonape 65
Jonathan Trotta 35
Timothy C Tyler 71
Kenju Urakubo 77
C J Weber 72
Michael Wood 74
Zhaoming Wu 75
Ryan Wurmser 76
Joseph M Yuhasz 73
Shawn Zents 3

With special thanks to Raymond Leech,
whose painting appears on the front cover

Message from the Publisher

We have taken the "learn by observing" approach six huge steps further.

Welcome to the latest title in our innovative 6-Volume series. Each volume contains 100 different interpretations of the subject by some outstanding artists working in the world today — in all mediums.

There are five more Volumes in the series, each tackling a popular subject. Titles you can collect are:

100 Ways to paint Still Life & Florals

100 Ways to paint Landscapes

100 Ways to paint Flowers & Gardens

100 ways to paint Seascapes, Rivers & Lakes

100 ways to paint Favorite Subjects

Turn to page 128 for more details on how you can order each volume.

Studying the work of other artists is one of the best ways to learn, but in this series of Volumes the artists give much more information about a favorite painting. Here's what you can expect from each of the Volumes in the series.

- 100 different artists give 100 different interpretations of the subject category.
- Each one gives tips, instruction and insight.
- The range of paintings shows the variety of effects possible in every medium.
- A list of colors, supports used, brushes and other tools accompanies each picture.

- The artists reveal what they wanted to say when they painted the picture — the meaning behind the painting and its message.
- Each artist explains their inspiration, motivation and the working methodology for their painting.
- Artists say what they think is so special about their painting, telling how and why they arrived at the design, color and techniques in their composition.
- The artists describe the main challenges in painting their picture, and how they solved problems along the way.
- They offer suggestions and exercises that you can try yourself.
- They give their best advice on painting each subject based on their experience.
- Others explain why they work with their chosen medium and why they choose the supports and tools they do.
- The main learning point of each painting is identified in the headline.

Each of the explanations shown in **100 Ways to Paint People & Figures** was generously provided by artists who want you to share their joy of painting. Take the time to read each description fully, because you never know which piece of advice will be the turning point in your own career.

Vincent Miller

Vincent Miller
Publisher

If you were standing beside Raymond Leech, the artist who created this painting, the first thing you would ask is, "Raymond, how did you paint that?" Then a multitude of other questions would follow, fed by your insatiable hunger to know what it is that goes into making a masterpiece like this.

Our series of books is the next best thing to having direct access to exemplary artists like Raymond Leech. And on your behalf we asked them the burning questions that you would ask if you met them face to face.

Here's the kind of information and insight you can expect to find on the following pages from the other generous artists in this book.

I wanted you to notice the story

my message
This young girl drawing in the sand with a toy spade encapsulates those carefree, whimsical days on the beach. For children it is an endless summer of fun. For adults, scenes like this remind us of a time when electronic devices did not rule the world, and people were able to create their own amusement.

my challenge
I made lots of sketches in order to get the most difficult bit right — the drawing of the child.

my design
I created a high horizon and followed the gold rule/triangle plan.

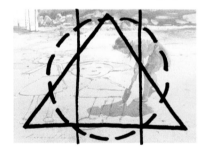

my goals
I wanted to create a dramatic effect so I used a strong shadow to anchor the girl firmly to the beach. And I wanted the feeling of sunlight and movement.

the eyepath
I wanted the eye to flow through the painting in a circular motion, contained in the paitning by observing the girl, her dra wing, the figures in the background and then back down again to the girl.

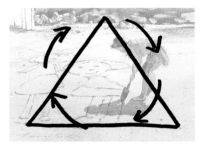

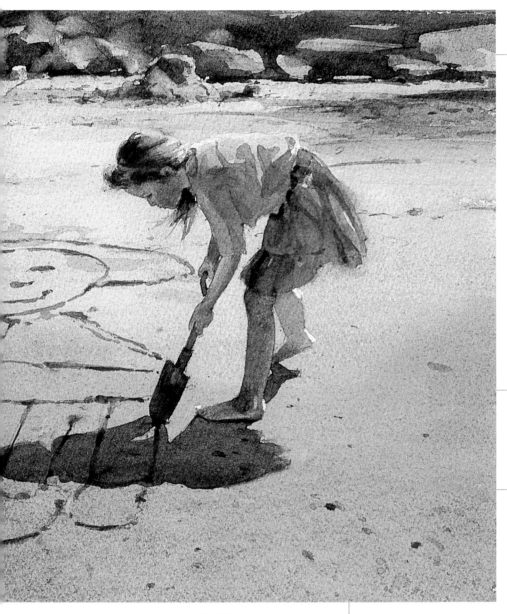

The Sand Artist, watercolor, 10 x 13½" (25 x 34cm)

my materials

watercolor palette

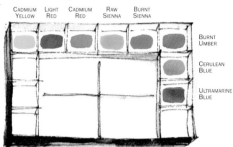

Cadmium Yellow	Light Red	Cadmium Red	Raw Sienna	Burnt Sienna	

Burnt Umber

Cerulean Blue

Ultramarine Blue

brushes
#6, #12 pointed sables
Large flat squirrel hair for washes

paper
Quality Rough paper stretched onto a board

other
Masking fluid
Sponge
Tissues

color plan
I wanted to keep this painting simple, with a limited palette. I wanted it to be fresh and not look overworked.

my working method
I sketched out the image onto my stretched paper. Then I masked out the highlights with masking fluid. When that was dry I wet the paper slightly and mixed enough color to block in the important elements.

I worked with the board at a good angle and quickly worked in the colors from top to bottom, following my sketch, so that most of the image was started wet on wet.

Whenever I do figure work I aim to suggest movement. Texture played an important role here.

Raymond Leech lives in the UK.
Telephone +44 1502 582 424

tonal value plan
Look at the difference this dark shape makes to the painting.

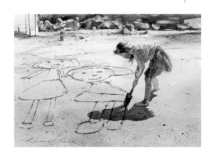

acrylic paint

Fast drying, waterproof, long lasting acrylic is an elastic paint that flexes and resists cracking.

Use it straight from the tube for intense color, dilute with water for transparent washes, or mix with an assortment of mediums to create texture. Available in tubes or jars, liquid or impasto, matte or gloss finish.

Binder: Acrylic resin emulsified with water.
Support: Flexible and inflexible, primed or unprimed.

alkyd

Looks similar to oil paints and can be mixed with them. Alkyds resist yellowing and they dry faster than oils.
Support: Prime flexible or inflexible surfaces first with oil or acrylic primer.
Binder: Alcohol and acid oil modified resin.

casein

This old medium, bound with skim milk curds, has mostly been overtaken by acrylic paints. However, casein is still available and many artists swear by it. The medium dries quickly to a velvety matte finish and is water-resistant when dry. It does become brittle, and if you apply too much, it can crack. Like acrylic paint, casein is versatile and can be applied as a thin wash or as an underpainting for oils and oil glazes. When it is varnished it looks like oil paint.

Support: Because casein does not flex like acrylics it is not suitable for canvas. Use watercolor paper or rigid surfaces, primed or unprimed.

egg tempera

This product uses egg yolk in oil emulsion as its binder. It dries quickly, doesn't yellow and can be used just as it is or diluted with water. Egg tempera will crack on canvas so only use rigid supports. Use as underpainting for oils and oil glazes.

gouache

This medium is opaque and can be rewetted and reworked. It comes in vivid colors.
Binder: gum arabic
Support: paper and paper boards. Dilute with water or use neat. Don't apply too thickly or it will crack.

acrylic gouache

This gouache uses water-soluble acrylic resin as the binder. Use it just like gouache, but notice that because it is water-resistant you can layer to intensify color.

oil

The classic painting medium. You can achieve everything from luminous glazes to opaque impasto. As the paintings from the Old Masters show, oil paintings can crack, yellow and darken with age. Oil paint dries slowly on its own, or the

bud or soft brush. Hard pastels enable finer detail to be added as the work progresses or as a primary drawing medium for planning sketches and outdoor studies. Pastel pencils can be used for drawing and for extra fine detail on your pastel painting.

You can combine pastel with acrylic, gouache and watercolor. As long as the surface upon which you are working has a "tooth" (a textured surface that provides grip), then it is suitable for pastel.

Support: There is a variety of papers available in different grades and textures. Some have a different texture on each side. These days you can buy sandpaper type surfaces either already colored or you can prime them yourself with a colored pastel primer. Some artists prepaint watercolor paper with a wash and apply pastel over that.

water-thinned oil

A recent development. Looks like oil paint but cleans up in water instead of solvent. Dries like traditional oil. Use straight or modify with traditional oils and oil painting medium. Transparent or impasto.

Support: Flexible and inflexible canvas or wood.

watercolor

Ancient medium. Pigments are very finely ground so that when the watercolor paint is mixed with water the paint goes on evenly. Some pigments do retain a grainy appearance, but this can be used to advantage. Provided you let previous washes dry, you can apply other washes (glazes) on top without disturbing the color beneath. Know that watercolor dries lighter than it looks.

Watercolor is diluted with different ratios of pigment to water to achieve thin, transparent glazes or rich, pigment filled accents of color. Watercolor pigments can be divided into transparent, semi-transparent and opaque. It is important to know which colors are opaque, because it is difficult to regain transparency once it is lost. Watercolor can be lifted out with a sponge, a damp brush or tissue.

Support: There are many different grade watercolor papers available from very rough, dimply surfaces to smooth and shiny. Different effects are achieved with each. Although many traditional watercolorists allow the white of the paper to show through, there are also colored watercolor papers available.

process can be accelerated using drying medium. There are many mediums that facilitate oil painting, including low odor types. Turps is widely used to thin oil paint in the early layers. Oils can be applied transparently in glazes or as thick impasto. You can blend totally or take advantage of brush marks, depending on your intention. Oil can be used on both flexible and inflexible surfaces. Prime these first with oil or acrylic primers. Many artists underpaint using flexible acrylic paint and then apply oil paint in layers. You can work oils all in one go (the alla prima method), or allow previous layers to dry before overpainting. Once the painting is finished allow as much time as possible before varnishing.

Binder: linseed, poppy, safflower, sunflower oil.
Support: Flexible and inflexible canvas or wood.

oil stick

This relatively new medium is artist quality oil paint in stick form. Dries faster than tube oils. Oil sticks allow calligraphic effects and they can be mixed with traditional oils and oil medium. Oil stick work can be varnished.

pastel

Use soft pastels to cover large areas of a painting. Use the side of the pastel to rapidly cover an area, either thickly or in a thin restrained manner. You can blend pastel with a finger, cotton

Find-it-Faster Directory

Color coded numbers let you quickly find the paintings you like,
all the methods and materials used and how each artist painted them

1 **Jung Han Kim**
Inside Muni
18 x 24" (46 x 61cm)
OIL

Contrast

2 **Susan Lyon**
Movement
20 x 30" (51 x 76cm)
OIL

Backlighting

3 **Shawn Zents**
Sisterly Advice
30 x 38" (76 x 97cm)
OIL

Light

4 **Judith Carducci**
Ennui
19 x 24" (49 x 61cm)
PASTEL

Mood

5 **Rich Nelson**
Nicole
24 x 28" (61 x 71cm)
OIL

Narrative

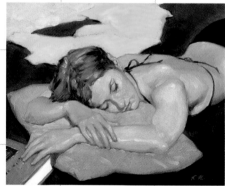
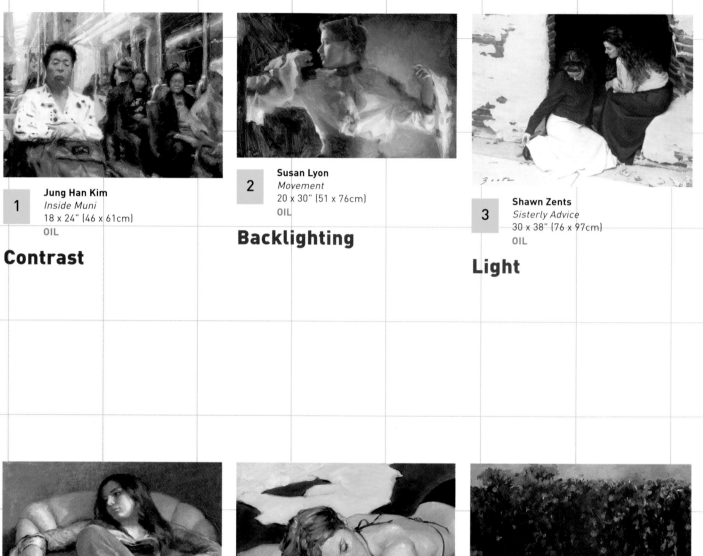

6 **Devdatta D Padekar**
A Peaceful Day
48 x 48" (122 x 122cm)
OIL

Mood

8

Mark Laguë
Chat Room
24 x 48" (61 x 122cm)
OIL

Simplification

7

Jolanda Richter
Temptation
20 x 28" (50 x 70cm)
OIL

Color and focus

9

Dona Abbott
Cambodian Bikers — Market Bound
17½ x 27" (45 x 69cm)
WATERCOLOR

Design

11

Robert Buckner
Eskimo Girl
28 x 38" (71 x 97cm)
OIL

Gesture, tone and texture

12

Joan Stevens Taylor
Circle of Friends
12 x 12" (31 x 31cm)
OIL

Mood

10

Scott Burdick
Waiting
OIL
46 x 24" (117 x 61cm)

Emphasis

Find-it-Faster Directory

Color coded numbers let you quickly find the paintings you like, all the methods and materials used and how each artist painted them

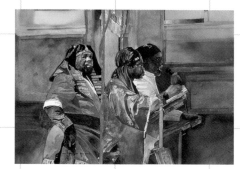

13 **John T Salminen**
Times Square Speakers
22 x 30" (56 x 76cm)
WATERCOLOR

Color, tone and texture

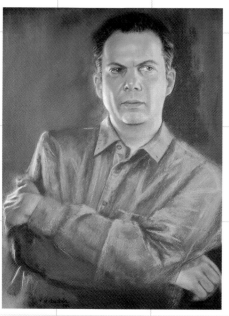

14 **Marie Hélene Auclair**
Robin
25 x 19" (64 x 49cm)
PASTEL

Design for impact

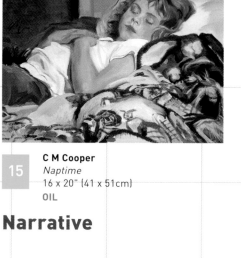

15 **C M Cooper**
Naptime
16 x 20" (41 x 51cm)
OIL

Narrative

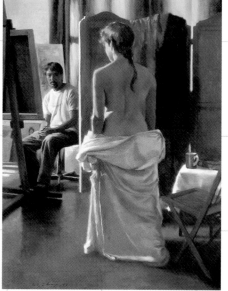

16 **Warren Chang**
Entrance
40 x 30" (102 x 76cm)
OIL

Light and color

17 **Magdalena Castañeda**
Mr Wilson Study
16 x 20" (41 x 51cm)
OIL

Shaping

18 **Lucille Carter**
Hopes & Dreams
30 x 24" (76 x 61cm)
OIL

Dynamic balance

19 **Jeffrey W Bass**
Sam
14 x 20½" (36 x 52cm)
WATERCOLOR

Balance

20 **Ryan S Brown**
Lexie
10 x 8" (26 x 20cm)
OIL

Pose

21 **Jenny Buckner**
Tess
30 x 40" (76 x 102cm)
OIL

Pose

22 **Marian De Berry**
Getting the Feeling Of It
12½ x 17½" (31 x 45cm)
WATERCOLOR BATIK

Technique

23 **Shirley de Maio**
Seeing Beyond
16 x 20" (41 x 51cm)
OIL

Abstraction

24 **Margaret Dyer**
Picnic Preparations
19 x 24" (49 x 61cm)
PASTEL

Design

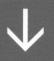

Find-it-Faster Directory
Color coded numbers let you quickly find the paintings you like,
all the methods and materials used and how each artist painted them

25 **Don Ealy**
Redhead
10 x 8" (26 x 20cm)
OIL

Narrative

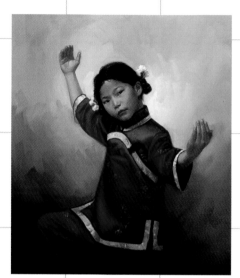

26 **John Ennis**
Julia
30 x 26" (76 x 66cm)
OIL

Design

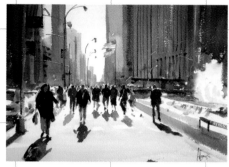

27 **Andy Evansen**
New York Pedestrians
19 x 25" (49 x 64cm)
WATERCOLOR

Movement

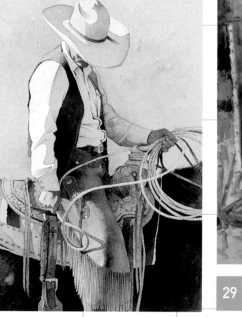

28 **J Mark Kohler**
Won't Suffer Fools
11 x 8¼" (28 x 21cm)
WATERCOLOR

Presence via cropping

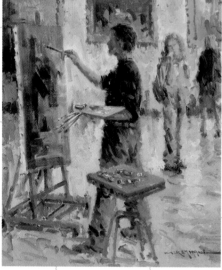

29 **Mostafa Keyhani**
Copyist (Musee d'Orsay)
20 x 16" (51 x 41cm)
OIL

Depth and tension

30 **Burt Levitsky**
Bus Stop Reflections
24 x 30" (61 x 76cm)
OIL

Mood

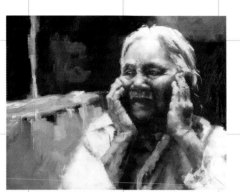

31 Kristan Anh Le
Aged
24 x 30" (61 x 76cm)
OIL

Power with color and tone

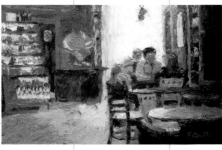

32 Colleen Lauter
Afternoon Espresso
8 x 12½" (20 x 31cm)
OIL

Backlighting

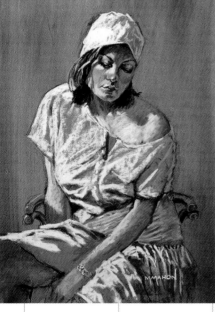

33 Alda Kaufman
Looking Back
12 x 17" (31 x 44cm)
WATERCOLOR

Drama

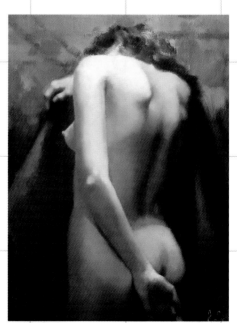

34 Jimmy Lu
On Her Back
24 x 18" (61 x 46cm)
OIL

Dramatic light

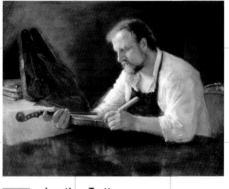

35 Jonathan Trotta
The Luthier (Portrait of Andrius Faruolo)
32 x 40" (81 x 102cm)
OIL

Classic approach

36 Mike Mahon
Memories
16 x 12" (41 x 31cm)
PASTEL

Dynamic pose

↓ Find-it-Faster Directory
**Color coded numbers let you quickly find the paintings you like,
all the methods and materials used and how each artist painted them**

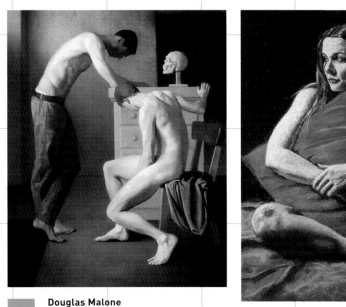

37
Douglas Malone
Convocation
40 x 32" (102 x 81cm)
OIL

Balance and harmony

38
Lee McManus
Cut-Offs and Tank Top
25 x 20" (64 x 51cm)
PASTEL

Mood

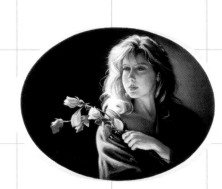

39
Judith Mroski-Gonzalez
Morning Light
16 x 20" oval (41 x 51cm)
OIL

Chiaroscuro

40
Christopher Near
Rob
28 x 22" (71 x 56cm)
OIL

Narrative

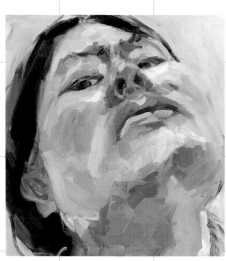

41
Karen Goins
Self-Portrait: Inside Out
22 x 20" (56 x 51cm)
OIL

Exaggeration

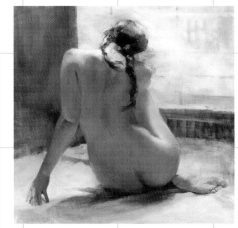

42
Shu-Ping Hsieh
City Life
30 x 30" (76 x 76cm)
OIL

Eye paths

You'll find all the information you want about how each painting was created by turning to the tab number indicated, in sequence from 1 to 100

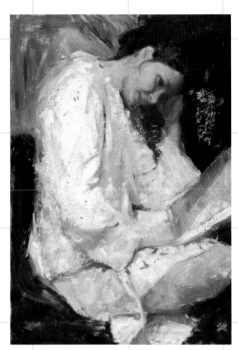

43 Irena Jablonski
Reading in a White Robe
36 x 24" (92 x 61cm)
OIL

Shape

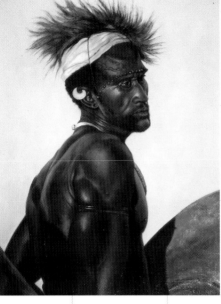

44 Dick Jenkins
Warrior
21 x 15" (54 x 38cm)
OIL

Highlights

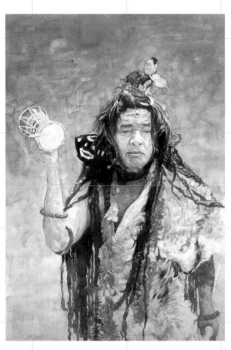

45 Bill James
The Medicine Man
28 x 19" (71 x 49cm)
GOUACHE

Color

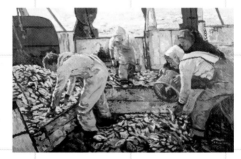

46 Dennis Poirier
Crew of the Carol Ann
24 x 36" (61 x 92cm)
OIL

Light and color

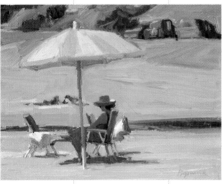

47 Camille Przewodek
Beach Memories
8 x 10" (20 x 26cm)
OIL

Color temperature

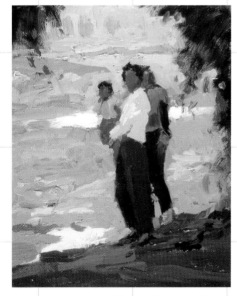

48 Barry John Raybould
Togetherness
10 x 8" (26 x 20cm)
OIL

Harmony

Find-it-Faster Directory

Color coded numbers let you quickly find the paintings you like,
all the methods and materials used and how each artist painted them

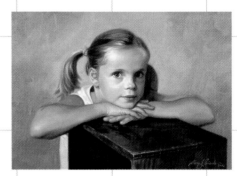

49 **Cara J Reische**
Katie
18 x 24" (46 x 61cm)
OIL

An inspired prop

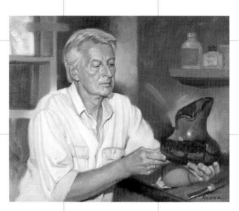

50 **Donald Renner**
Final Inspection
20 x 24" (51 x 61cm)
OIL

Enriched composition

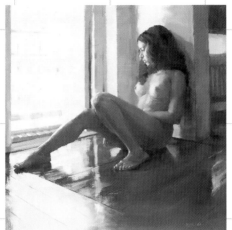

51 **Tae Rhea**
Out of the Door
44 x 43" (112 x 109cm)
OIL

Light and shadow

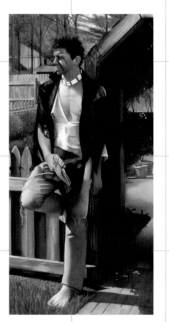

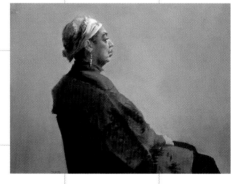

53 **Patricia A Rohrbacher**
Mercedes
14 x 18" (36 x 46cm)
OIL

Positive and negative shapes

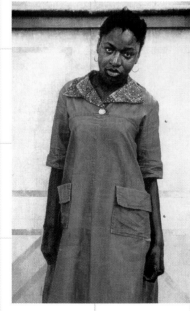

52 **Candice Rivard**
Urban Warrior
44 x 22" (112 x 56cm)
PASTEL

Format

54 **Mario Robinson**
Blue Daze
40 x 28" (102 x 71cm)
PASTEL

Powerful pose

55
Tom Ross
Sonita
11 x 14" (28 x 36cm)
OIL

Defining with color

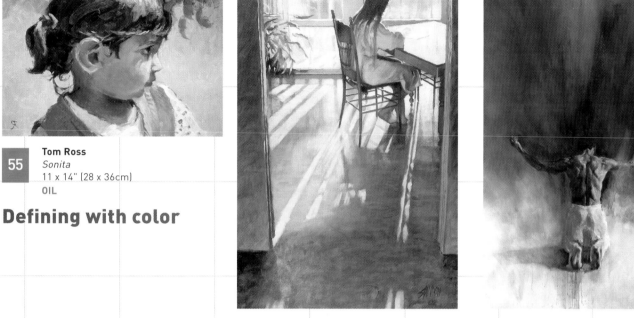

56
Paul Saindon
Morning Reading
28 x 18" (71 x 46cm)
ACRYLIC

Contrast

57
Suzy Schultz
Prodigal
60 x 36" (153 x 92cm)
OIL

Lighting

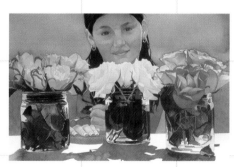

58
Maurice Spector
Cart Brigade
24 x 36" (61 x 92cm)
OIL

Movement and depth

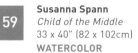

59
Susanna Spann
Child of the Middle
33 x 40" (82 x 102cm)
WATERCOLOR

Contrasting shapes

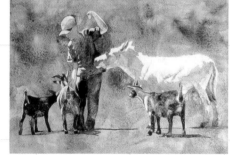

60
Kim Stenberg
Kids
14 x 20" (36 x 51cm)
WATERCOLOR

Undercoat breakthrough

↓ # Find-it-Faster Directory
Color coded numbers let you quickly find the paintings you like,
all the methods and materials used and how each artist painted them

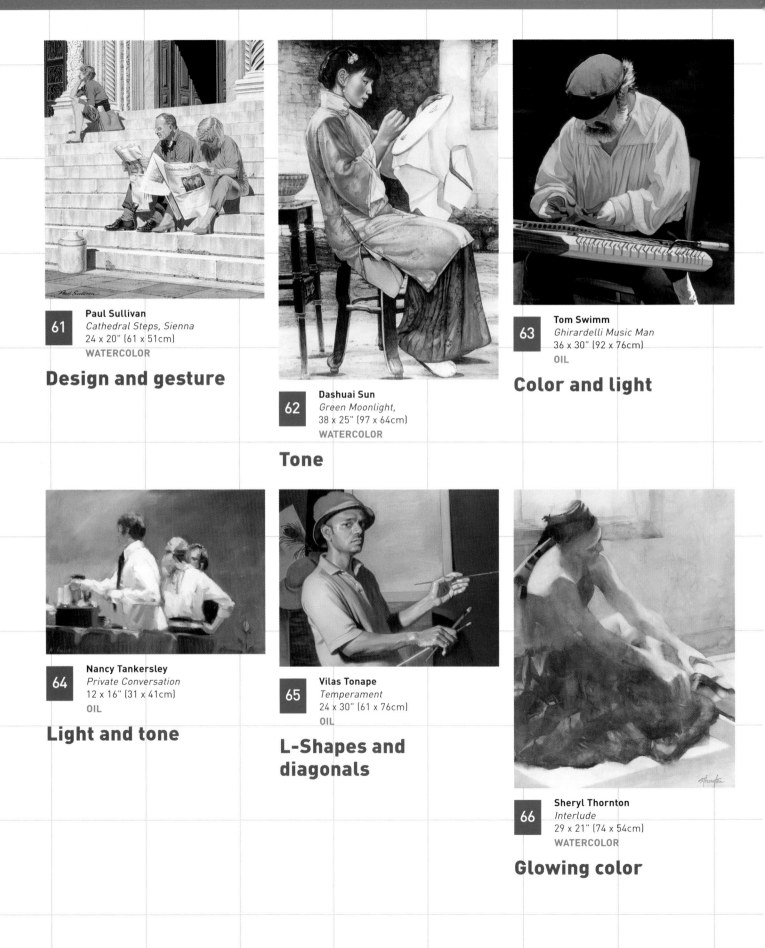

61 Paul Sullivan
Cathedral Steps, Sienna
24 x 20" (61 x 51cm)
WATERCOLOR

Design and gesture

62 Dashuai Sun
Green Moonlight,
38 x 25" (97 x 64cm)
WATERCOLOR

Tone

63 Tom Swimm
Ghirardelli Music Man
36 x 30" (92 x 76cm)
OIL

Color and light

64 Nancy Tankersley
Private Conversation
12 x 16" (31 x 41cm)
OIL

Light and tone

65 Vilas Tonape
Temperament
24 x 30" (61 x 76cm)
OIL

L-Shapes and diagonals

66 Sheryl Thornton
Interlude
29 x 21" (74 x 54cm)
WATERCOLOR

Glowing color

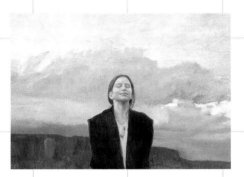

67 **Vincent Fazio**
Sarah
18 x 24" (46 x 61cm)
OIL

Emphasis

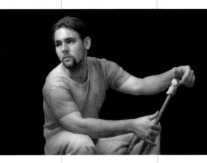

68 **Douglas Flynt**
John with Artist's Mahl Stick
24 x 36" (61 x 92cm)
OIL

Movement

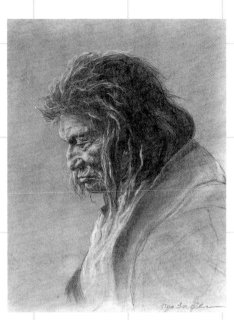

69 **Anna J Farawell**
Introspection
22 x 16" (56 x 41cm)
PASTEL

Line and tone

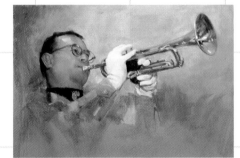

70 **Brian Freeman**
Brass Taps
16 x 21" (41 x 54cm)
PASTEL

Focal point

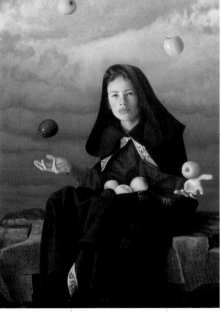

71 **Timothy C Tyler**
Juggler
40 x 30" (102 x 76cm)
OIL

Design, tone and color

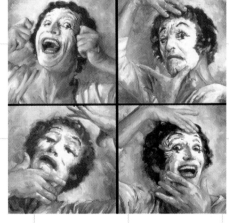

72 **C J Weber**
Listen
28 x 28" (71 x 71cm)
OIL

Color temperature

↓ # Find-it-Faster Directory
Color coded numbers let you quickly find the paintings you like,
all the methods and materials used and how each artist painted them

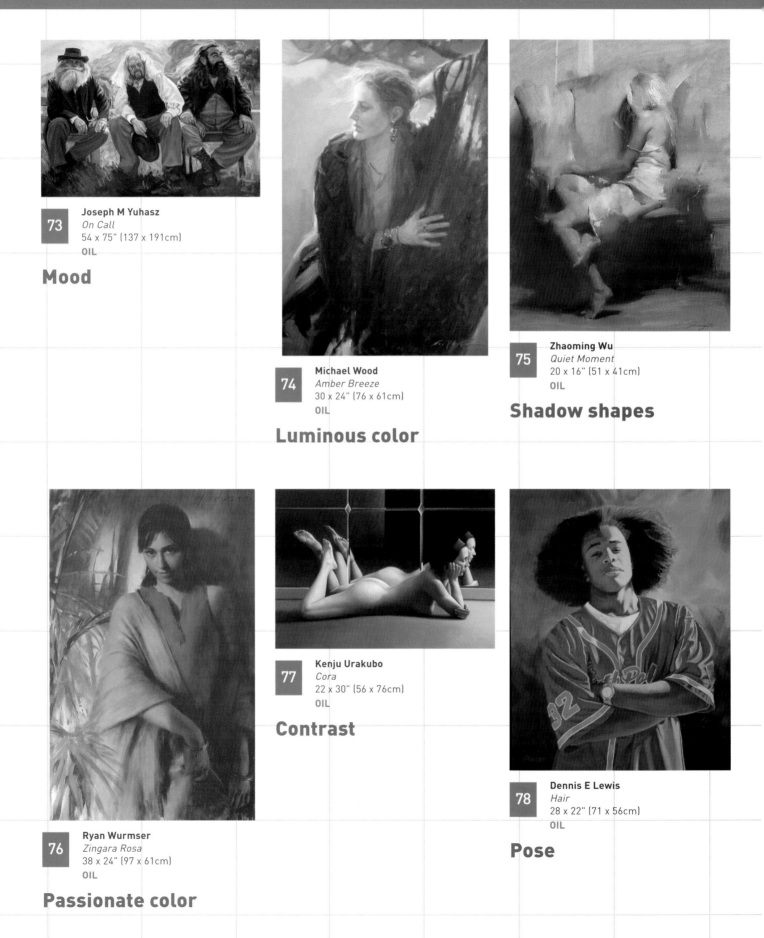

73 Joseph M Yuhasz
On Call
54 x 75" (137 x 191cm)
OIL

Mood

74 Michael Wood
Amber Breeze
30 x 24" (76 x 61cm)
OIL

Luminous color

75 Zhaoming Wu
Quiet Moment
20 x 16" (51 x 41cm)
OIL

Shadow shapes

77 Kenju Urakubo
Cora
22 x 30" (56 x 76cm)
OIL

Contrast

76 Ryan Wurmser
Zingara Rosa
38 x 24" (97 x 61cm)
OIL

Passionate color

78 Dennis E Lewis
Hair
28 x 22" (71 x 56cm)
OIL

Pose

You'll find all the information you want about how each painting was created by turning to the tab number indicated, in sequence from 1 to 100

79 David Neil Mack
A Dream of Castles
16½ x 14½" (42 x 37cm)
TRANSPARENT WATERCOLOR

Technological aids

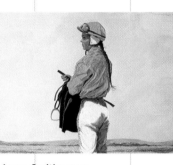

80 Larry Smitherman
Southwest Jockey
16 x 30" (41 x 76cm)
ACRYLIC

Pigment handling

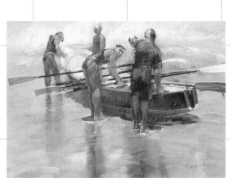

81 Tony Duarte
Training Day
55 x 75" (140 x 191cm)
PASTEL

Balance

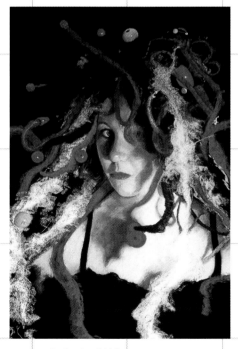

82 Catherine Lidden
Rebel
47 x 34" (120 x 86cm)
PASTEL

Lighting

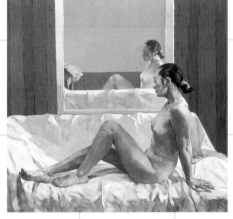

83 Fu Hong
Nude Portrait of Echo with Mirror
36 x 36" (92 x 92cm)
OIL

Contrast

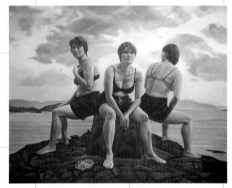

84 Steve Lopes
Third Trimester
55 x 78" (140 x 198cm)
OIL

Design and color

Find-it-Faster Directory
Color coded numbers let you quickly find the paintings you like,
all the methods and materials used and how each artist painted them

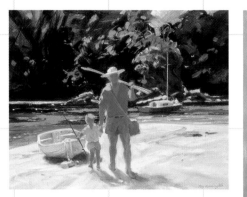

85 Ray Harrington
The Day of the Catch
18 x 22" (46 x 56cm)
OIL

Design

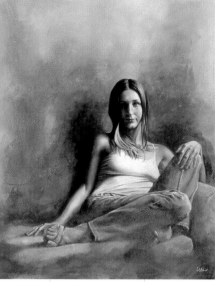

86 Fletcher Crossman
Erin Eckman
35 x 28" (89 x 71cm)
ACRYLIC

Shape

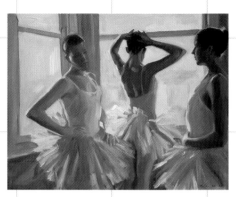

87 Aldo Balding
Rehearsal
16 x 20" (41 x 51cm)
OIL

Color temperature

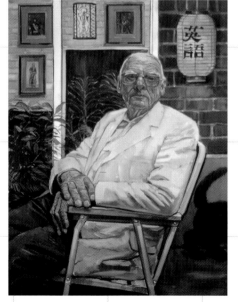

88 Kevin M A Cunningham
Francis King
59 x 39½" (150 x 100cm)
OIL

Theme with meaning

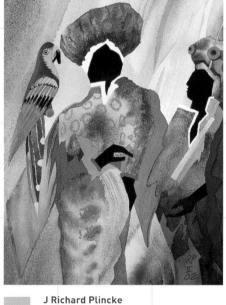

89 J Richard Plincke
Family Discussion
11½ x 8½" (30 x 21cm)
WATERCOLOR/GOUACHE

Gesture and color

90 Ginny Fletcher
On the Beach
39½ x 59" (100 x 150cm)
OIL

Mood

You'll find all the information you want about how each painting was created by turning to the tab number indicated, in sequence from 1 to 100

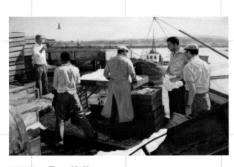

91 Tom Kelly
What's the Catch
22 x 26" (56 x 66cm)
OIL

Movement

92 Gez Cox
People of Paris
13½ x 9½" (35 x 25cm)
WATERCOLOR

Cropping

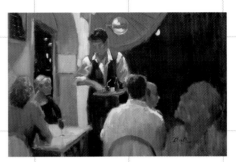

93 Anne Bull
The Waiter Montmartre
30 x 40" (76 x 102cm)
OIL

Placement

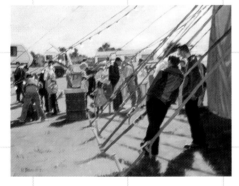

94 Bob Brandt
Roll Up
14 x 18" (36 x 46cm)
OIL

Shape and color

95 Tiziama Ciaghi
Piccole Dolomiti
16 x 20" (41 x 51cm)
ACRYLIC

Tone

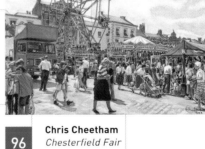

96 Chris Cheetham
Chesterfield Fair
8 x 11" (20 x 28cm)
PASTEL AND GOUACHE

Tone

Find-it-Faster Directory

**Color coded numbers let you quickly find the paintings you like,
all the methods and materials used and how each artist painted them**

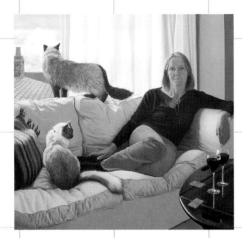

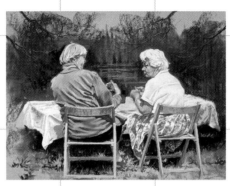

You'll find all the information
you want about how each
painting was created by turning
to the tab number indicated,
in sequence from 1 to 100

97 **Andrew Paterson**
Mary-Jane
57 x 57" (145 x 145cm)
OIL

Shape and scale

98 **Des Thomas**
Serious Discussion
19 x 25" (49 x 64cm)
PASTEL

Body language

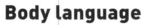

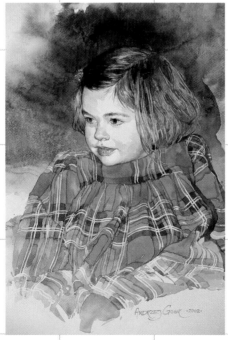

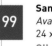

99 **Sandra Bos**
Ava
24 x 36" (61 x 92cm)
OIL

Line and color

100 **Andrzej Gosik**
Susan
19 x 23½" (49 x 60cm)
WATERCOLOR

Emphasis

I used contrast to emphasize the dream-like atmosphere.

Inside Muni, oil, 18 x 24" (46 x 61cm)

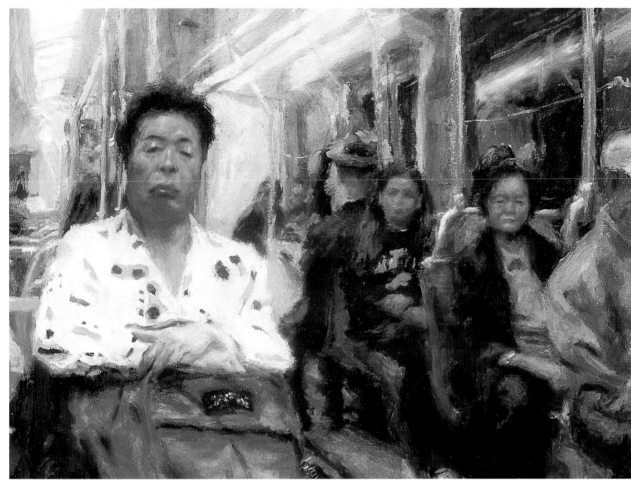

my inspiration

I ride on Muni — the public transportation system in San Francisco — almost every day. On Muni, I have noticed thousands and thousands of faces, smells and voices. Those things have become questions in my mind. Who are these people? What are they doing? It goes on and on. I believe these questions are the heartbeats of my Muni painting series.

This painting is no exception. One day, with those queries buried down inside me, I saw a woman with a grim face in a shining white shirt. I then noticed another woman in a thick red jacket with no expression on her face, and a girl in a dark blue sweater with curious, dreamy eyes. All of them were under cold, pale florescent lights. The strange atmosphere in that moment intrigued me enough to inpsire this painting.

follow my eye-path

Since the focal point of this painting is the grim-faced woman in the white shirt, I put the strongest value contrast there. Your eyes, hopefully, start there and move along the florescent lights above her to the window on the right, another point of strong contrast. Then the eye-path moves to the face of the woman in the red jacket and wanders around that part. In the end, it comes back to the starting point. That was my intention, and I designed a few quick value studies with that in my mind.

my working process

- Because the vehicle and the people were constantly moving, I had to work from photographs. These gave me the fresh and direct feeling of the real lives of real people.

- After sketching my value maps in pencil, I prepared a Masonite board to paint on, which I gessoed three times.

- In the beginning of the painting, I blocked in the darker parts of the canvas. I put my darkest dark tone at the focal point.

- Next, I went through the half-tones all around the painting.

- Working wet-on-wet, I added details on the focal point and balanced these with some details on the other parts.

the main challenge in painting this picture

While I was working on this painting, I thought many times about my intuition from the scene and the right atmosphere for this painting. I worked hard to get that right. To think right, even to try to think right, is the hardest thing.

what the artist used

support
Masonite board primed with three coats of gesso

brushes
Bristle flats, Nos. 2 through 14

oil colors

Naples Yellow Hue	Raw Sienna	Burnt Umber
Cadmium Yellow Deep	Burnt Sienna	Ultramarine Blue
Yellow Ochre	Terra Verte	Prussian Blue
Cadmium Scarlet	Winsor Green	
Alizarin Crimson	Sap Green	

Jung Han Kim lives in San Francisco, California, USA → www.kimfineart.com

Backlighting and a dark background cast a beautiful rim of light on my model's face.

Movement, oil, 20 x 30" (51 x 76cm)

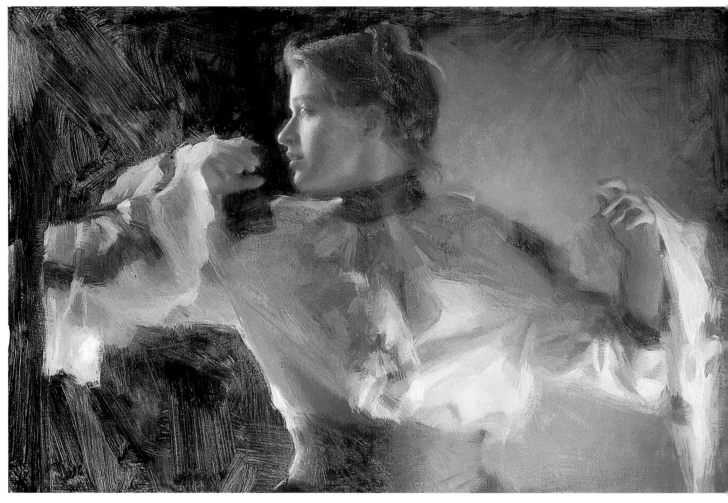

my inspiration

I was inspired by this costume, an authentic wedding outfit that I bought on a trip to Prague. I loved the way the sleeves puffed out and how the cuffs were so ruffled. Having the model lift her arms and then lighting her from behind accentuated the design.

my design strategy

Using backlighting with a dark background provided a beautiful rim of light on the side of her face. She was facing a north light window, which I supplemented by putting a strong, warm light on the ground to the right. The drama of having her hands up leads your eye around the canvas, and having such strong lighting really emphasizes the cool and warm color design.

try these tactics yourself

- I hired a model that I thought would look great in the costume. I did a photo session with her for about an hour and a half, moving the lighting and using different props to see what the best composition was. I worked from a photo since the model would have never been able to hold the pose long enough.

- I first did a 9 x 12" full color oil sketch to plan out the light and dark pattern.

- I then painted the final painting in oil, which I prefer because it dries slowly and allows me to work the edges. I also like to contrast thin washes against thick paint in certain areas to create interesting effects.

what the artist used

support
Double oil-primed portrait texture canvas, stretched

brushes
Filbert bristle brushes in Nos. 8, 10, 12; synthetics of various sizes

oil colors

CADMIUM LEMON · CADMIUM YELLOW · YELLOW OCHRE · CADMIUM ORANGE · CADMIUM RED · PERMANENT ROSE · ALIZARIN CRIMSON · TRANSPARENT OXIDE RED · VIRIDIAN · COBALT BLUE · ULTRAMARINE BLUE · IVORY BLACK · TITANIUM WHITE

Susan Lyon lives in King, North Carolina, USA → SusanLyon.com

My goal was to capture the beauty of cool, subtle light falling on these forms.

Sisterly Advice, oil, 30 x 38" (76 x 97cm)

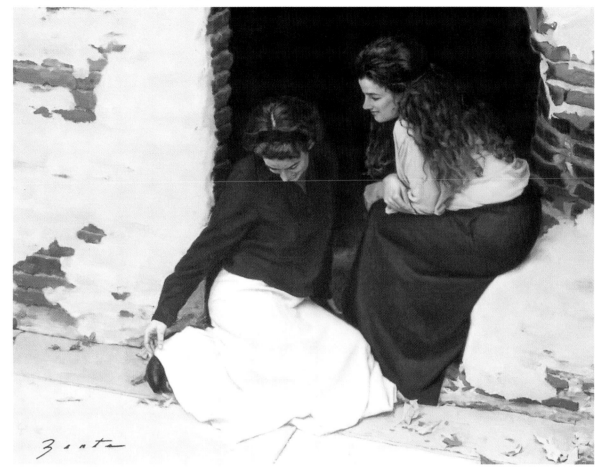

what I wanted to say

I wanted to capture an intimate moment between sisters. To enhance the mood, I chose a subtle lighting condition, which promotes a decorative effect through patterns. I also hoped to create a timeless quality to this piece through clothing and environment selection.

my design strategy

When composing, I always try to incorporate linear and tonal composition. I subdivide the picture plane into pleasing arrangements. Also, by composing with a white, light, dark, and black value pattern, I'm guaranteed to draw the viewer in and create punch within the image.

my working process

- First, I stretched and toned an oil-primed linen canvas to a light gray that closely matched my palette's value.

- Then I blocked in my drawing and composition with a pencil. I spent a little extra time refining and designing the shapes in each area. Once satisfied, I spray-fixed the image.

- Before painting, I determined the quality and color of the light. The lighting is an overcast lighting condition, which creates a cool bluish/violet gray over the entire scene. This creates color harmony and sets up the color relationship of cool light versus warm shadows, which I maintained throughout the painting. In addition, I noted that the diffused light would show off each form's pattern rather than strong shapes of light and shadow.

- Starting with my focal point — the sister's head on the right — I laid in the average darks in each area and then worked into

this average with darker darks. I then mixed up an average flesh tone, laid it in and slowly sculpted the light by going darker until my color-values met the shadow.

- Then I stated the crest lights and highlights. I finished as I went, completing each figure and finally the background while always working wet-into-wet.

the main challenge in painting this picture

Capturing this quality of light was very difficult because of the lack of shadow shapes and the subtlety of values and color.

my advice to you

Learn to paint what you see, not what you know. When painting an eye, for example, don't paint what you know about the form, but try to capture the illusion of the light and dark shapes. Paint the light on the things, not the things!

what the artist used

support
Double oil-primed linen canvas mounted on heavy-duty stretcher bars

brushes
Filbert bristle brushes #4, 6, 8, 10, 12; round synthetic brushes #4, 6

oil colors
Titanium White (soft formula)
Yellow Ochre Pale
Terra Rosa
Burnt Umber
Viridian
Blue Black (Viridian + Black)
Ivory Black

medium
1 part stand oil, 1 part Damar varnish and 5 parts turpentine

Shawn Zents lives in Simi Valley, California, USA → www.shawnzents.com

Judith Carducci

Through color, cropping and gesture, I expressed the world-weary demeanor of my teenage model.

Ennui, pastel, 19 x 24" (49 x 61cm)

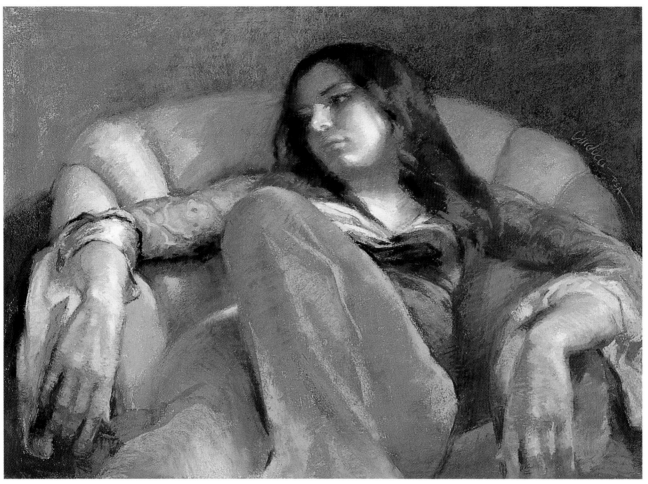

what I wanted to say

My model was young, slender, graceful and languid. I had asked her to sit in the chair as if she were at home alone. The way she snuggled into it, hands dangling at her side, seemed to personify the dreamy and perhaps world-weary mood that overcomes teenagers at times. She seemed lost in her own thoughts, inaccessible. It was this mood that interested me.

my design strategy

Figure paintings are so often vertical, so I was pleased to discover that a frontal view allowed all of the important elements to fit nicely into a horizontal. I liked the stability of the symmetrical head and axis of the body in the center embraced by the chair, which contrasted against the asymmetrical angles of the arms, curve of the body and the diagonal of the leg, thereby creating tension. In a daring but exciting move, I cut off the raised leg almost at the angle, knowing I could use curved lines and values to lead the eye into the hair and head.

about light and color

Normally, I paint from natural north light, but in this case used a studio spot which, while approximating natural light, tends to be warm. Thus, the entrancing shadows on her face and hands were cool, a plus in describing the mood. This was enhanced by the color scheme — the soft harmony of warm browns, tans, creams and golds complemented by touches of cool aqua and turquoise. The background of both cool and warm gray seemed to me to pull it all together.

my working process

- I worked from life and did not make studies before beginning to paint — they dissipate my creative spark.

- I began by framing the composition by sight, and then sweeping my fingertips lightly over the painting surface to picture how it would fit on the page. Then I lightly recorded that gesture, including the darks, with soft vine charcoal.

- A loose underpainting of hard pastels washed with sweeps of a wet sponge followed.

- I then proceeded to paint what I saw, refining the drawing as I worked. For instance, I painted the pants not as I saw them but with the simplified look required by the painting.

- Over the course of several days, I repeatedly returned to study the image and make adjustments. Constantly half-closing my eyes to see values, I re-worked the values on and around the hands and dramatized the light.

- I was particularly pleased with the result, which seemed to rate a freshness, simplicity and charm.

what the artist used

support

A board with a hand-applied gesso on a marble dust surface

pastels

Countless colors of hard, semi-soft and very soft pastels

other materials

A wet sponge

Soft vine charcoal

Liquid gloves

Paper towels

Judith Carducci lives in Hudson, Ohio, USA → www.artshow.com/apow (click on Judith Carducci)

This pose allowed me to tell a story in paint.

Nicole, oil, 24 x 28" (61 x 71cm)

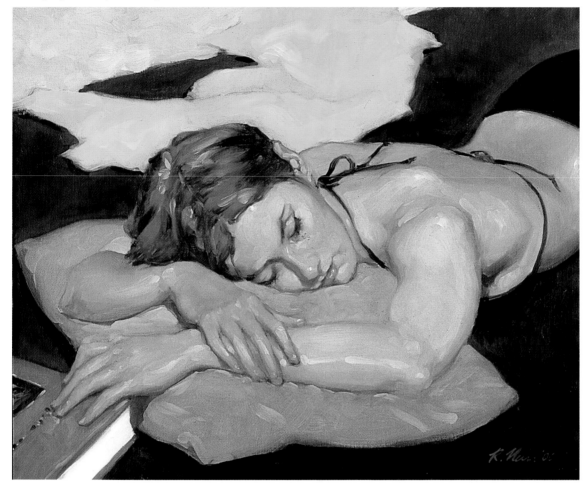

my inspiration

I love hiring models and working one-on-one in my studio. This particular model is an artist as well, Nicole Nelson (no relation to me), so she is very sensitive to composition. She understands the importance of holding and getting back into the pose. We worked to find a comfortable pose that would express some simple narrative, an elemental aspect of life in paint. I brought in additional elements to complete the picture after getting a good understanding of the pose and cropping. I am always trying to interpret observations from life in a painterly way.

my working process

• My first step was to get a quick, yet pretty accurate, drawing of the composition, using a #4 filbert to rapidly apply thin strokes of Raw Umber. In some places, I wiped this out three or four times before moving ahead.

• Then I started laying in color with attention to value, adjusting the drawing as needed. I love the fresh application of lots of paint, using big brushes (#8 or #10 filbert) and overlapping edges. I worked from the general to the specific, first in the background, then the basic tones of the figure, then refining details.

• Once the basic tones were blocked and working on the entire canvas, I began to work from the mid-tones to the highlights, paying attention to hard and soft edges.

• This was done in one day, with some slight adjustments the next day when I looked at it with fresh eyes.

special note

Near the end, I could sense that Nicole was getting worn out from holding the pose. Additionally, a great, noisy thunderstorm had rolled in and I realized that all of the windows at home were open. I tried to just focus on quickly finishing the work, and the result was one of my best paintings.

HOT TIP!

One trick of mine is my palette. It is a 14 x 17" piece of cardboard close in color and value to my toned canvas with a thumbhole cut in it. At the start of each painting session, I use spray adhesive to tack on a clean sheet of tracing paper, also with a thumbhole. When I'm done, I toss the sheet out and tack on another one. This lets me mix up a ton of paint and not feel restrained in any way. I can always have a fresh palette.

what the artist used

support
Linen canvas primed with two coats of rabbit skin glue and one coat of light gray oil primer

brushes
Extra long filbert brushes (#4, 6, 8, 10, 12); #4 sable round for details

oil colors
Cremnitz White
Cadmium Yellow Pale
Cadmium Red
Permanent Alizarin Crimson
Yellow Ochre
Burnt Sienna
Raw Umber
Cadmium Green
Ultramarine Blue
Ivory Black

medium
Odorless solvent
Varnish

Devdatta D Padekar

I used an impressionistic method to convey a relaxed mood.

A Peaceful Day, oil, 48 x 48" (122 x 122cm)

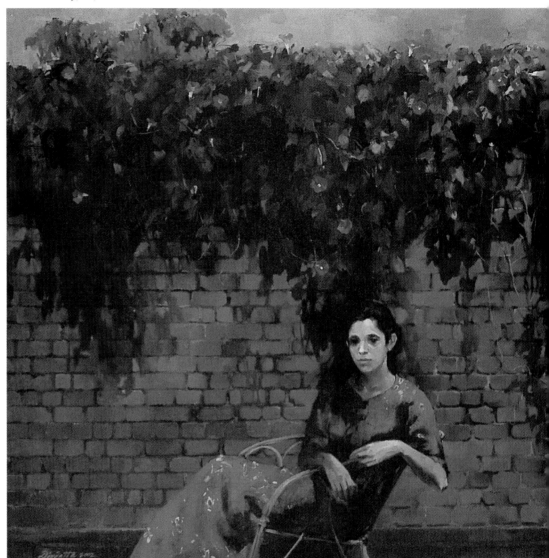

my inspiration

I frequently visit a friend whose large garden contains a colorful morning-glory creeper growing along a brick wall. Though my primary inspiration was the fascinating variety of colors in the wall, I also wanted to create a relaxed mood. This is why I placed the figure of a girl in casual attire in front of the wall.

my design strategy

One troublesome aspect of my subject was the even symmetry of the bricks' lines. I tried to break this up by using the long shadows of the creeper and the human figure. It is a part of my design strategy. Though the theme of my painting evolved largely around the brick wall, I also gave prominence to the human figure because I felt it helped to create a hushed and pleasant mood. Finding the perfect balance in these two dissimilar shapes was challenging. The focal point is the girl's head, which I have treated with a lighter tonal value. Essentially, I wanted to give the viewer's eye a thread to follow from the head down to the hands and drapery, gradually to the immense wall, then back to the head.

my working process

- I began by drawing a couple of color sketches on location to decide on the pose of the figure and final composition.

- After deciding on the composition, I started painting on location. I created a thin, mid-toned ground of Raw Sienna and a dull green to help me judge appropriate tonal values.

- I then used a blue pencil to indicate the wall, the creepers and the proportion of the model on the canvas.

- Over several mornings so that I'd be working under the same light conditions each time, I worked on the painting part by part. I tried to get the values and colors correct from the beginning. I started with creeper and its shadows, then the myriad tones and shades of the brick wall — a challenge! I then started with the figure, including the wall behind her. It was only for this phase that the model was required to pose.

- When the painting neared completion, I added the finishing touches. These included minute details like stems, buds and bright accents in the flowers and leaves, as well as the highlights on the face and the drapery.

what the artist used

support
Medium-grain canvas coated with a middle-tone ground color

oil colors

Naples Yellow	Sap Green	Cerulean Blue
Cadmium Yellow	Burnt Sienna	Ultramarine Blue
Cadmium Orange	Raw Sienna	Purple
Cadmium Red Light	Yellow Ochre	Ivory Black
Venetian Red	Alizarin Crimson	Flake White

brushes
Hog hair brushes ranging from Nos. 3 to 20

medium
Linseed oil

Devdatta D Padekar lives in Marol, Mumbai, India → padekardevdatta@rediffmail.com

A soft focus and cooler colors balanced out the intensity of my theme — temptation.

Temptation, oil, 20 x 28" (50 x 70cm)

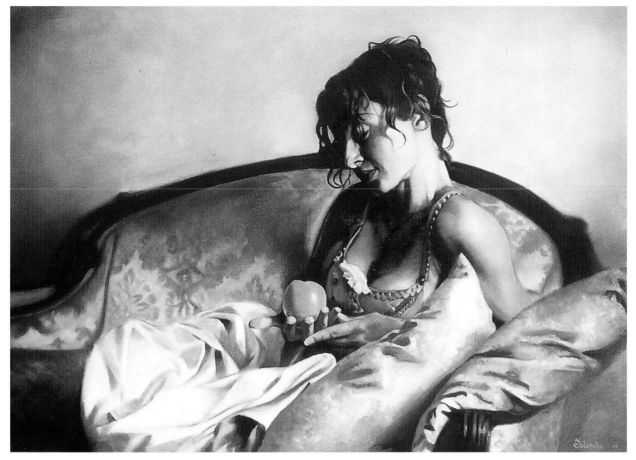

what I wanted to say

Last summer I became acquainted with a young actress. When she invited me to her home, I was surprised to find it looked like a theater set. I was curiously looking around when I saw some self-sewn Baroque looking dresses, which I asked her to show me. Suddenly, it turned into one of those rare moments I am always looking for. This combination of beauty, charisma and summer heat was, for me, quite clearly synonymous for "temptation". The green apple became an additional symbol for transporting my concept. The challenge was to express the significance of this special moment, not just the beauty of the woman.

my design strategy

The centre of the painting is exactly between the apple and the face. As a result, I achieved a very harmonious balance. Furthermore, I let the woman's face look away from the observer with a coquettish expression of self-confidence and charisma. Body language is generally a very important aspect in representing characters. But because I didn't want to overdo the theme, I balanced these elements with cooler colors and an easy, soft-focus representation of relatively unimportant parts.

my working process

- As always, I nearly completed the image in my mind before I started.
- First, I made a sketch with charcoal on the white, primed canvas.
- The underpainting of shadows followed. A perfect underpainting of forms is a very important foundation for a good painting, as it allows me to focus on color separately later on. What isn't correctly done at this stage cannot be compensated for afterwards. I used Raw Umber as it is the best suited for skin tones and provides a nice color harmony throughout.
- I painted only the figure in a layered technique; all other elements were done in an alla prima technique. I refined the skin of the figure with several layers of glazes painted from dark to bright, each layer heightened with white. These thin layers allowed me to achieve a more luminous effect in the skin. I used my whole palette for the skin tones, except for Cadmium Yellow and Cadmium Green.
- The darkest and brightest tone values were painted at the end.

please notice

Usually, I don't use cadmium colors, only natural earth tones, but in this case the apple and the light through the window seemed artificial. Therefore, I used a broader color palette.

what the artist used

brushes

Synthetic No. 16 for the background; red sables in a range of sizes

oil colors

Cadmium Yellow	Burnt Umber
Yellow Ochre	Cadmium Green
Cadmium Red Dark	Prussian Blue
Indian Red	Paynes Gray
Burnt Sienna	Titanium White
Raw Umber	Zinc White

Jolanda Richter lives in Vienna, Austria → www.jolanda.at

By simplifying the subordinate figures, I kept attention on the primary center of interest.

Chat Room, oil, 24 x 48" (61 x 122cm)

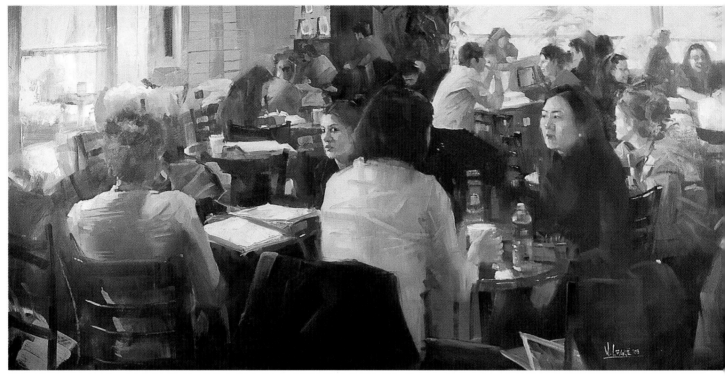

my inspiration

Just walking into this university caf? filled with students was instantly inspiring, both visually and conceptually. I am always inspired by the wonderful design patterns that come from groupings of people, and in this case it was coupled with the subtle interplay in the relationships of the four girls in the foreground.

my design strategy

For me, tonal value is the most important design element. As with every painting I do, my main objective was to eliminate detail and to link up the shapes of the figures (and what surrounds them) to form an interesting abstract foundation with clear focal areas.

my working process

- I started with a value drawing done with a woodless pencil to work out the format and size of the painting.

- Next, I spent 20 minutes doing a small oil sketch to determine whether my idea was worthy of a larger finished painting.

- Switching to my full-size piece of primed Masonite, I applied a pale wash of Burnt Sienna acrylic to kill the stark white of the gesso.

- Next came an underpainting, very broad and devoid of detail, but accurate in shapes.

- Once that dried, I proceeded with an alla prima technique, laying in thin darks and thick, juicy lights all at once. With this technique, I prefer to more or less finish each section before moving on to the next to allow working wet-into-wet over the whole surface while avoiding muddy color.

- I put the painting aside and started on something else so that I could return with a fresh look before touching it up.

please notice

This was painted from photographs for the obvious reasons that it would be impossible to get this many figures posed and it was in a place where it would not be acceptable to paint. However, it would not have been possible for me to imbue the figures with so much life if it weren't for the countless hours I've spent drawing and painting figures from life.

One thing about this painting that I would particularly like viewers to appreciate is how I managed to keep the four figures in the foreground prominent by eliminating detail on all of the figures in the distance. This was especially challenging because the temptation is always to paint things as you see them in a photo, which would have led to a very busy painting with no clear focal area.

what the artist used

support
Masonite panel textured with three coats of gesso applied with a house-painting brush

brushes
Mostly filbert and flat hog-bristle brushes; a large flat sable for blending; small sables for fine details

medium
Odorless mineral spirits for thinning and cleaning

oil colors
Cadmium Lemon
Cadmium Yellow
Yellow Ochre
Cadmium Red
Permanent Alizarin Crimson
Burnt Umber
Phthalo Green
Permanent Green
Terra Rosa
Manganese Blue Hue
Phthalo Blue
Ultramarine Blue
Winsor Violet
Permanent Magenta
Titanium White

Mark Laguë lives in Pointe Claire, Quebec, Canada → www.marklague.com

Placing the horizon high helped simplify the story.

Cambodian Bikers — Market Bound, watercolor, 17½ x 27" (45 x 69cm)

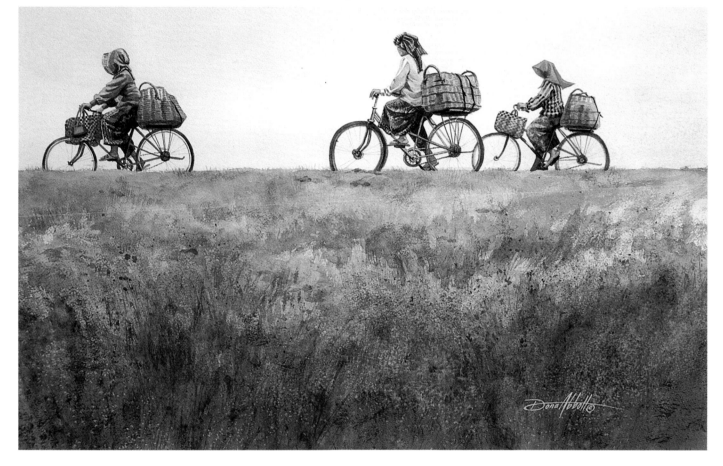

what I wanted to say

Each spring, the waters of the Tonle Sap ("Great Lake") rise to inundate the thatched huts and houseboats of Cambodian villagers living along the shore. The flooding gives rise to a bustling trade that provides half of the country's annual production. Watching the transactions from a rickety boat below on the lake, I caught sight of the bikers in my peripheral vision. I felt like a voyeur. Silhouetted against the sky, the figures bumped along a dirt road well above my eye level. The road's red dust tinted virtually everything with the same brush.

staying true to my memory

None of the photos I snapped that day did justice to the image that had tugged at my peripheral vision. I sketched several compositions, combining various elements in the photographs, eliminating lots of detail to remain true to the simplicity of the sight that had inspired me. Placing the horizon high and simplifying the land helped me to capture this feeling.

The overall "color feeling" was emblazoned on my memory. There was a cohesive harmony brought about by the road dust that landed on everything nearby — painting huts, banana leaves, vehicles, people — all with the same palette. The colors and patterns on the clothing evolved as I worked on the painting, playing one element against another to create both variety and harmony. All choices were weighed against the memory of my peripheral vision.

my working process

- Beginning with a light pencil sketch of the figures, I masked only the few areas that would remain lighter than the sky.

- With a wet wash, I graded the sky from warm to cool. As that dried, I developed the values in the grasses to create interest without getting too detailed.

- Painting the figures was a special joy. I changed the prints and colors in my photographs to create both variation and harmony.

- Only then did I put the finishing touches on the grasses, taking care not to draw attention away from the focal point.

my advice to you

Don't feel like you have to wait for the "perfect" composition or subject. Wherever people congregate, there is unlimited inspiration for paintings. Take the individual elements that inspire you and combine them in an interesting way. Don't be locked into the detail and color that is there. Editing out distracting detail or changing color often strengthens a piece.

what the artist used

support
300lb cold-pressed watercolor paper

watercolors
Naples Yellow
Raw Sienna
Burnt Sienna
Burnt Umber
Vermilion

Permanent Alizarin Crimson
Cobalt Blue
Ultramarine Blue
Winsor Violet

brushes
Rounds #00, 4, 12; a 2" flat wash; ½" filbert grass comb

Dona Abbott lives in Boulder, Colorado, USA → members.aol.com/dabbott303

All of my design and color decisions keep the eye on the central figure.

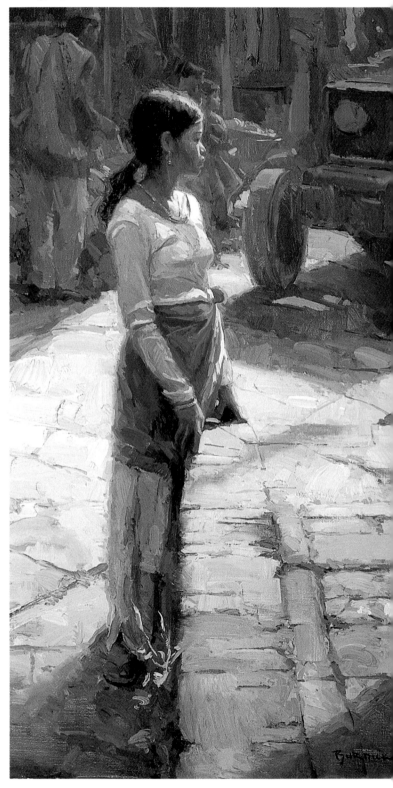

Waiting, oil, 46 x 24" (117 x 61cm)

my inspiration

The inspiration for this painting occurred the moment I saw this particular girl near Durbar Square in Kathmandu, Nepal. Alone among the crush of traffic and crowds, she had a lonely, expectant quality that immediately attracted me to her as a subject.

my design strategy

I wanted to make the girl's face the central point of focus. By cropping out all the unnecessary parts to both sides and deciding on an extreme vertical format, I hoped to keep too many other elements from drawing the eye away from her. Next, I greatly simplified the values and colors of the background, which in reality was every bit as contrasting and brightly colored as the main figure. This helped to give depth and a sense of atmosphere to the composition. I also slightly adjusted the perspective of the stone platform in front of the girl so that the vanishing point was just in front of her face, subconsciously leading your eye to my central point of focus.

try these tactics yourself

For this painting, I did quite a bit of preparation. First, I scanned in the 35mm negative I'd taken in Nepal, adjusted it for color and value and then printed out a 19 x 13" photo to work from. Next, I completed a charcoal drawing to work out all the compositional issues. Then I also painted a small oil study of the painting that took three or four hours to further refine my composition as well as color harmony.

my working process

• For the full-sized version of the painting, I sketched the subject in loosely but accurately with a piece of vine charcoal.

• Once I was certain everything was placed correctly, I then began painting from my center of interest (the girl's face) outward, finishing each section as I went. The surrounding white canvas didn't bother me since I had already worked out my colors in the study.

• To get the sense of the backlit glow of the intense sunlight, I added a thin "halo" of purples around the right edge of the girl. In this way I was able to keep the value of the actual light pattern light enough, while also suggesting the brilliant color of the sunlight.

my advice to you

Always paint only what you're interested in, not what galleries or anyone else tells you to paint! True art is a personal expression of your individual soul and shouldn't be wasted.

what the artist used

support
Double oil-primed linen stretched onto heavy-duty stretcher bars

brushes
Flat and filbert bristle brushes; a few small round watercolor brushes for details

medium
Odorless mineral spirits for thinning and cleaning

oil colors
Cadmium Yellow
Yellow Ochre
Cadmium Red
Alizarin Crimson
Transparent Oxide Red
Cobalt Blue
Ivory Black

Scott Burdick lives in King, North Carolina, USA → ScottBurdick.com

I used a strong gesture, a full range of values and unusual textures.

Eskimo Girl, oil, 28 x 38" (71 x 97cm)

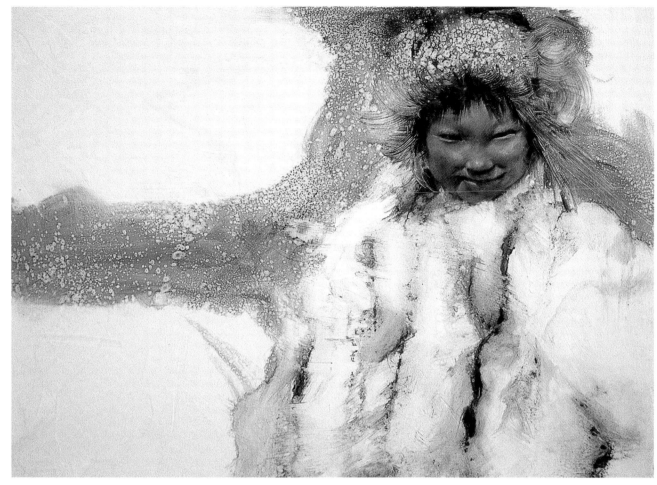

what I wanted to say

The inspiration for this piece came from researching the different cultures of the North American Indian. I wanted to present a strong gesture and center of interest that captured the viewer's eye.

my design strategy

Value is a primary concern in my paintings. The palette used here was limited, so the strength of my work was reliant on the proper treatment of value. The horizontal element leads the eye to the center of interest and grounds the subject.

special techniques

- I did two or three small value sketches in graphite to determine the composition and position of the subject.

- Before starting, I completely covered the panel in linseed oil to increase the working time.

- Starting with an old No. 2 bright, mixing Burnt Sienna and a little Burnt Umber, I did a quick line drawing directly on the oiled panel.

- Using Burnt Umber and a large filbert, I roughly laid in the dark areas and middle values of the face, striving for shape and value, not detail. Ultramarine Blue was used sparingly to cool down and recede certain elements.

- Wrapping a small cotton rag around my finger, I rubbed out the larger mid-lights to give the face shape. Folding the rag several times created a smaller rubout "tool" that allowed me to define the smaller highlights. No white was used, other than the white of the background.

- Darker details were done with a small round sable, and blending with a No. 4 sable fan.

- For the fur, I applied Burnt Umber and Burnt Sienna with an oil-soaked rag, then used a large bristle fan to apply thinner to the upper part of the fur. I allowed the thinner to run for a minute or two.

- Laying the panel horizontally, I masked off the face with tracing paper, then splattered thinner over the horizontal element and cap for desired texture.

what the artist used

support

A cradled hardboard panel, heavily textured and coated with four coats of white gesso

brushes

#10, #12 filberts; #2 sable round; #4 sable fan; 12 x 12" cotton rags torn from old sheets

oil colors

Burnt Sienna
Burnt Umber
Ultramarine Blue

something you could try

Observe people constantly. I am occasionally guilty of staring at a person, trying to impress on my memory the different ways shadow falls below an eye or nose or the way a neck muscle tenses. It also allows me to study gestures, which is one of the most powerful observations in a portrait painting. Gesture conveys the essence of the subject.

Robert Buckner lives in Wichita, Kansas, USA → www.robertbuckner.com

The warm, relaxed feeling of a day at the beach is the result of my simplified, yet realistic, depiction.

Circle of Friends, oil, 12 x 12" (31 x 31cm)

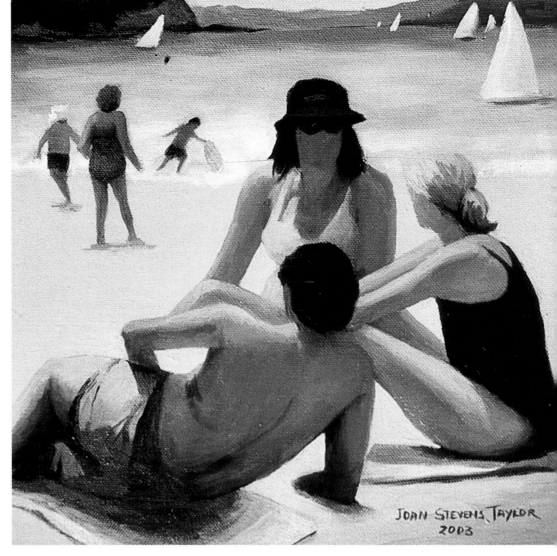

my inspiration

I wanted to capture the feeling of summer — the hot sun and the joys of being able to relax with the whole family on the beach and on and in the water.

follow my eye-path

The main group of figures form a triangle, the apex of which is the girl in the hat. I decided to lead the viewer's eye around the painting and make this figure the centre of interest. To achieve this, I adopted a spiral design device where the eye was led into the painting via the left towel and wound its way around the top and down to the figures, ending up at the focal point. Here, I created a strong tonal contrast. The triangular design fit well into a square format. I used a dominance of diagonal lines to suggest movement and mostly warm colors with enough cool accents to enhance them.

my working process

- During the summer, I take many photos of scenes on the beaches. I also do small sketches of groups of figures, individuals and arrangements of light and dark patterns. Color notes are important here, too. Using several photographs and sketches, I began by drawing my design onto the canvas in charcoal.

- When I was happy with this, I re-drew the main elements with black acrylic paint and gave an indication of the tonal pattern.

- Once this was dry, I applied a thin coating of a warm color over the whole canvas.

- Working quickly with thin paint, I covered as much of the canvas as possible, establishing large areas of color and tonal relationships. I began by looking for the lightest lights and the darkest areas and painting these. In some areas, I felt it appropriate to leave some of the under-color visible.

- From here on, it was a matter of developing the forms and adjusting the colors and tones, using thicker paint.

the main challenge in painting this picture

The greatest challenge with this painting was achieving a simple, yet realistic, depiction of the figures so that their relaxed inaction looked spontaneous and not contrived.

what the artist used

support
Stretched canvas

medium
Liquin

brushes
Hog hair filberts, sizes 11, 7, 6, 5, 4, 3; synthetic flats, sizes 12, 4, 2; synthetic rounds, sizes 6, 4

oil colors

Yellow Ochre	Permanent Rose	Cobalt Blue
Lemon Yellow	Alizarin Crimson	Ultramarine Blue
Cadmium Yellow	Cadmium Red	Titanium White
Cadmium Yellow Deep	Viridian	
Burnt Sienna	Cerulean	

Joan Stevens Taylor lives in Devonport, Auckland, New Zealand → aftaylor@xtra.co.nz

Color, value and texture highlight the main point.

Times Square Speakers, watercolor, 22 x 30" (56 x 76cm)

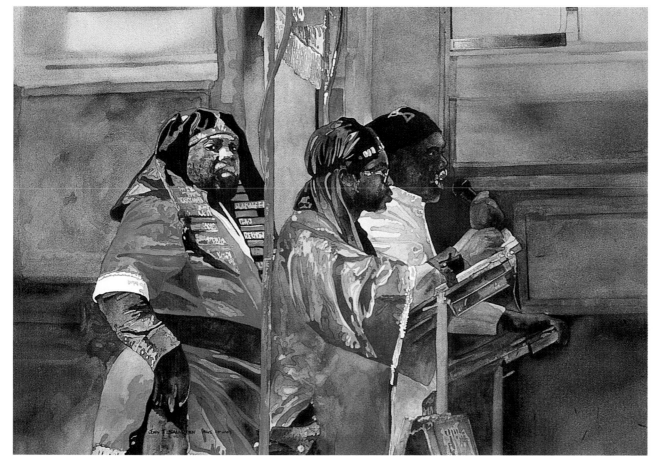

focus on content

I work from photographs that I take on the street, and the streets of New York City are some of my favorite subjects. I like the camera's ability to capture small slices of life. It is my hope that, caught in a brief unguarded moment, my subjects can convey truths that posed subjects often mask.

Here, I was watching some speakers at Times Square and took several shots of them. Just as the shutter on my camera snapped, the man in red turned and stared directly into the lens. In viewing the photos later, I was drawn to this subject by a combination of three things: the composition, the technical challenge and the content.

Content is often subjective and elusive. The story this painting tells is entirely dependent upon the expression on the face of the man in red. I leave the interpretation of the man's expression and attitude to the viewer.

my design strategy

I composed the subject through my camera lens, placing the figures, which are curvilinear and organic, in juxtaposition to the horizontal and vertical elements of the background. Because the photo captured both the physical likeness of the subject and the emotional impact of the experience, I only needed to work with color, value and texture to draw the viewer's eye to the center of interest.

try these tactics yourself

- I focused on the speakers by eliminating distracting background detail and contrasting the soft, brushed background with the sharp edges of the figures.
- I further attempted to draw the viewer's eye to the figures by using closely related values of neutral grays in the background while reserving the unmixed,

intense, brighter colors for sharper contrast in the figures.

- As with all of my paintings, for every hour I spent painting, I spent at least an hour studying the work in progress. I placed the painting behind Plexiglass and a mat to evaluate what I'd done and to plan my next move. In many instances, the partially completed painting can dictate what happens next but in this case, I remained true to the original concept.

my advice to you

- Try to catch subjects in unguarded moments.
- Avoid sentimentality.
- Design the entire painting, not just the figure.

what the artist used

support
140lb cold-pressed watercolor paper

brushes
Flats and rounds from #4 rounds to 3" flats

watercolors
Cadmium Yellow Light
Cadmium Red Light
Yellow Ochre
Indian Red
Rose Madder
Alizarin Crimson
Raw Sienna
Burnt Sienna
Burnt Umber
Phthalo Green
Cerulean Blue
Ultramarine Blue
Phthalo Blue
Thioindigo Violet
Davy's Gray
Lamp Black

John T Salminen lives in Duluth, Minnesota, USA → salminen@cpinternet.com

Marie Hélene Auclair

Thanks to tight cropping and strong colors, my painting hints at a story.

Robin, pastel, 25 x 19" (64 x 49cm)

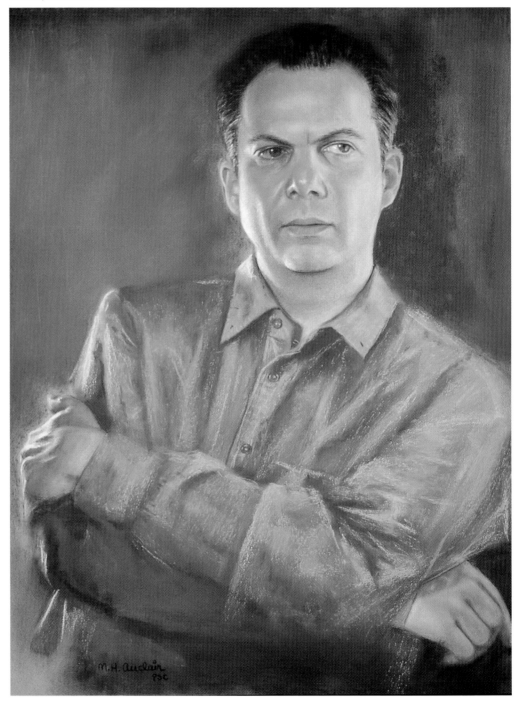

my inspiration

Robin, my model, was looking at a portrait of a young girl that I was working on. I wanted to capture the emotion of the moment, as well as his strength of character and his sensibility.

my design strategy

The focal point is Robin's look, and the tight cropping arouses curiosity as to what he is looking at. Diagonal movement is brought about by highlights on his face and hand. The strong colors in the background enhance his character.

my working process

• I have portrayed and sketched Robin on different occasions from life, but for this portrait I preferred to use a photograph to capture the emotion of the moment. I did a charcoal sketch that I used as a guide for design and tonal value.

• On sanded pastel paper, I started building up successive layers of pastel with no attention to detail, just establishing big shapes.

• To achieve the skin texture, I blended together many layers of soft pastel on the support. For fine detail, I blended with a silicone shaper point.

• To create contrasting textures, I applied pastel sticks directly to the background without blending. I used the same method for the shirt and the facial highlights.

• For the last step, I applied pastel powder with my fingertips, as well as a filbert and a flat brush.

• I had a mental image of what I wanted to transmit, and I continually went over and adjusted my painting until they matched.

my advice to you

If you paint from a photograph (Degas did, too!), set aside the photo from time to time so that the creative process and your imagination can take over.

what the artist used

support
Sanded pastel paper

other materials
Vine charcoal
Filbert brush No. 6
Flat brush No. 4
Silicone shaper point No. 0
Tissue paper

predominant pastel colors

red brown	Van Dyck brown
golden ochre	purplish-blue gray
dead leaf green	burnt sienna
olive green	helios red

Marie Hélene Auclair lives in Mirabel, Quebec, Canada → www.mhauclair.com

My intention was to capture a candid moment of innocence.

Naptime, oil, 16 x 20" (41 x 51cm)

what I wanted to say

The work of Jessie Wilcox Smith captures children's innocence and openness, and has been a great inspiration to me. This model is my great niece, who is a real beauty. My intent was to capture that spirit of innocence of a time in life we adults can never return to.

my design strategy

The child's hands and the stuffed rabbit both help lead the eye to the main interest, the child's face. (Human faces always grab attention, anyway). The dominant color is blue surrounded by a variety of grays. The painting also has high contrast for appeal.

try these tactics yourself

Let's face it, children are not generally willing and able to hold still for long periods of time so photo shoots are the best answer. I formed my initial idea way ahead of the actual scheduled shoot, but did the majority of my composing through the camera lens. I had also done small, preliminary pencil and color sketches first, including notes about the color of light, focal areas, edges and so forth.

my working process

- Using thin, warm darks applied with bristle brushes, I blocked in the pattern of light and shadow, connecting as many darks as possible in order to simplify.

- Next, I blocked in a middle value of each hue, taking into account the highest contrast and sharpest edge near the focal area. As I went along, I corrected the value, accuracy and edges of my shapes as needed.

- As I continued to refine the image, I used softer, natural bristle brushes for more subtle transitions. I repeatedly stepped back from the work to get a better view of the whole.

- Finally, I set the painting aside and returned to it in a few days with a fresh eye. To reassess accurately, I looked upside down at the painting, used a mirror and also a black mirror. This helped me identify some distractions that needed to be corrected.

- My ending procedure consisted of refining detail, but not too much. Simple is best.

HOT TIP!

Unless you have had many, many initial years of good structured drawing classes, I think it's essential to keep your drawing skills sharp. I recommend taking a drawing class at least once a week and/or working in a sketchbook from life for five to 25 minutes per day. When you draw, strive for simplicity yet accuracy in shapes, edges and values.

what the artist used

brushes

Bristle flats and filberts #12 to #4; natural flats and brights; very soft, long flats and fans for blending

oil colors

Titanium White (soft version)	Transparent Oxide Red
Hansa Yellow	Raw Umber (earth color)
Yellow Ochre	Green Gold
Cadmium Yellow Deep	Permanent Green
Cadmium Red Light	Phthalo Green
Quinacridrone Red	Cerulean Blue Hue
Alizarin Crimson	Ultramarine Blue
Venetian Red	Black

other materials

Mahl stick

Regular mirror

Black mirror (primarily for value comparisons but also helps finding drawing problems)

Palette knife

Painting knives

C M Cooper lives in Valencia, California, USA → www.cmcooperstudio.com

I used light and color to create mood.

what's important to me

Biographical subjects concerning me and my studio have been favorite themes in my paintings. Because these subjects are both familiar and intimate, they allow me to create paintings with substance and sincerity, not superficiality.

my design strategy

At first glance, the subject may appear to be the model in the foreground. But upon second glance, the eye is drawn away from her and to the artist, with all of his painting accoutrements surrounding him, in the background. Notice how I used light and color to emphasize this center of interest. The area surrounding the artist receives the dominant light source and the most active color, while the surrounding areas are flatter in tone and form. In this way, I achieved my primary objective of creating a sense of mood with light.

my working process

- I had thought about this idea for quite a while before I finally made a rough thumbnail sketch of the layout, including the lighting.

- After taking great pains to carefully arrange everything down to the smallest details, I took photographs of the subject.

- Using only Burnt Sienna, I first completed a tonal oil study, thinning the paint with turpentine where needed. This acted as my underpainting, sort of a "rehearsal" in which I solved compositional, drawing and tonal problems.

- As I continued to develop the painting, I left small parts of this underpainting exposed, which created a contrast of thin and thick paint while helping to unify color. I used both the palette knife to create the thicker, more textured areas (mostly in the lights) and sable brushes to soften and diffuse edges where I felt it was most effective. Enhancing the mood with light was my priority throughout this process.

Entrance, oil, 40 x 30" (102 x 76cm)

my advice to you

I completed this painting with the aid of photography but cannot emphasize the importance of painting from life. Only through years of training in drawing and painting from life did I learn to understand light, color and form. Thanks to this experience, I am able to use photography as an aid to working on complex compositions and capturing poses and moments impossible for live models to hold.

CAREER TIP!

If possible, delay your entrance into the professional field until you are qualified and ready. You won't regret delaying your career to further your studies, but you may regret starting before you are ready.

what the artist used

support
Double oil-primed stretched canvas

brushes
Flat bristle brushes; flat synthetics; smaller synthetic sables; palette knife for mixing

medium
A half and half mixture of linseed oil and Turpenoid

oil colors
Titanium White
Yellow Ochre
Cadmium Red
Ivory Black

I know that if I can capture the planes of the head, I will capture the character of the person.

Mr Wilson Study, oil, 16 x 20" (41 x 51cm)

my inspiration

Mr Wilson was a man who always had a calm, quiet strength about him. The gentle rim light falling on his head and shoulders, defining the planes of the figure, supported me in portraying the character of this gentleman.

my design strategy

Using the principle of the golden mean, I divided the canvas to create a well balanced composition. Contrasting the two flat drapery colors on the left with the airy background on the right gives this portrait an interesting abstract element. Their value differences also invite the viewer into the painting. Finally, the light falling on the face and head brings the viewer to the center of interest, his sculpted features and strong presence.

session one

- The main challenge for me in this painting was to be able to capture the quiet strength of this gentleman on a fairly small canvas. How could I put all that feeling into a small format? And how could I capture the character of a person visually? These were the two most important questions I had to answer for myself before beginning this painting. Doing a charcoal sketch first gave me both answers. In it, I worked out the composition, and in this case, gained knowledge of the model's head and shoulder anatomy. I then felt ready to begin the painting.
- On a canvas with acrylic gesso as a ground, I lightly rubbed in a thin film of linseed oil with a soft cotton rag. Over this, I brushed on a layer of Burnt Umber to the value of his average flesh tone.

- Next, I "drew" the contour of the planes of his head and shoulders by lifting color with the eraser end of a regular pencil. Then, with a small clean cotton rag, I subtracted the lights from the planes on his head, shirt and background drapery. This was all done in the first 3.5 hour session, after which I let it dry overnight.

session two

- The next day, I painted in the background with varying values of carefully mixed warm grays. For the drapery, I used Permalba White and Cadmium Red Light for the pink.
- Continuing to use a limited palette, I then finished the shirt and added a few necessary accents to the head.

HOT TIP!

Live life, with all its challenges and joys, to the fullest. It will strengthen and enrich your painting.

what the artist used

brushes
Brights in Nos. 12, 10 and 4; filberts in Nos. 8 and 6

oil colors
Permalba White
Cadmium Red Light
Cadmium Red Deep
Burnt Umber
Ivory Black

medium
40% Turpenoid and 60% refined linseed oil

Magdalena Castañeda lives in Portland, Oregon, USA → mcastanedafineart@yahoo.com

Interesting composition and dynamic balance made this painting work.

Hopes & Dreams, oil, 30 x 24" (76 x 61cm)

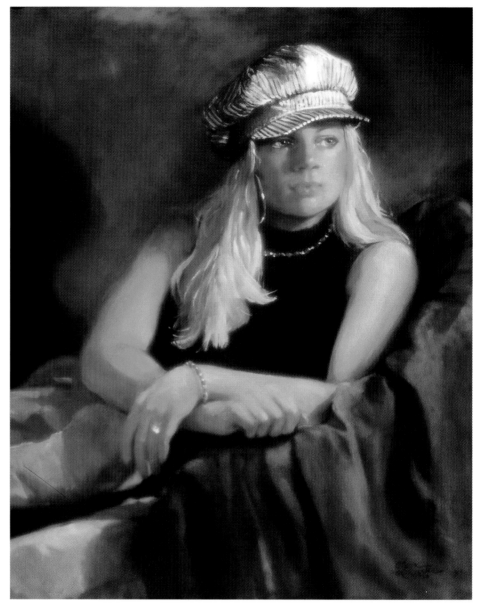

my inspiration

Sarah's combination of youthful "attitude" and deep concentration made for a very interesting subject. I loved the jaunty slant of her cap and the slight pout of her lips, yet wanted her sweetness and beauty to dominate.

my design strategy

The strong shadow in the background created an interesting compositional balance, allowing me to move the figure farther off center. I wanted the viewer's eye to be captured by Sarah's face, then travel down her arm to her relaxed and graceful hands. I chose to keep the background somewhat neutral so the contrast of her lovely blond hair would bring her alive. My portraits don't feel finished until the subject appears ready to "talk" to the viewer.

at the first sitting

- Painting from life, I skipped the usual thumbnail sketches and went directly to the canvas, which was toned with a mixture of Burnt Sienna and Cobalt Blue.

- I mixed the under-colors with odorless turpentine, applied with a large brush and wiped the whole thing down with a soft cloth so the canvas had a fairly even medium tone.

- This dried rapidly, and I was then able to block in the composition with straight Burnt Sienna.

- Starting with the darkest darks, I painted the deep shadow areas. I mixed Permanent Alizarin Crimson, Sap Green and Titanium White for the shadowed skin tones. I added some Liquin to speed the drying time, allowing for almost immediate changes and over-painting.

- Next, I began to lay in the light skin tones with a mixture of Cadmium Red Light, Indian Yellow and Titanium White, using #4 and #6 filberts. The background was developed at the same time so it wouldn't appear to be an afterthought.

- At some time during this first sitting, I also took at least a dozen reference photographs under various light conditions. Many were close-ups of Sarah's face and hands that I could work from back in the studio.

a studio finish

- To finish the portrait, I worked from photos rather than the live model. I gradually refined the mid-tones and added more intense color. Using a very light touch, I blended these with a mop brush.

- At the very last, I put in a minimum of white highlights, black accents and small details.

- When the painting was dry to the touch, I laid over an extremely transparent glaze of Burnt Sienna to warm up flat, cool areas.

what the artist used

support
Canvas

medium
Liquin

brushes
2" bristle or foam brush for under toning; #2, 4, 6 and 8 bristle and sable (or synthetic) flats; small sable rounds (#0 or #1) for details; large watercolor "mop" brush

oil colors

Titanium White	Burnt Umber
Lemon Yellow	Sap Green
Indian Yellow	Viridian Green
Cadmium Yellow Deep	Ultramarine Blue
Yellow Ochre	Cerulean Blue
Cadmium Red Light	Cobalt Blue
Permanent Alizarin Crimson	Ivory Black
Burnt Sienna	

Lucille Carter lives in Dallas, Texas, USA → www.lucillecarter.com

Cropping, carefully balanced masses and a warm-versus-cool interplay give my painting a monumental quality.

Sam, watercolor, 14 x 20½" (36 x 52cm)

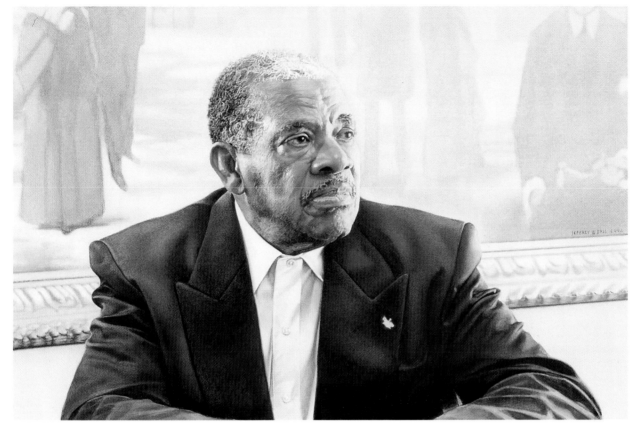

what I wanted to say

In preparation for a different, multiple-subject portrait, I took reference photos of Sam while he sat in front of a large figurative painting in a conference room. I was intrigued by the dark, shadowy figures in the painting that seemed to hover behind Sam, so contradictory to his spirituality and warm demeanor. While I don't usually employ cloying allegory in a painting, one could also view the painting as emblematic of good versus evil or of the struggle we wage with personal demons.

my design strategy

Tight cropping of the model's body, as well as the background figures, resulted in a triangular arrangement that gives the painting a monumental quality.

about light and color

To separate the subject from the background while simultaneously unifying the painting as a whole, I exploited the warm/cool dichotomy of complementary colors. The warm yellow and orange color notes in the subject's face and clothing thrust the subject forward in space. Reciprocally, the diffused blue color notes and light values in the background painting lent atmospheric perspective.

Multiple, varied light sources accentuated this warm/cool interplay. The warm hues of an overhead light made the frontal planes of the face come forward, while the cool reflected hues of natural light from a nearby window made the side planes of the head recede.

my working process

- For this painting, I made many thumbnail sketches to refine the composition. I then pounced the well-developed drawing onto the watercolor surface.

- To establish the basic masses, I started with controlled washes consisting of a neutral mixture of Ultramarine Blue and Alizarin Crimson, applied with a large Kolinsky round. Using a smaller Kolinsky round, I began modeling the face with the same neutral wash, being careful to preserve the white highlights. I also used a small bristle oil painting brush dipped in clean water to quickly blunt any hard edges.

- After developing the neutral underpainting, I began applying color to the face with small, controlled washes. I moved around the painting at this point, developing the painting evenly.

- In the final stages of the painting, I drybrushed to refine the modeling of the forms and soften tonal gradations. Additionally, I applied glazes of color to unify passages.

- Finally, using a large, flat wash brush, I applied virtually clear washes to the background painting to sufficiently blur the figures and diffuse the color.

what the artist used

support
Hot pressed watercolor board with archival backing

brushes
1½ inch flat synthetic wash brush; #12, 7 Kolinsky rounds; #2, 1, 0, 00 synthetic rounds for dry-brush; #0, 8, 12 oil painting bristle brushes (brights) for lifting out pigment, softening edges

watercolors
Cadmium Yellow Pale
Cadmium Orange
Cadmium Red
Alizarin Crimson Permanent
Raw Sienna
Burnt Sienna
Viridian
Antwerp Blue
Cerulean Blue
Cobalt Blue
Ultramarine Blue
Ivory Black

Jeffrey W Bass lives in Pensacola, Florida, USA → www.jeffbass.com

My painting pivots on the subject's compelling gaze.

what I wanted to say

I have always loved the depth of emotion that can be portrayed from person to person without words. It was my goal to convey a certain feeling through the expression of this little girl. It is the way we look at and interpret things differently that makes art worthy of viewing. I love, most of all, those paintings in which the viewer can see a part of himself or herself, and feel as if the canvas is looking back. It is this unspoken interaction that I find captivating in art.

unified by design

Several strategic decisions tied this painting together:

- The focus of this painting was to be the eye of the model — her gaze is gripping — but this area also needed to relate to the whole. This is why I placed the eye at the top of a triangle, the other two points of which fall on either edge of the flowers.

- Many of the background colors are present in the flesh tones, and the flesh tones are present in many other parts of the painting. Repeated color adds to the overall sense of unity, although the transparent darks play up the opacity of the lights.

- Simplified brush strokes bring the painting together while still managing to reveal the different textures.

- A natural, cool north light falls over the entire model and setting.

my working process

- This painting was done fairly quickly in about six hours.

- I began with a toned canvas of a warm brown (mostly Asphaltum and a bit of Ultramarine Blue). I then used this same mixture to draw a rough outline consisting of less than 10 lines, just enough to set up my overall proportions and gesture.

- To separate the light and dark shapes, I blocked in thin, dark washes.

- Next, I brought in color, working very carefully on getting the right color in the right value in the right place in the right shape.

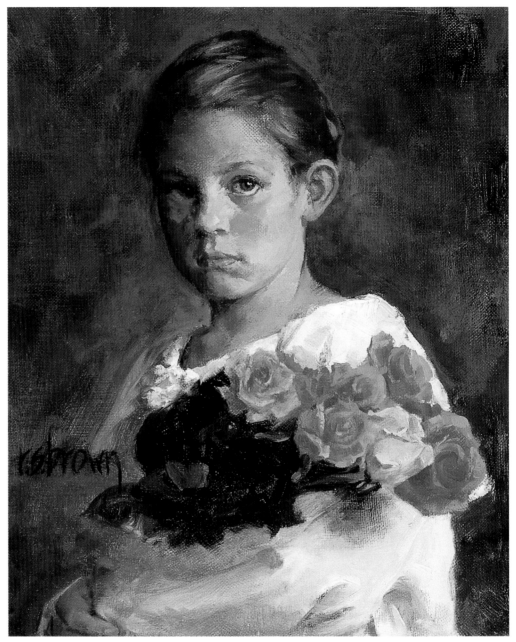

Lexie, oil, 10 x 8" (26 x 20cm)

Very little blending of values or colors was required. The transitions were made by bringing one shape of color up against another and leaving it. Much of what you see are the initial brushstrokes that were laid down and never changed.

- I used many bristle brushes and a palette knife for areas in the shirt so I didn't do too much mixing and kept my colors clean.

what the artist used

support
Italian linen

oil colors
Cadmium Yellow Light
Yellow Ochre
Cadmium Red Light
Alizarin Crimson Permanent
Raw Umber

brushes
Hog-hair filbert bristle brushes #2 to 8; a palette knife

Asphaltum
Sap Green
Ultramarine Blue
Paynes Gray
White

Ryan S Brown lives in Springville, Utah, USA → www.ryansbrownart.com

For me, an appealing pose, contrast and interesting colors made this a good portrait.

Tess, oil, 30 x 40" (76 x 102cm)

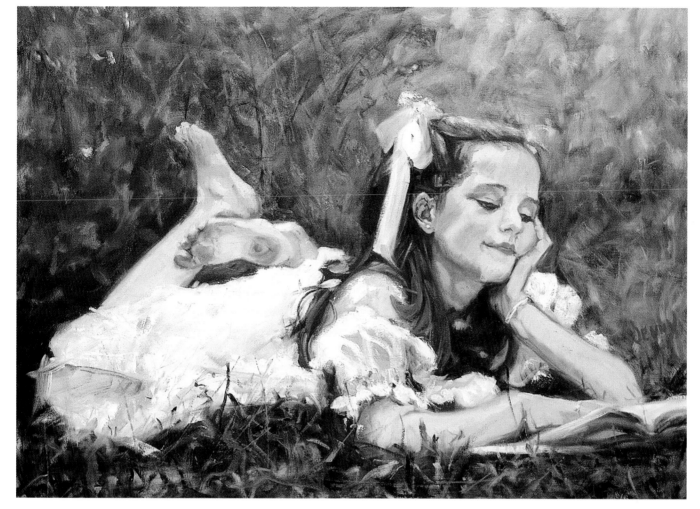

my inspiration

Children portray an innocence and a simple enjoyment of life. Finding a quiet spot to kick her shoes off and read, the young lady struck a very appealing pose I just had to paint.

my design strategy

I wanted the figure to fill the canvas. The background was unimportant except to frame her. I focused most of my attention on her face. It is easier to paint a child in white than any other color. It can reflect all the colors around it. There are no hard lines, only soft flowing ones. Her enjoyment of the book from her eyes to the page was my line of focus.

my working process

- I photographed my model to capture the perfect look. After spending lots of time with her to understand her better, I felt ready to paint from the photo.

- I covered the canvas with a wash of Cadmium Yellow Medium. I then sketched directly onto the canvas with Alizarin Crimson. I let this dry for two days so it would be fairly permanent.

- Next, I put in a dark wash for the dark areas of the painting. The dark wash is made up of Alizarin Crimson, Ultramarine Blue, Sap Green and Raw Umber. Again, I let this dry for two days before continuing.

- In the next phase, I finished the painting all at once. I started with the face, spending most of time there to get it right. The face must be accurate — it is the person.

- Working out from there, I painted loose and fast. The hair was my favorite part to paint. I used broad strokes with strong colors. I used all of the colors in my palette, bouncing them everywhere to create color harmony.

what the artist used

support
Standard pre-stretched linen canvas

brushes
Round oil brushes in sizes 6-12

medium
Odorless mineral spirits

commission advice

When doing a child's portrait, let the parent help set up the picture. They know the child best. Focus on the face, getting it exactly right. Then be loose and free with the rest of the painting, repeating colors to tie everything together.

oil colors
Cadmium Yellow Light
Cadmium Yellow Medium
Cadmium Red Medium
Alizarin Crimson
Raw Umber
Sap Green
Cobalt Blue
Ultramarine Blue
Titanium White

Jenny Buckner lives in Waynesville, North Carolina, USA → paintingsbyjenny@msn.com

If you enjoy surprises try my watercolor batik approach.

Getting the Feeling Of It, watercolor batik, 12½ x 17½" (31 x 45cm)

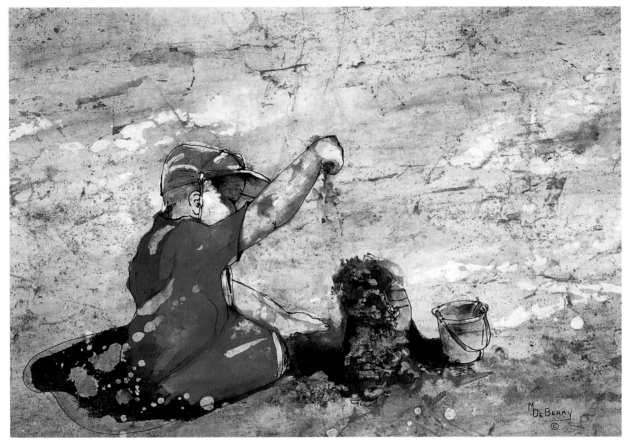

my inspiration

We lost a 12-year-old grandson to cancer the year before this painting was done. Looking through old photographs, I found one of him as a toddler, playing at the beach. I hoped to capture the feelings of peace and warmth and the newness of his experience.

my design strategy

The child's shadow leads you into the painting, and the path to the upraised arm down to the sand buckets forms a triangle. This would be static except for the sand falling from the child's hand and the oblique shapes in the sand, water and waves.

special techniques

• I chose watercolor batik (a wax resist method) because the end result is always a bit of a mystery and surprise.

• First, I drew the composition on newsprint paper, which I then traced onto a sheet of rice paper with a waterproof drawing pen.

• After laying the rice paper over waxed paper taped to a piece of foam core, I covered the shapes that were to be kept white with melted wax. I used an electric skillet to melt the wax and old watercolor brushes to apply it.

• When the wax was dry, I painted in all of the lightest values and allowed them to dry. I then covered those parts of the painting that were to stay this value with melted wax and again allowed it to dry.

• I repeated this cycle several times, adding darker values each time and balancing warms against cools. When the values were satisfactory, I covered the entire painting with wax and allowed it to dry.

• After carefully removing the painting from the waxed paper, I gently crumpled it to cause cracks in the wax surface. After smoothing the painting out on the wax paper once more, I painted the entire surface with a medium value red. While the

painting was still wet, I covered it again with wax to push the color into the cracks.

• After allowing it to dry overnight, I removed the wax by placing the painting between layers of newspaper and pressing with a warm iron.

• To finish the painting, I dry mounted it onto a white mat board.

tips on batiking

Don't let the wax get too hot (around 240 degrees is good). Wet paint tends to spread quickly on rice paper, so know where you want to put it and use more paint and less water when you want to keep it contained. And don't get discouraged by the way it looks as you go along!

what the artist used

support
Paper
Rice paper
Mat board

brushes
Rounds #10, 7, 5, 3; miscellaneous old w/c brushes for the wax

watercolors

Quinacridone Gold	Perylene Red	Viridian
Cadmium Red Orange	Raw Sienna	Manganese Blue
Cadmium Red	Burnt Sienna	Cobalt Blue

other materials
Waterproof drawing pen .05
Waxed paper
Kitchen wax
Electric Skillet
Electric Iron
Newspapers

Marian De Berry can be contacted at 3573 Beltway So., Abilene TX 79606 USA

By abstracting and manipulating shapes I suggested movement.

Seeing Beyond, oil, 16 x 20" (41 x 51cm)

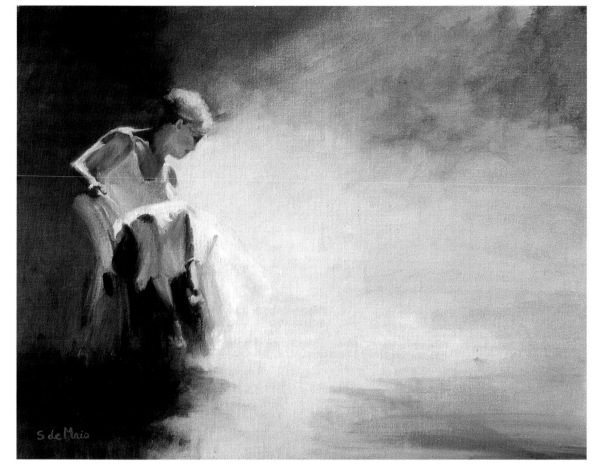

what I wanted to say

I wanted this painting to have a lot of presence — to seem uncomplicated while providing a complex message on many levels. The viewer should be drawn into its reality; however, the emotional response remains open to the viewer's interpretation. Merely suggesting the sky, trees and ground helped create a more compelling visual statement.

my design strategy

This painting has three large vertical shapes that are divided into three tonal values. The area with the darkest value, which includes the figure, has the most intense color and the sharpest contrast. The figure is caught in a "contrapposto" (counterbalanced) pose; she is in the middle of a movement, giving you the impression that a moment later or earlier the pose would have been different.

I placed the figure to one side to generate tension. The figure is looking off, causing the viewer to follow that gaze in a diagonal line, thereby relieving the vertical tension in the painting. The gesture of her body and the direction of her gaze also suggest movement. Motion is further implied by having her white dress flow into the light value, although the mid-value diagonals lead the viewer back toward the figure.

my working process

- The first gesture and value sketch was made on site. Back in the studio, details were filled in with the aid of photographs.

- Using my reference material, I started on a linen panel with a loose sketch drawn with a paintbrush, using thinned Burnt Umber and Ultramarine Blue.

- Then I blocked in the dark area, then the mid values and finally the light values.

- After all areas were blocked in, I started adding the details to the figure. My goal was to keep edges soft and loose to maintain an airy mood and to contrast the few hard edges.

- Last, I refined the background by suggesting the sky, trees and the ground. I wanted make certain that these elements were simply implied as to allow the conceptual sentiment of the painting to persist, which turned out to be a challenge. Often I feel the need to say more than is needed, so this painting was an exercise in self-control and brevity.

please notice

By catching the model unaware in this dynamic pose, I gave this painting an edginess that is sometimes lacking in traditional or staged poses.

what the artist used

support
Oil-primed linen on Baltic birch panel

oil colors
Naples Yellow
Cadmium Yellow Pale
Cadmium Yellow Deep
Yellow Ochre
Cadmium Red Light

brushes
Nos. 2, 4, 6, 10 and 12 filberts, sables and bristles

Cadmium Red
Rose Madder
Alizarin Crimson
Terra Rosa
Burnt Umber

medium
Odorless thinner as medium and brush cleaner

Viridian
Sap Green
Translucent Turquoise
Cobalt Blue
Ultramarine Blue

Shirley de Maio lives in Clovis, New Mexico, USA ➔ www.sdemaio.com

Correct perspective, anatomy and form support the story.

Picnic Preparations, pastel, 19 x 24" (49 x 61cm)

Margaret Dyer

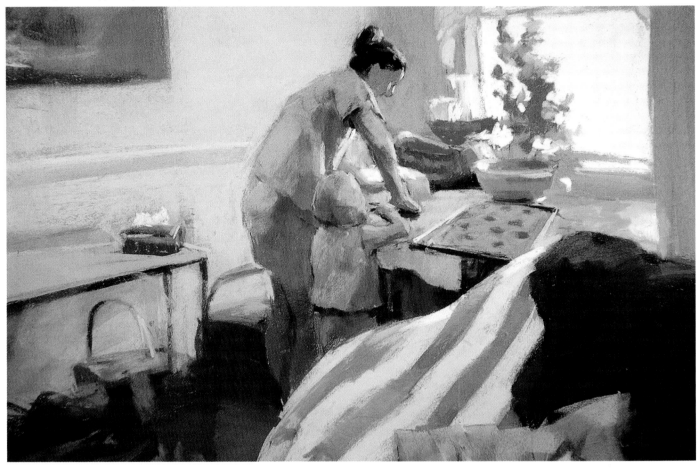

my inspiration

This little girl helping her mother so earnestly inspired me. I wanted to capture and create the impression that the little girl's entire world, for that moment, was in the preparation for that picnic. I wanted to capture the innocent moment in a child's life, but to do it without sentiment or coyness.

about photography

I used to be a purist, insisting on drawing from life, until my psychologist brother-in-law helped me realize my models all looked bored from posing so long! Now I'm willing to work from the photographs I take. This is one example. I didn't arrange the setting — life arranged it. All I did was to "frame" the scene in an interesting way and add the striped chair in the foreground to create a sense of depth.

my working process

- I begin every pastel painting with a gesture drawing in vine charcoal or hard pastel. Perspective, anatomy, solid form — everything is worked out in the drawing stage. When resolved, I re-draw with a darker material to help me distinguish the correct lines from all the "searching".

- Once I have a solid scene in front of me, I squint to determine the values. I outline the dark shapes, creating a path that unifies the piece. Then I fill in the darks with a hard pastel. If I'm not very excited about continuing at this point, I will either re-draw or just toss the paper aside and try something else.

- Next, I begin to mass in the dark colors with soft pastels, layering color on color lightly, warm on cool, cool on warm, staying within the outlines. Only darks — no middle-tones or lights!

- I then repeat the process, focusing on just the middle-tones and then just the light values.

- Finally, I hold the almost-finished piece in front of a mirror. Any mistakes will shout back at me, and I will correct them. I check my edges, and lose them or find them more emphatically. I will add hot reds to areas where skin presses against skin, like between fingers. I will use sweeping strokes to loosen anything that looks too tight. I will fidget with it until I like it, but I do not fidget with it long or I will inevitably not like it.

- And then, of course, I photograph it, frame it and put a huge price tag on it (just kidding!).

what the artist used

support
Pastel paper

drawing/painting materials
Vine charcoal
Hard pastels
Soft pastels

other materials
An easel with a foam-core backing board

Margaret Dyer lives in Carrollton, Georgia, USA → www.margaretdyer.com

I wanted a lively, informal painting that revealed an expression of this woman's personality.

Redhead, oil, 10 x 8" (26 x 20cm)

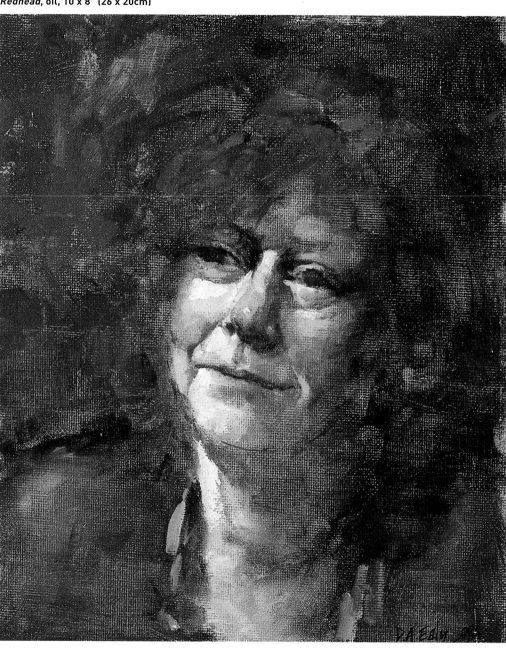

my inspiration

First of all, I love painting faces. A shadow, a nose, a high cheekbone or, as in this painting, an expression of personality will get me started. That expression is what I wanted to convey in this painting. It is a fleeting expression that I don't think would work very well in a more formal portrait.

my design strategy

The cocked head and lack of props keeps this informal. The light comes from the left, which exaggerates the highlights and causes the shadowed side to trail off. This effect goes all the way back to Rembrandt — a lovely effect it is. The face is quite warm and appears even more so because of the swath of red in the background that is much cooler than the red in the cheeks. There is also a tinge of green in the shadowed side, adding life to the warm tones.

my working process

- This was done from a pen sketch made in a busy caf? — a favorite occupation of mine — so there is a good deal of invention.

- On canvas mounted on hard board and covered with a ground of white lead, I applied a very thin turp wash of Burnt Sienna and a little Black. Using a #12 pointed sable and the same colors with only slightly heavier consistency, I created a loose drawing. I washed in some darks and lifted out some lights with a rag. At this point, I have made a big mess. The rest of the time will be spent trying to fix it.

- A faithful likeness was not my concern, but I did want the essence of her expression. Using various combinations of Yellow Ochre, White, Venetian Red and Terre Verte, I scrubbed in the planes of the face, eyes, cheeks and nose.

- For the background, from the top down, I used several colors combined with Black.

- Using a small, soft flat brush, I applied thicker paint in the final details, definitions and highlights.

the main challenge in painting this picture

The biggest challenge for me is keeping it simple. I want an interesting surface texture, so I scrub and scrape and draw over. I want all that to show somewhere in the painting, yet I must also keep that toned down so the painting remains loose and sketch-like.

what the artist used

support

Heavy canvas mounted on Masonite; sized with PVA sizing; primed with white lead spread with both a spatula and a brush for texture

brushes

Large and medium bristles for roughing in; medium and small synthetic rounds and script liner for finishing

oil colors

Cadmium Yellow
Yellow Ochre
Cadmium Red Light
Venetian Red
Alizarin Crimson
Terre Verte
Burnt Sienna
Viridian
Cobalt Blue
Ultramarine Blue
Black
White

Don Ealy lives in Spirit Lake, Idaho, USA → donealy@msn.com

A good design provided the perfect, relaxed environment in which my little model could dance.

Julia, oil, 30 x 26" (76 x 66cm)

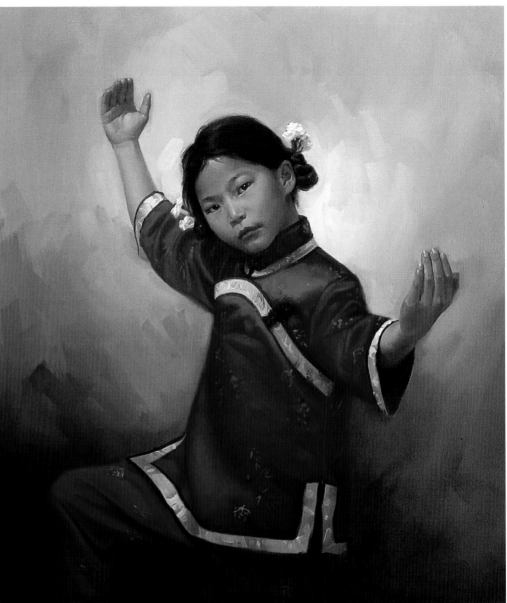

my inspiration

Julia and her parents are so enthusiastic about her involvement in traditional Chinese folk dance. She has a focused, self-confident and yet totally relaxed composure while dancing. Bringing this element into the composition is what made this portrait so unique.

my design strategy

Since most portraits are a study of character, it is a common temptation to crop in on the subject. But this painting was also about the action of dance, so I created a generous amount of space around the figure to give her room to move.

about light and color

Julia was posed in form lighting; that is, lit from an overhead light that places her three-quarters in the light and one-quarter in the shadow. It is most helpful in creating the illusion of three-dimensional form on a two-dimensional surface.

The color scheme was dictated by the powerful and dominating color of the dancing outfit. The other colors were used to support the red and balance the painting.

my working process

- I invited Julia and her parents to the studio, where I asked her to slowly move through her dance routines until an inspired pose was struck. At this point, I took digital photos. While sharing these with the subject and her family, we agreed on a pose that became a good basis for her portrait.

- Next, I created a color sketch to work from. Not only did it allow me to confirm the design and color scheme, it also gave me a chance to correct the distortions in the hands that existed in the photographs.

- On a blank canvas, I created a drawing of the figure, not detailed, just the basic structure of the shapes along with the location of the eyes, nose, head, hands and figure.

- After re-drawing this line drawing in sepia ink, I covered the whole canvas with a coat of Burnt Umber thinned to the approximate value of the shadow of the skin.

- I then used cheese cloth to rub out the lights and mid-tones. This created a tonal underpainting, which dried by the next day so it was ready for painting.

- After mixing up a palette of flesh-tones approximating the model's complexion, I completed the portrait.

what the artist used

support
Stretched canvas

brushes
Mostly filbert brushes

medium
Linseed oil and odorless mineral spirits

oil colors
Cadmium Yellow
Yellow Ochre
Cadmium Orange
Cadmium Red
Alizarin Crimson
Perylene Red
Burnt Sienna
Burnt Umber
Dioxazine Purple
Ivory Black
Titanium White

John Ennis lives in Yardley, Pennsylvania, USA → www.john-ennis.com

Loose brushwork over a careful drawing — not detail — allowed me to convey the impression of busy movement.

New York Pedestrians, watercolor, 19 x 25" (49 x 64cm)

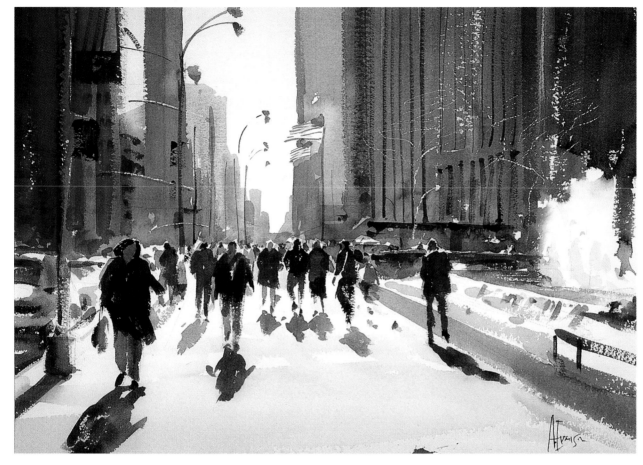

my inspiration

My main goal for this painting was to capture the movement of the city — all of the people needing to be somewhere — as well as to create the feeling of a cool, bright day.

my design strategy

The backlighting allowed me to load up the colors on these pedestrians, resulting in a powerful value contrast that gives the impression of bright sunlight. The lines of the architecture and diminishing figures lend a sense of recession to the scene. The fact that the figures reside in the lower half of the composition aids in the illusion of towering buildings.

my working process

• The complexity of this scene required a fairly detailed drawing. I find that accurate pencil work allows me to loosen up with my brush!

• I began with light washes on the distant buildings and pavement, stopping at the highlights along the top of the pedestrians' heads in order to preserve them.

• When the distant buildings were almost dry, I quickly laid in the other buildings with a variety of greens and blues. Too much detail here would have distracted from the people and made the painting busier than it should be. I then softened edges around the fountain.

• Now it was time to load up the brush and paint the main characters. The accurate drawing and placement of the figures allowed me to paint them rapidly with rich colors, giving the impression of movement.

• I finished with some details. Drybrushed strokes on the buildings indicated windows and such. The figures' shadows connect them to the foreground. Notice that they follow the rules of perspective as well. To make the barely visible "wispy" trees to the left of the fountain, I scratched with a razor blade. A few quick lamp posts finished things up.

my color philosophy

The dominance of cool colors was important in this painting. It really added to the effect that these people are hurrying along. Warm colors would have lent a leisurely attitude to the painting, as if the pedestrians were out enjoying the sunshine instead of "on a mission".

the main challenge in painting this picture

Capturing the activity of this busy city sidewalk while maintaining a loose style was a challenge. It would have been very easy to get bogged down with details in a scene such as this, but I try to stay impressionistic, regardless of subject matter.

what the artist used

support
140lb cold pressed paper, stretched

brushes
Large squirrel mop;
#12 and #6 rounds

watercolors
Aureolin
New Gamboge
Yellow Ochre
Cadmium Red
Alizarin Crimson
Burnt Sienna
Burnt Umber
Sepia
Sap Green
Cerulean Blue
Cobalt Blue
Ultramarine Blue

Andy Evansen lives in Vermillion, Minnesota, USA → www.andyevansen.com

Zooming in gives this figure presence.

what I wanted to say

I strive to capture the proud nature that exudes from nearly all the working cowboys I meet. I tried to paint this cowboy, Shawn Goemmer from Arizona, as he sees himself — independent, strong and fiercely dedicated to his vanishing way of life. I wanted my collectors to be fascinated with him, and to feel the emotions I have about this breed of people. Most importantly, I wanted them to see the "reality" of my subject.

my design strategy

I isolated the figure and allowed him to stand on his own. My composition is vignetted and therefore eliminates any of the background that takes away from the strong image.

try this tactic yourself

This work was lit by natural light, so value became the strongest element. Early on, I tried to bring the painting into a middle value and establish my darkest darks. I've found that when my values are correct, my color choices aren't so critical. This doesn't hold true for flesh tones, but the majority of a painting can be established with good use of tone.

my working process

- After traveling out west to a remote ranch to find this "real cowboy" in his natural habitat, I observed his mannerisms and style. I took hundreds of photos for reference, and I did quick gesture studies to isolate the design I was comfortable with. Much like a portrait artist, I created a composition that defined my subject.

- After creating a fairly tight pencil drawing, I culled everything that wasn't needed. I feel more comfortable with less information.

- I started with large flat washes and gradually worked down to the smaller details, generally working from light to dark and from top to bottom.

- When I knew I'd captured the facial features satisfactorily, I moved ahead, relaxed and enjoying the entire painting process. I remained painterly, yet retained the likeness and essence of the subject.

- Although I usually don't do this, in this particular painting, I added white gouache to pop the whites.

HOT TIP!

Do extensive color studies of your palette, especially if you use different surfaces. Knowing how paints interact with different papers gives me confidence. The way I see it, watercolor painting presents enough puzzles on its own, so any problems I can resolve in the early stages will only help me in rendering a successful painting.

J Mark Kohler lives in Sabinal, Texas, USA → www.markkohlerstudio.com

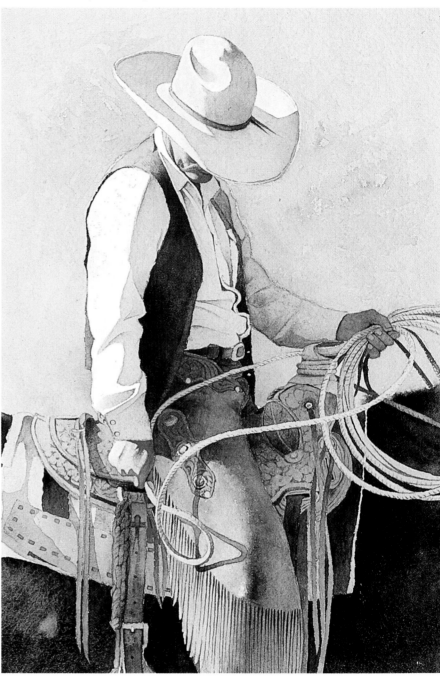

Won't Suffer Fools, watercolor, 11 x 8¼" (28 x 21cm)

what the artist used

support
Rough, handmade, surface-sized paper

brushes
Sable rounds, #4 to 20; a script liner; several small flats

watercolors

New Gamboge
Quinacridone Gold
Cadmium Orange
Quinacridone Burnt Orange
Cadmium Red
Alizarin Crimson
Burnt Umber
Raw Umber

Burnt Sienna
Sap Green
Indigo
Ultramarine Blue
Cobalt Blue
Cerulean Blue
White Gouache

A careful composition provides depth and tension.

Copyist (Musee d'Orsay), 20 x 16" (51 x 41cm)

what I wanted to say

On a recent painting trip to Europe, I visited the Musee d'Orsay in Paris. I was struck by the importance of the art museum, not only its obvious value in housing and protecting art, but also its value in exposing people of various cultures to all levels and dimensions of art, thus enriching our world culture. It occurred to me to do a painting inside the museum, especially when I spotted a copyist at work. It took me back to my student days.

follow my eye-path

The entrance to the painting is the copyist's paint valise on the stool, pointing at him. It jump starts the visual path that leads the eye to the middle ground character, then to the background character. My use of light, warm browns on the valise, the easel and the framed paintings on the back walls sews together the overall scene. Lining up the copyist, the young woman mid-ground and the background lady added depth as well as tension.

gathering references on site

I began by doing quick pencil sketches, looking for structure, design and satisfying flow. I also did a quick color study in oil. At this point, I realized how soft and flat the light was - no dramatic shadows or bright splashes. Finally, I shot various aspects of selected areas with black-and-white film.

my working process

- Selecting one of my drawings, I sketched with a No. 2 brush on a prepared board, using violet brown for the structure. Although my reference provided details and information, I modified my design.

- I then filled in the background with light greys to create the flat interior lighting.

- The copyist, being the dominant part of the painting, was modeled in darker colors.

- I then concentrated on flat colors to give a sense of the soft light, and allowed certain key colors to dramatize the characters. Slight shadowing was added to anchor the figures to the floor and to heighten the depth.

my advice to you

Figurative painting is arguably the most difficult subject. We all must study and practice drawing the human figure intensely, day after day. In effect, we must learn to see minute detail and read body language. If you want to learn even more, study the masters. Hundreds of years ago, the only important subject was the portrait or figure.

what the artist used

support
Prepared board

oil colors
Cadmium Lemon
Cadmium Yellow Medium
Cadmium Yellow Deep
Cadmium Orange
Grumbacher Red
Transparent Oxide Red

brushes
A range of oil painting brushes

Alizarin Crimson
Transparent Oxide Brown
Rembrandt Green
Cobalt Blue
Ultramarine Blue Deep
Titanium White

Mostafa Keyhani lives in Toronto, Ontario, Canada → www.mkeyhani.com

Notice how I used primary colors to create a specific mood and atmosphere.

Bus Stop Reflections, oil, 24 x 30" (61 x 76cm)

my inspiration

A reflective mood on a sunny San Francisco afternoon was my inspiration. I wanted to establish the feeling of reflection, in the moods of the people as well as the glass window reflecting the edifices from across the street.

designing with color

To attract the viewer's eye to the center, I used strong yellow ochres in the man's jacket, the garbage can and the bright yellow triangle of light on the lower part of the wall on the left. I then contrasted this dominance of warm yellows against the cool blues of the window and clothing of the men. I added a pair of complements — the Cadmium Red traffic markings and the Cadmium Green backpack — for more excitement. These color blocks visually link up to form strong horizontals and verticals, with a diagonal interaction in the shadow element of the background.

my working process

- After taking several snapshots of the people in black-and-white, I went up close to the subject and sketched in the window reflections and other details in the massive concrete building and hose connections.

- I then made several drawings from the photos and sketches until I got the composition I liked. I transferred this to stretched portrait grade linen, and created a detailed pencil drawing.

- In Raw Umber and Ivory Black, I created a thin underpainting, getting a close proximity of the values.

- When the underpainting was blocked in, I used thicker paint ("fat over lean") to lay down glazes within the shadow areas, becoming more opaque as I worked into the light areas.

- To paint the facial features, hands and clothing of the figures, I posed myself and a friend and painted from life.

my advice to you

For figurative art, the knowledge of human anatomy is of prime importance. Study muscle groupings and how they work, bone structure, even how the figure appears under clothing.

what the artist used

support
Oil primed, portrait grade stretched linen

brushes
Synthetic sable brushes in filberts, rounds and flats; synthetic badger hair brushes from #000 to #14

oil colors

White	Cadmium Red Light	Cadmium Green
Naples Yellow	Terra Rosa	Chrome Green
Yellow Ochre	Alizarin Crimson	Prussian Blue
Cadmium Orange	Raw Umber	Ivory Black

Burt Levitsky lives in Santa Cruz, California, USA → burtlevitsky.com

A limited palette and strong value contrasts support my subject's powerful expression.

Aged, oil, 24 x 30" (61 x 76cm)

what I wanted to say

This painting is an image of a traditional Vietnamese woman, a portrait of accumulated experiences and knowledge. Her white hair tells us of the endless conflicts and sacrifices she has made. The wrinkles around her eyes tell us of all she has witnessed. Her rugged hands tell us of all the labor she has endured. I chose to do this painting in black and white because her life story is from a time long ago and came to me in a black-and-white image, reminiscent of the newspaper clippings of the Vietnam War.

follow my eye-path

The focal point is her white hair and forehead, which then lead the viewer to her eyes as the second read because of the details painted in that area. Her eyes gaze off the canvas but the viewer is led back into the painting by the abstract lines in the background and by her two hands.

my design strategy

The brushwork is loose and textured to suggest the model's age and the roughness of her life, although it also adds more interest to the art work.

my working process

- I started the painting with a gesture line sketch to place the figure.
- Over this, I made blocked in the dark, light and mid-tone shapes.
- I then worked the painting by adding more value changes where necessary to sculpt out the features of the face and hands. I mostly painted this piece by putting shapes of values next to each other. There was not much blending.
- Throughout my painting, I stepped back to squint to analyze the overall value patterns. I had to make sure the shapes were interesting and were holding together.
- I used a palette knife in areas that I felt needed more texture and thicker paint. I used a house painting brush to paint loose areas in the background.
- My last step was to add the brightest highlight and the darkest accent to give the painting strong contrast.

the main challenges in painting this picture

One of the main challenges for me was painting the shadow side. Without color, I could only rely on very subtle value changes to create shapes on the shadow side. Another thing was to bring out the highlight of the focal point. I had to make sure the surrounding area was dark, and I had to make it thick and textured.

what the artist used

support
Stretched canvas

oil colors
White and Ivory Black

brushes
Flat hog bristle brushes, #4, 6, 8, 10; palette knife; 2" house painting brush

To instill a sense of peace and intimacy, I used backlighting.

Afternoon Espresso, oil, 8 x 12½" (20 x 31cm)

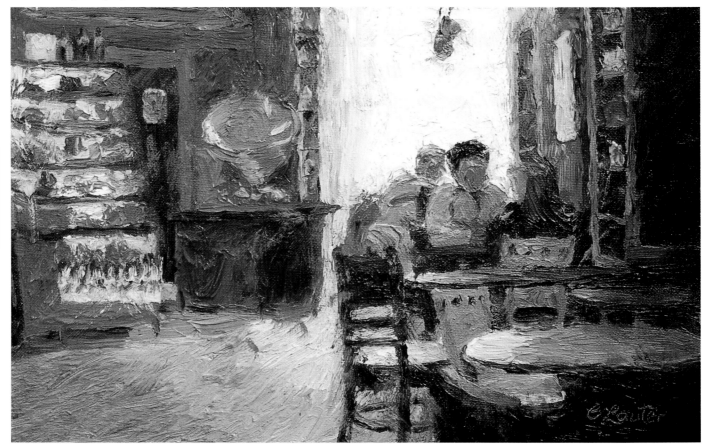

what I wanted to say

I wanted to convey the calm and intimate atmosphere of this little coffee shop, and to capture a moment in time. Quiet moments like these are few and far between for many people in today's busy world. I like for my paintings to instill a sense of peace.

about light and color

I wanted to capture the effect of the light radiating through the rear window, as well as the color harmony. The light initially draws your attention, and then directs you to the people and to the rich color and points of interest in the interior of the café.

my working process

- I made preliminary sketches to see what I wanted to include in the painting. When I had my design, I sketched the design in pencil onto the canvas panel.

- I began painting in the darks first, then the light coming through the window since this was my lightest light. Using the appropriate size bristle brush, I picked up large amounts of paint and laid it on, paying close attention to values. I continued blocking in the larger areas until I had covered the entire canvas.

- I then began using small bristle and sable brushes to apply the lighter colors and details on the people, the lit case, the shelves and so forth. I worked my way from the darks to the lights on the details, using separate brushes for each color/value group to keep my colors clean.

- This was painted alla prima (all in one sitting), which is how I prefer to work, using the wet-into-wet advantage for edge control. I do not use any medium or turp while painting.

something you could try

If you like oils, you may want to try alkyds, especially for painting alla prima. You'll find you have more control with alkyds since, toward the end of the painting, the paint has already begun to dry. You can more easily go over the darks with the lights without the paint getting muddy. The painting will also be dry in a day or two, which means it's ready to be varnished, framed and hung (or sold!) within a few days.

what the artist used

support
Canvas panel

brushes
Bristle filbert brushes, sizes 2-10; sable filbert brushes, sizes 2-8; palette knife

medium
Gamsol (clean up)

alkyd oil colors
Cadmium Yellow Light
Cadmium Yellow Medium
Yellow Ochre
Cadmium Orange
Cadmium Red Light
Cadmium Red Medium
Permanent Alizarin Crimson
Raw Sienna
Burnt Sienna
Raw Umber
Viridian
Olive Green
Cerulean Blue
Ultramarine Blue

Colleen Lauter lives in Mooresville, Indiana, USA → colleenlauter.com

I chose to evoke a sense of drama with an unusual subject, a limited palette and strong value contrasts.

Looking Back, watercolor, 12 x 17" (31 x 44cm)

Alda Kaufman

what I wanted to say

I wanted to portray a nostalgic scene of my childhood. Using figures from my past, I also included a suggested skyline of Riga, Latvia, my country of origin. Using a limited palette, strong value contrasts, and simplicity of subject, I chose to emphasize design and evoke a sense of drama and mystery.

follow my eye-path

I used a pattern of lights to lead the eye through the painting from the lower left, back and forth across the steps, and ending on the standing figure. The sharp value contrasts serve to add drama, and the softened background enhances the sense of mystery.

my working process

- After a thumbnail sketch to organize my design, I drew the basic figures and steps on my paper.

- With a large, flat brush, I deposited areas of color, disregarding local color, but keeping my initial composition in mind.

- While the pigment was still wet, I used a spray bottle of water to encourage the areas of color to blend, and as the pigment began to dry, the added water formed interesting textures.

- After the paint was dry, I used a damp brush to lift the light areas. Due to the non-absorbent surface of the paper, the pigment lifted easily, leaving behind a ghost of color in some places.

- Next, I carefully used a drybrushing technique to add darks that defined the figures.

- To intensify color in some areas, I used watercolor crayons. These enabled me to add color without disturbing the layer underneath.

- Finally, I used a mixture of watercolor and white gouache to soften the background. I applied this with a small sponge roller and a light touch.

try these tactics yourself

- A limited palette enhances the simplicity of the painting, provides continuity throughout and allows for a few dramatic accents of color.

- Using a non-absorptive surface for watercolor provides interesting effects and more intense color due. This surface, however, makes subsequent washes difficult to lay down, since the previous layers are easily disturbed. The previous layers have to be very dry and can only handle a single touch per layer. I suggest drybrushing for small areas and small sponge rollers for large.

what the artist used

support
Synthetic paper with a very smooth, nonporous surface

brushes
2" flat; ½" and #3 and #4 round

other materials
Watercolor crayons
White gouache
Spray bottle
Small sponge roller

watercolors
Yellow Ochre
Cadmium Red Medium
Alizarin Crimson
Burnt Sienna
Phthalo Blue
Paynes Gray

Alda Kaufman lives in Dubuque, Iowa, USA → rkfmn@earthlink.net

This is a study of dramatic light.

my inspiration

My eye was drawn to the perfect play of overhead light on the torso of the model. The light was dancing up and down her back, like music notes moving in a tender Chopin nocturne. The dramatic light created a primary focal point on her shoulder. As the light continued to travel downward, her left hip and hand emerged as a secondary focus. Light is the most dominating element in my painting language. It stimulated the emotion and produced the mood I like in my paintings.

all about focal points

I always want to address focal points in my painting. On the model's back, the dramatic light created a sharp value contrast between her head and shoulder, which inevitably became my first focal point. As the overhead light jumped over the gray area of the torso and hit the convex hip and her left hand, it formed the secondary focal point. Compositionally, I liked that these two focal areas were diagonally arranged within the torso and were connected by her left arm. To avoid severe cropping, I decided to downplay her lower limb and let it vanish into shadow.

my working process

- I used a very small brush with very thin Burnt Umber to make a quick sketch. I wanted to catch her gesture precisely, yet simply.

- Then I quickly applied the mix of Burnt Umber and turpentine to establish light, mid-tone and dark values. The use of a big brush and simple value pattern enabled me to gain unity in the block-in stage.

- I continued the quick block-in by applying more colors both to the background and the figure.

- To establish enough color and temperature contrast immediately, I started painting the cool shadow at the bottom, using Sap Green, Ultramarine Blue and Cobalt Violet. Then I applied Naples Yellow, Ochre, Alizarin Crimson and White to build up the warm flesh tone of light side.

- For the gray and dark sides of the figure, I went cooler and somehow let the greenish background tone appear to reflect the influence of the environment.

- Finally, I refined the focal areas, with special care on key anatomical points. On the highlight of her shoulder and hair, I applied heavier paint to create a more interesting brushstroke and texture. Edge control was also critical in this stage to create depth and mood.

- I allowed the upper part of background to remain abstract.

ARTIST 34

Jimmy Lu

On Her Back, oil, 24 x 18" (61 x 46cm)

what the artist used

support
7 ounce natural duck canvas, double primed with acrylic gesso

brushes
Bristle Nos. 2, 4, 6, 8, 10, 12; filbert No. 1; fan brush No. 6

medium
Turpentine
Liquin

oil colors

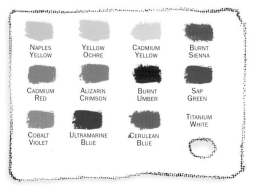

NAPLES YELLOW · YELLOW OCHRE · CADMIUM YELLOW · BURNT SIENNA
CADMIUM RED · ALIZARIN CRIMSON · BURNT UMBER · SAP GREEN
COBALT VIOLET · ULTRAMARINE BLUE · CERULEAN BLUE · TITANIUM WHITE

Jimmy Lu lives in Milpitas, California, USA → jimmyluart@hotmail.com

My painting follows Rembrandt's method.

The Luthier (Portrait of Andrius Faruolo), oil, 32 x 40" (81 x 102cm)

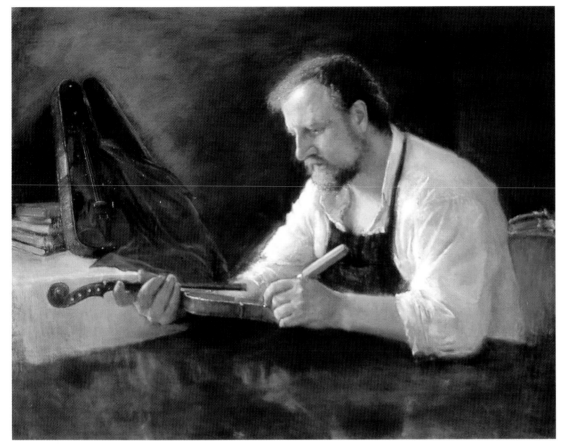

my inspiration

The Luthier, Andrius J Faruolo, crafts beautiful, handmade violins in the tradition of Stradivari and Guarneri. I was intrigued by the idea of mirroring his antiquated process in my portrait. For this, I referred to Rembrandt's color, light and impressionistic, painterly style. However, I did incorporate a few modern conveniences.

follow my eye-path

The brilliance of the white sleeve acts as a lightning bolt of energy between the two focal areas: the subject's head and the violin he is creating. I then used other lines and angles to direct the eye to the held violin.

try these tactics yourself

- Once I had the pose and props, I took many photos for reference. I also did a life drawing of the subject's head, as well as a watercolor sketch of the composition.

- Using a photocopy machine, I enlarged the drawing of the head to the appropriate size. I then used a fine point marker to trace the features onto acetate. I pricked the outlines of the drawing on the acetate with a pin, laid the pricked drawing of the head over a medium-toned canvas, pounced the image onto the canvas (using charcoal powder in a cloth bag), and traced the dotted charcoal image with a paint mixture of Ivory Black and Burnt Umber.

- Next, I laid in the composition with a brown tonal wash. To build up the luminosity, I smeared thick Flake White in the light areas of the shirt.

- I massed in the big tone/color relationships, ignoring the details and modeling of form. I kept my darks thin and flat, but built up texture in the light areas of the shirt, face and hair. For the smock, I sanded over the dried color to reveal the thread of the canvas and re-create the feel of its denim texture.

- Every once in a while, I looked at my painting and the subject in a mirror to check proportion, angle, tonal and color accuracy.

- When the big design felt right, I started to work on the modeling of form and the feeling of light. I switched from using only Turpenoid to a mixture of three or four parts Turpenoid to one part Stand Oil.

- Then I glazed back some areas, and brought up the face, hands and violin more than other areas so the eye is drawn to these focal points.

what the artist used

support
Oil primed linen, medium texture

brushes
Large assortment of bristle and sable brushes of various sizes

oil colors
Cadmium Yellow	Burnt Umber
Yellow Ochre	Raw Umber
Cadmium Red	Viridian
Venetian Red	Ultramarine Blue
Alizarin Crimson	Cobalt Blue
Raw Sienna	Flake White
Burnt Sienna	Ivory Black

medium
Turpenoid for lay in; a mixture of three or four parts Turpenoid to one part Stand Oil for modeling and finishing stages

other materials
Palette knife
Sand paper
Mirror
Acetate
Pin
Fine point marker
Small pouncing bag of cotton jersey, loosely filled with charcoal powder
Watercolors (for sketch)
Charcoal (for drawing)

Jonathan Trotta lives in Fort Lee, New Jersey, USA → jonathantrotta@aol.com

A dynamic, spiral pose added movement and mood to my interpretive figure painting.

ARTIST 36

Mike Mahon

what interests me

I don't always have something to say, nor am I always inspired. Painting is enough of a struggle without the added burden of making a statement. Thus, I let the subject speak to me, and I simply serve as the editor and interpreter for my audience. The subject matter is usually more profound and interesting than I am. It is this realization that freed me from 20 years of a fear of painting.

In this piece, I simply wanted to depict the sensuous way in which the single source light seems to caress and reveal the model's form while suggesting a strong sense of weight, movement and tension.

my design strategy

Although the pose appears passive at first glance, the image projects strong dynamics of movement and mood. The left arm helps draw the viewer's eye up into the body. Her twisting body then presents a series of planes in which each major part faces a different direction, creating a spiral that turns back on itself.

my working process

- I began with a detailed carbon pencil drawing, lightly applied at first but gradually heavier as I became more confident of the position of the elements, the direction of important angles and the shape of the shadows.

- Using hard pastels, I applied the darkest darks, then the secondary darks, then the lights (not highlights). The toned paper served as a place holder for the mid-tones. This quickly established the overall range of values.

- Over this foundation, I continued to apply the pastel lightly and in layers, using variations in pressure. I did not blend so that I could maintain the painterly quality of pastel. I allowed a good deal of the underlying paper to show through to unify the image.

- As the painting drew to completion, I applied more of my soft pastels, especially the lights and more intense colors, with decisive strokes, which tend to give the appearance of spontaneity, even if it took hours to reach this point. At this stage, I concentrated on refining my focal areas, values and edges through contrast.

- This painting was done in about two to three hours from life. No fixative was used on the finished pastel.

Memories, pastel, 16 x 12" (41 x 31cm)

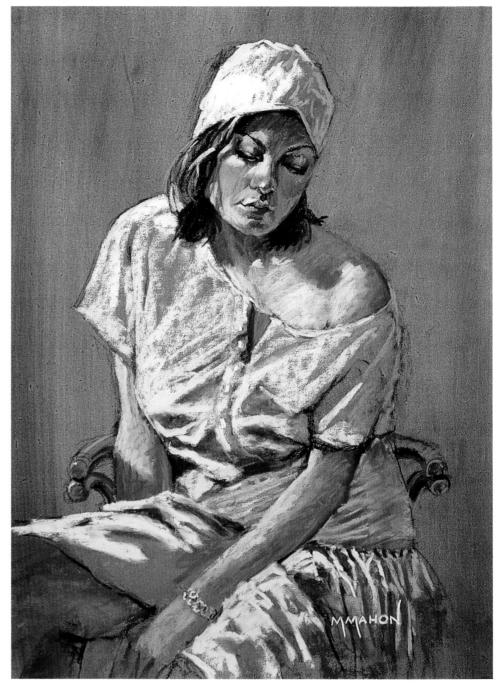

HOT TIP!

Painting a person's face or figure from a photograph at one's leisure can not compare to the animation, expression, subtlety and pure adrenaline manifested in painting from life.

what the artist used

support
White sanded paper toned with a pastel and Turpenoid wash

pastels
Primarily hard with a few soft pastels and a carbon pencil

Mike Mahon lives in Amarillo, Texas, USA → www.mmahon.com

This painting is all about balance and harmony.

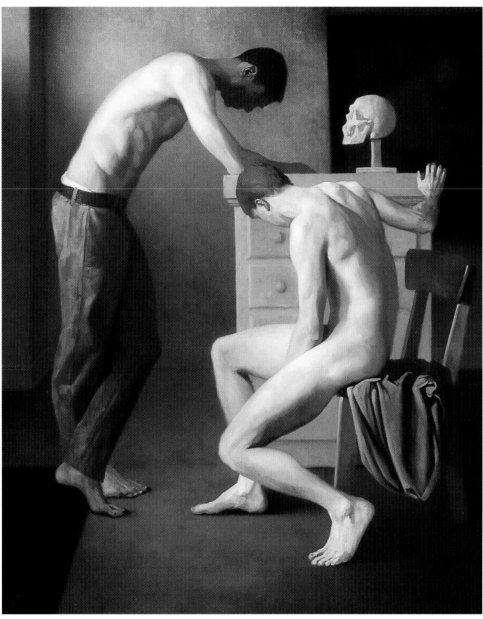

Convocation, oil, 40 x 32" (102 x 81cm)

what I wanted to say

The word "convocation" literally means "calling together," an assembly. In my picture we have a "calling together" of different figurative elements in the form of two people, a skull and a painting of a person. In another sense, we have a "calling together" of different compositional elements to create a refined and harmonious arrangement.

My paintings, while realistic, are not simply depictions of recognizable imagery, but are carefully arranged formal constructions or "ordered systems" in which all pictorial elements are deliberately designed to satisfy my own sense of balance and harmony. The components of the painting function as representational imagery as well as formal elements of pictorial structure.

my design strategy

While this is a rather rectilinear composition overall, you'll notice that the gestures of the figures in the painting create a spiral shape that compliments and offsets the strong vertical and horizontal forms.

my working process

- The image you see in the picture was never actually set up in front of me. Instead, it is a combination of imagination, live models, drawings, photos and things I set up in my studio. I started out with a rather general compositional idea that gradually became more refined as the painting progressed.

- After stretching the linen, I covered it with a neutral warm gray thinned with a little odorless mineral spirits.

- When this initial tone had dried, I started the painting with a rough sketch, using Raw Umber and a small brush to lay out the basic linear structure of the picture (knowing that it would change as the painting developed).

- After broadly massing in the basic shapes, I began to develop and refine the image. I kept each layer rather thin so I could easily make changes and adjustments, such as adding the skull and changing the gestures of the figures.

- I did eventually apply thicker paint in certain areas.

my advice to you

Don't be afraid to make changes. When I begin a painting, I have a general idea in mind, but then it takes on a life of its own. Choices invariably arise that I could not have foreseen, and I have to be willing to let the painting — to a certain extent — guide the course of its own development. This is not to say that I abandon my initial concept, but rather that I allow the idea to evolve.

what the artist used

support
Oil-primed Belgian linen, stretched

brushes
Primarily bristle flats; some round red sables or nylon sables; palette knife for mixing

medium
Simple mixture of stand oil and odorless mineral spirits

oil colors
Titanium White
Yellow Ochre
Cadmium Red Medium
Raw Sienna
Burnt Sienna
Raw Umber
Ultramarine Blue
Ivory Black

other materials
Retouch varnish
Turpenoid natural for brush cleaning
Paper towels

Douglas Malone lives in San Francisco, California, USA → DMaloneFineArt@aol.com

I used all my design skills to produce this moody painting.

Cut-Offs and Tank Top, pastel, 25 x 20" (64 x 51cm)

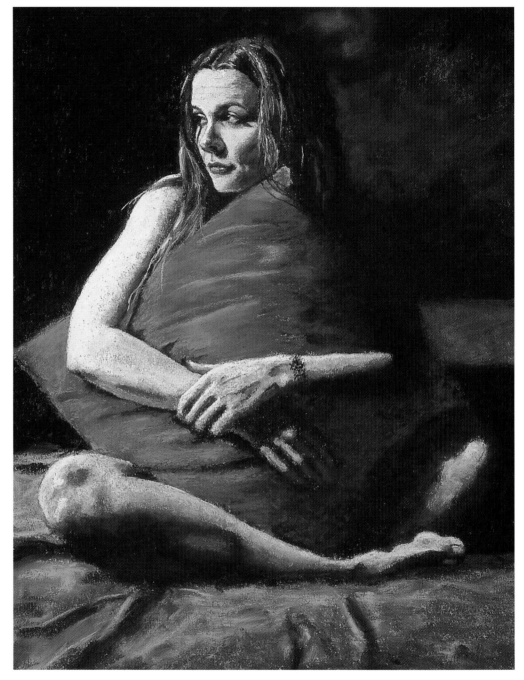

ARTIST
38

Lee McManus

my inspiration

Although I find the human form inspirational in itself, the inspiration for this particular painting was primarily the mood of the subject. Calli, a friend I paint frequently, took this pose during a break in a drawing session. She appeared "lost in thought", and I felt it would make a good painting. I think the painting speaks to the power of pensiveness, and I was hoping to state that quiet can also be strong.

my design strategy

My intentions behind this painting were more about capturing the mood than constructing elements to end up with a painting. That stated, there are some interesting design elements that fell into place almost by accident. For instance, the overall pose is triangular, but the pillow the subject is holding is square and contrasts well against the triangle. The painting is primarily warm but accented with cool colors. Contrast is a very important part of this painting, and I tried to keep it on a high note.

about the lighting

Initially, the model was lit by window light from the left side of the painting. But when I decided to develop this piece into a finished painting, I added a soft spotlight from the left and above to create strong shadow patterns.

my working process

- Through sketches and studies, I arrived at a pose that I thought would make a good painting.

- After I had drawn out the painting on the surface, I did a very loose watercolor wash to block in colors and contrast.

- From there, it was pretty much direct painting with soft pastels. I worked from dark to light and big to small.

- The biggest challenge came when I had to address the edges. Some of the soft, hidden edges had to be maintained so that the viewer would know that there was actual form and dimension within those shadows, while others had to "disappear" completely to make this painting

work. The hard edges on the left side of the painting (face, arm, pillow, leg) needed to be sharp in obvious contrast to the softer edges.

- Finally, I added the splash of red in the background behind Calli's head not only to add some color (picked up from the pillow) but to separate her hair from the background and to create depth.

what the artist used

support
Pastel paper heat mounted on foam core

media
Primarily soft pastels
Watercolor
(for underpainting only)

Lee McManus lives in Sioux Falls, South Dakota, USA → leemcmanus@sio.midco.net

Caravaggio's chiaroscuro technique was the inspiration for this painting.

Morning Light, oil, 16 x 20" oval (41 x 51cm)

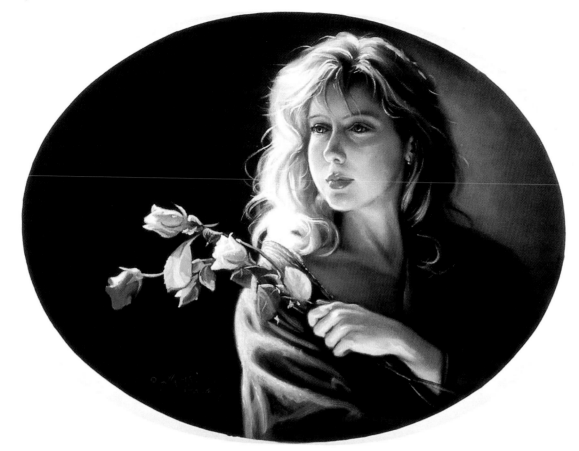

Judith Mroski-Gonzalez

my inspiration

The inspiration for this painting came from my love for Caravaggio's mastery of the chiaroscuro technique. I wanted to capture the light shining through the model's hair and through the rose petals.

my design strategy

I wanted the painting to have a dark background to make the lighting the main focus. I chose an oval canvas because the curving edges and negative space of the background looked more interesting and feminine.

my working process

- First, I toned down the white surface of the canvas with a watered-down layer of neutral umber acrylic paint. The acrylic layer dries quickly and its medium tonal value is a good starting point for highlights and shadows.

- I began the painting with a semi-detailed underpainting, using a mixture of Black, Raw Umber, Yellow Ochre and white to make a grayish-green. I used the grisaille technique, meaning that I painted the entire figure with the monochromatic values of this one color.

- After the underpainting dried, I built up glazes of local color thinned down with a medium called Liquin, using flat brushes. For the skin tones, I used a combination of Vermilion, Yellow Ochre and White. For the shadow areas of the face, I mixed in the background color.

- I kept adding layers of glazes until the overall contrast of the painting looked correct. One thing I have learned is that when I change the value of one area of a painting, it changes/affects all other areas and they need to be adjusted to work with the new area of value.

- Finally, I added fine details and bright, thick highlights, using small pointed brushes.

something you could try

I used photographs as the reference for this painting because I posed as the model. The painting is not meant to be a self-portrait, but rather a study of a figure with strong chiaroscuro lighting. I worked out the idea in my sketchbook with loose value studies in pencil, and then had my husband photograph me next to a bright window for reference.

HOT TIP!

A very helpful tool in portrait painting is a small mirror from a makeup powder compact. Viewing what you've done through a mirror shows the image in reverse, and any mistakes will become glaring and obvious.

what the artist used

support
Primed canvas

brushes
Large, flat sables in #20, 18, 14, 6 and 3); small round pointed sables; sable blending brush #4

medium
Liquin

oil colors

CADMIUM YELLOW LIGHT · YELLOW OCHRE · CADMIUM RED LIGHT · VERMILION · ALIZARIN CRIMSON · BURNT SIENNA · RAW UMBER · BROWN MADDER · ULTRAMARINE BLUE · IVORY BLACK

Judith Mroski-Gonzalez lives in Friendswood, Texas, USA → www.gonzalezstudios.com

Unconscious actions captured the essence of this sitter.

ARTIST
40

Christopher Near

what I wanted to say

This particular portrait is of a very good friend of mine. He has gone through some tough times, including the recent death of his father, which have left him at times extremely depressed and on occasion at the brink of suicide. He is not aware of his importance to others in this world, nor how he emanates empathy. I tried to express the intelligence, sadness, compassion and comforting feeling he exudes when I'm in his presence.

a rocky start

I had a hard time with the composition at first. I knew what I wanted to say, but needed the pose to show me how to say it. Robert became a little frustrated with me when I repeatedly wiped out my beginnings, especially when he'd been posing for an hour or two. It finally came together when Robert leaned on a chair backwards and placed his hand in the position you see it in.

my working process

- I learned my methods from Mike Hussar, a former instructor and one of the greatest painters I've ever met.
- I started by mixing a pile of Alizarin Crimson Permanent with a lot of Olive Green to get a very warm dark, not quite black but close.
- Adding a little turp, I washed the entire canvas with Indian Yellow in the light areas and the dark mixture for the darks.
- I then did a drawing with a #2 filbert brush, again using my dark mix.
- Next, I stained my darks and began to build my lights.
- To complete the portrait, I spent the most time on defining the eyes and worked out from there, putting in less and less detail as I worked my way out. I used a combination of dark and light, and finished and unfinished areas, to direct your eye and keep it moving.

try these tactics yourself

- Don't think too much when you're painting — too much thought can interfere with your natural artistic insight. Trust your brush, let it have a mind of its own and see where it takes you.

- Choose a model with an emotional quality. Sometimes good looks are not enough — you need substance.

- When you study your sitters, play psychologist with their unconscious actions and pick up on their habits. This is what captures their essence. They distinguish the portrait from the picture.

Rob, oil, 28 x 22" (71 x 56cm)

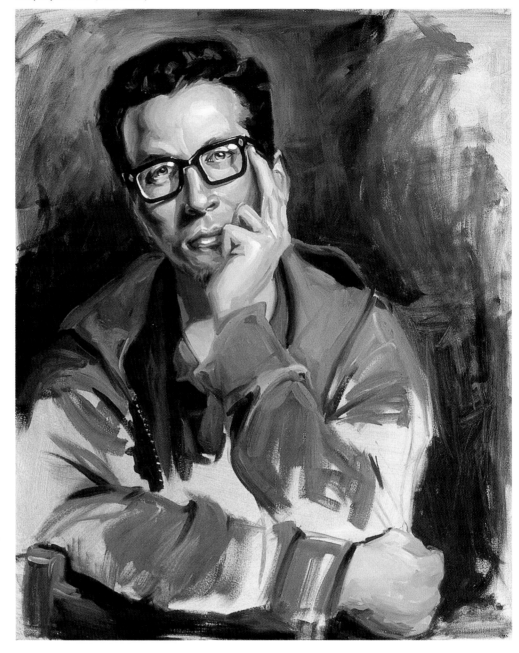

what the artist used

brushes
Hog-hair filberts ranging from #1 to about a # 10

medium
Turpentine

oil colors
Indian Yellow	Manganese Blue
Yellow Ochre Pale	Ultramarine Blue
Scarlet Lake	Indigo Blue
Alizarin Crimson Permanent	Winsor Violet
Burnt Sienna	Permalba White
Olive Green	

Christopher Near lives in Arcadia, California, USA → www.christophernear.com

My goal was to capture one aspect of myself through distortion and exaggeration.

Self-Portrait: Inside Out, oil, 22 x 20" (56 x 51cm)

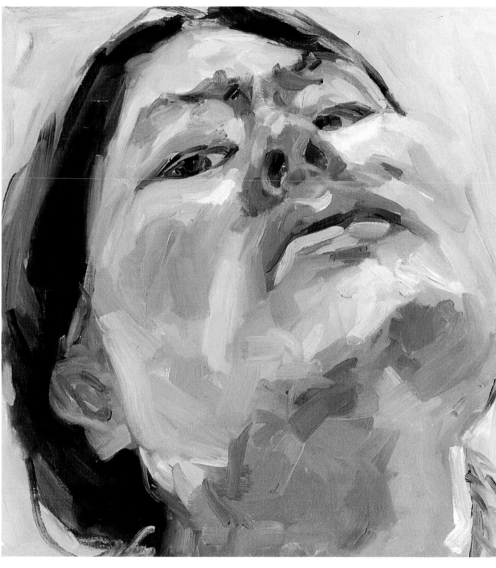

what I wanted to say

This painting reflects a state of mind. I wanted to convey a sense of emotion that stems from the deep psychology of constant introspection and self-examination. I was inspired to paint myself in reaction to personal anxieties and consuming thoughts of self, identity and person in the context of being.

my design strategy

I knew beforehand that the head would dominate the space in the painting. Its placement was therefore crucial. What was important for me with this painting was to somehow take advantage of the odd dimension that is nearly a perfect square to activate the negative space.

I am also interested with what the mask, a mere facade, can express. The distortion and exaggeration in the facial structure magnify an expression of such a reality. That uncomfortable and quite unflattering representation of myself reflects a certain psychological presence. Much as one may find oneself containing emotions, I wanted my portrait to parallel that containment.

the main challenges in painting this picture

Foregoing preliminary drawings or color sketches, I do all of the investigation and planning on the canvas. I finished this painting in one sitting of almost three hours. For me, beginning a painting without the intent of completing it that same day would somehow change the painting and evoke a different sensation. The struggle in the attempt to paint the intensity of that specific moment adds to the painting's visual and emotional strength. I work and re-work the surface constantly until I arrive at an existence of myself.

It was difficult to make each area of the canvas visually interesting from corner to corner. Often times, a work emphasizes a certain area more than others. However, in this work, it is the integration of the head to the surrounding space that engages the painting. It's important to resolve all areas of the painting as every element reinforces each other.

try these tactics yourself

- Allow yourself a time frame in which to complete a painting, such as one day. This approach will not only keep your work fresh and depict a sense of urgency, but also invoke a response of reaction.

- Too much logic and constructive planning sometimes takes away from a painting. Start with an idea and see what happens.

- Try limiting your palette to not more than five colors. Keep the approach simple.

what the artist used

support
Cotton duck canvas, medium texture

brushes
Flats #6, 8, 10, 12

oil colors

YELLOW OCHRE RAW SIENNA VERMILION

ALIZARIN CRIMSON BRILLIANT GREEN TITANIUM WHITE

Karen Goins lives in Honolulu, Hawaii, USA → karmigo@hotmail.com

ARTIST 41

Karen Goins

Can you find the two distinct eye-paths in my figure painting?

City Life, oil, 30 x 30" (76 x 76cm)

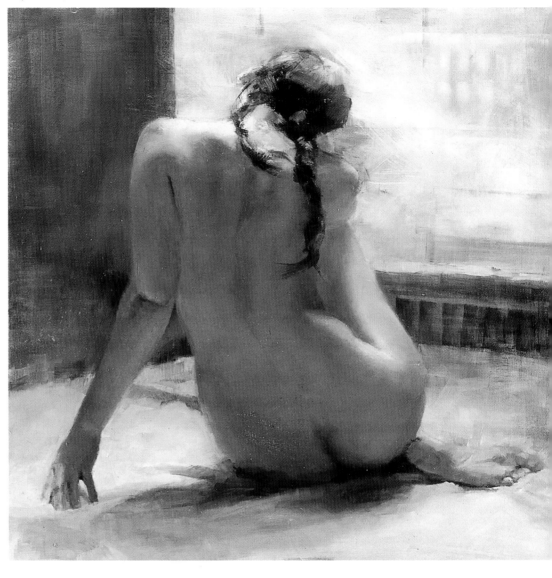

my inspiration

I always believe first impressions are important. When I saw this pose — the beautiful rhythm of the body, the natural light reflecting various colors — it touched my heart so deeply and made me want to record it on canvas.

follow my eye-paths

This is a triangular composition. In the main eye path, your eye starts at the head, moves down to the right foot, over to the left hand, and back to the top of the triangle. These three major areas were the primary parts I spent a lot of time on. I made these three areas detailed and loosened up the rest to make the viewer's eye go directly to them. Inside this triangle, there's a second eye-path in an "S" shape, which softens the gesture.

ARTIST 42

Shu-Ping Hsieh

my working process

- I used Burnt Sienna and Turpenoid to make a quick sketch with a #2 brush. Then I used the same materials to block in the values with a #12 brush.

- After that had dried completely, I started to paint spontaneously and freely with a large brush. I adjusted values and fixed the composition a little bit as I went.

- Next, I concentrated on creating the form in the light areas. I also started adding detail in the areas I wanted the viewer's eye to follow.

- Before I continued, I had to re-wet my canvas with a thin layer of linseed oil. In the shadows, I glazed the colors layer by layer.

- To put in the finishing touches, accents and details, I used #2 and 3 brushes.

about references

As I mentioned before, I was impressed by this pose, but I didn't like the background very much. I decided to take many photographs of the figure, but wanted to paint the background from life. For this part of the painting, I used the window view from my studio. It provided a strong, natural light hitting the figure.

the main challenges in painting this picture

This is a backside view, which does not have as clear a structure as a front view. This makes it difficult to see the forms turning in the figure. Also, this figure is mostly in the shadow, which has a variety of color in it as well. It was very challenging for me to get the right values and colors in the shadows.

what the artist used

support
Cotton canvas

brushes
Nos. 2, 4, 6, 8, 10 and 12 hog bristle filberts; nos. 12 and 16 flats

medium
Turpenoid
Linseed oil

oil colors
Titanium White
Cadmium Yellow
Yellow Ochre
Scarlet Lake
Cadmium Red Hue
Alizarin Crimson
Burnt Sienna
Raw Umber
Viridian
Cerulean Blue
Ultramarine Blue

Shu-Ping Hsieh lives in San Francisco, California, USA → shuhsieh@hotmail.com

I liked this juxtaposition of a quiet pose and dynamic shapes.

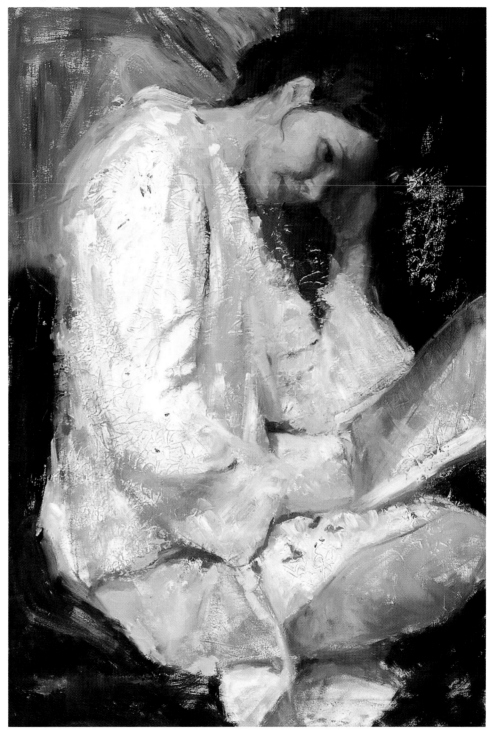

Reading in a White Robe, oil, 36 x 24" (92 x 61cm)

my inspiration

While painting from a live model at the studio, I took a photo of the model at a break. The pose seemed at once unusual, simple and inviting. The photo was haunting me for a couple of months before I decided to use it. I wanted to show the figure large and dynamic, in spite of the quietness imposed by the subject matter.

my design strategy

With the aid of a viewfinder to find the best composition, I decided to show just the figure with its flowing, rumbling shapes. This, in turn, made me realize the importance of the tonal values in the face and supporting hand mass. The way I cropped the photo left me with an interesting dark and light pattern with the predominant light color being the figure's robe. I added some darks in the background in order to lose the outline of the hair so that the face could stand out. The folds of the robe at the bottom of the painting contrasted with the darks of the support on which the figure sits, thus starting the path for the viewer's eye from the folds up the sleeve to the neck and face. The hand supporting the head would lead the eye down to the other hand, the book and leg, closing the path circle.

try these tactics yourself

- The vital factor in my initial process was choosing a used canvas. The previous painting, rendered in a heavy impasto way, depicted a vase with flowers. Used vertically, the canvas provided me with a rough, flowery design all over the area where I was going to paint the robe, which I thought would create a very desirable effect. I primed the canvas with white gesso, using a thicker coat in the areas where the robe would be and a thinner one in the remaining parts.

- Over this, I used Alizarin Crimson as an underpainting — basically spots of color forming a very basic sketch of the figure.

- I began the painting process by mixing a big pile for the basic light tone of the robe, and another pile for the basic light flesh tone. I then built up my image, paying close attention to tonality and avoiding too much detail.

ARTIST 43

Irena Jablonski

what the artist used

support
A re-used canvas
(previously a floral)

brushes
1" flats

oil colors

Cadmium Yellow	Indian Red	Phthalo Blue
Yellow Ochre	Alizarin Crimson	Ultramarine Blue
Cadmium Orange	Raw Umber	Magenta
Cadmium Red	Sap Green	

Irena Jablonski lives in Simi Valley, California, USA → www.portraittime.com

I accentuated the highlights on the muscles to lead the eye.

Warrior, oil, 21 x 15" (54 x 38cm)

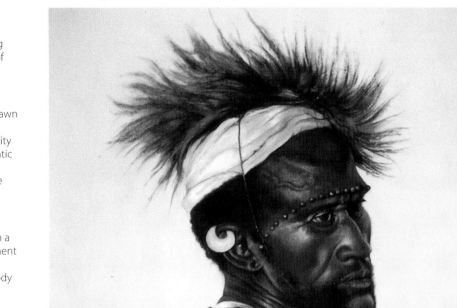

what I wanted to say

I wanted to capture the silent strength of the subject, pulling together the strong features of the face and body.

follow my eye-path

There seemed to be a path drawn to the deep-set eyes through highlights along the muscularity of the body. The monochromatic color and tones of the skin presented an excellent vehicle for accentuating this quality.

my working process

- The painting was done from a photograph, a specific moment not to be re-captured. The facial expression and the body position were natural and non-posed.

- I prepared sketches of areas of the head and body that would assist in developing the final painting.

- I used a smooth panel, primed with gesso and a Burnt Umber tint. The smooth panel allowed me to achieve the smoothness of the skin.

- I've always painted in oils and enjoy the ability to model the forms in a classical manner, which includes transparent shadows and opaque middle tones and lights. In this painting, I used cool highlights and warm middle tones.

my advice to you

- Study human anatomy from medical anatomy books, including studies in kinesiology, and anatomy books for artists.

- Study the old masters, particularly their sketches and preliminary drawings.

- Do preliminary sketches in detail, specifically those areas that will be focal paints in the painting

ARTIST
44

Dick Jenkins

what the artist used

support
Smooth panel, primed with gesso and tinted

brushes
Bristle brushes in rounds Nos. 2, 4, 6, filberts Nos. 4, 6, 10, 12, and fan No. 2

medium
Maroger medium

oil colors

YELLOW OCHRE	ALIZARIN CRIMSON	BURNT SIENNA	RAW UMBER
BURNT UMBER	ULTRAMARINE BLUE	IVORY BLACK	FLAKE WHITE

Dick Jenkins lives in Wittman, Maryland, USA → djenkins@goeasten.net

A harmonious color scheme gave my portrait greater authenticity.

The Medicine Man, watermedia, 28 x 19" (71 x 49cm)

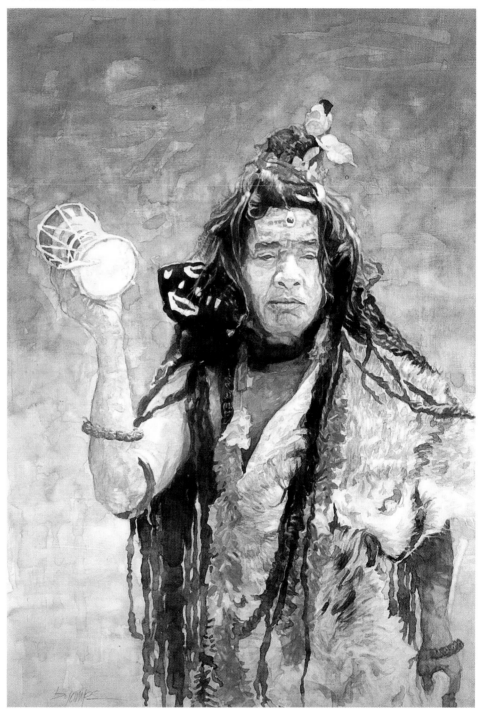

my inspiration

What interested me most about this figure was his costume and his face that had been covered with a medium blue color. I wanted the viewers of my painting to see exactly how an authentic Native American medicine man would appear.

my design strategy

The first element I want the viewer to notice is the figure's face. To achieve this, I placed him in a setting with a lot of space at the top. I then positioned him a little to the right so his face would be just right of center — an area where a person's eye would usually go first. The clothes he wore are obviously a traditional costume. The fur was a medium brown and gray. He also wore a red necklace with a little yellow in it. To harmonize these elements, I used the same brown and gray colors in the background.

my working process

- On a gesso-coated illustration board, I sketched in the figure. Over this, I applied a veil of light brown color to the surface. Because it was on gesso, I could then rub out areas for his face and costume.

- Next, I quickly worked in foundation colors to define each element in the painting. At the same time, I indicated where the dark and light areas would be.

- When that was complete, I used a large brush to paint a harmonious shade of brown into the background to see how the figure would relate to it.

- I then applied colors to the surface, building up layers. Always keeping the drawing and correct appearance of each element in mind, I completed the image with a range of smaller sable brushes.

- Finally, I scumbled in a light gray over the medium brown background to make it more harmonious with the figure.

about photography

All of my paintings (watercolors, pastels, and oils) are created in my studio. I use photography only as a way to capture the exact likeness of a figure or a landscape. For me, it is simply another tool in the creative process. I know that later in my studio, I can create different color schemes and invent a more suitable design if needed. I never use color studies because I feel I lose some of the spontaneity when working the final painting.

what the artist used

support
Hot-pressed illustration board primed with gesso and toned with a neutral brown-gray

brushes
Sable brushes, Nos. 2 to 12

gouache colors

Cadmium Yellow	Sap Green
Yellow Ochre	Sky Blue
Cadmium Orange	Ultramarine Blue
Cadmium Red Pale	Van Dyke Brown
Raw Umber	White

Bill James lives in Miami, Florida, USA → billjames@bellsouth.net

Light effects and color temperature help convey the action on a fishing boat.

Crew of the Carol Ann, oil, 24 x 36" (61 x 92cm)

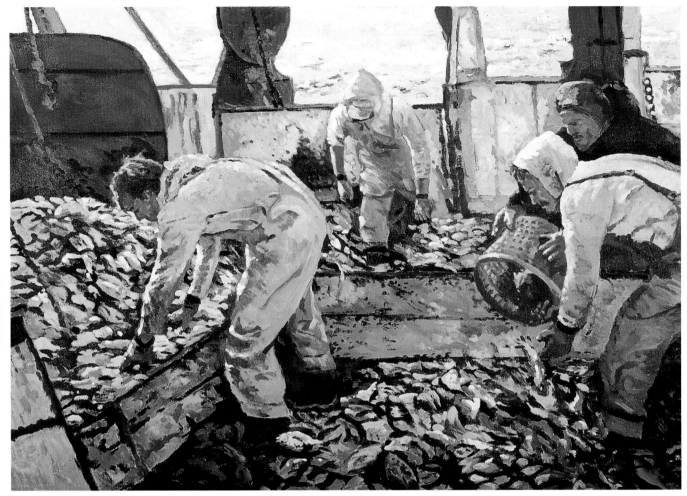

my inspiration

My inspiration for the painting was the play of light and the action of the figures working the fish. I also liked the play of warm grays and orange/yellows in the deck boards and oil slickers worn by the fisherman. Based on my own work experience on my uncle's lobster boat, I wanted to try to depict the feeling of the working atmosphere of a crew at sea.

my design strategy

I decided to design the painting in such a way as to lead your eye to the two figures at the right with the lines of the boards and ropes. The figure's actions and gestures would then lead to the glistening fish on the deck and then on to the figure on the left (my cousin, Captain Dean Dion).

about color

The cool silver-grays of the fish were a nice foil to the warmth of the oil skins. For me, that became the key to the palette I used throughout.

my working process

- Working from my own photographs, I did a few pencil sketches for the composition — just rough thumbnails really — to get the gesture of the figures and the values of the design.
- I then began with a full-color block-in directly on the canvas. The canvas was quite rough, so I really had to use a fully loaded brush to compensate for the coarse ground. The canvas seemed to soak up the color, which as it turned out, forced me to use very bold color.
- I continued using filbert bristle brushes to develop the image. I did employ a little drybrush work and some subtle glazes, but for the most part it was done alla prima.

please notice

The light came from top left of the painting, but I also enjoyed the reflected light bouncing off the fish and wet surface of the deck boards. I felt pleased with the rim lighting effect employed on Dean at far left and the mound of fish to his left.

what the artist used

support
Rough canvas

brushes
Filbert bristle brushes, Nos. 6 to 10

medium
Combination of stand oil, Damar varnish and turp

oil colors

CADMIUM YELLOW PALE | CADMIUM YELLOW ORANGE | CADMIUM RED | TERRA ROSA

BURNT SIENNA DEEP | COBALT BLUE | ULTRAMARINE BLUE | PRUSSIAN BLUE

FLAKE WHITE

Dennis Poirier lives in Kittery, Maine, USA → www.dennispoirierstudio.com

I used the contrast of warm against cool to re-create the sensation of bright sunlight at the beach.

Beach Memories, oil, 8 x 10" (20 x 26cm)

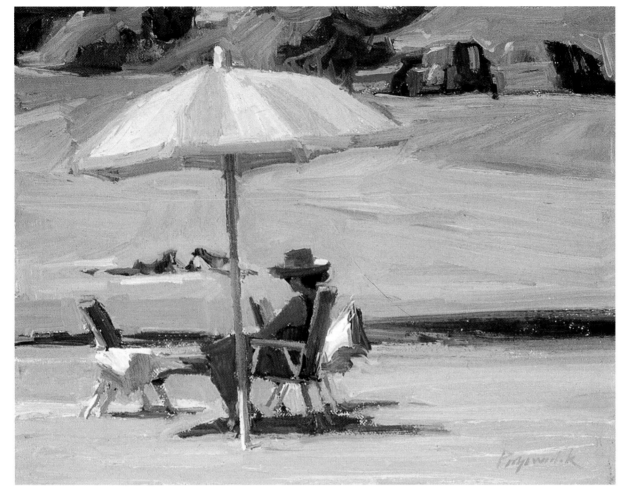

my inspiration

While at the beach, the warm sunlight falling on this woman caught my eye. The cool color notes of her figure under the shade of the umbrella contrasted beautifully with the warm sand, water and sunbathers in the background.

my design strategy

I placed the focal point off-center and balanced it with the cars in the upper right-hand corner. As I organized the composition further, I chose my point of view so that the various other elements in the dominant sunlit areas were placed nicely. Purer colors in the foreground and neutral colors in the background create depth. Crisper line and detail in and near the seated figure accentuate the focal point.

try these tactics yourself

When I start a painting, I think of all the colors in relationship to each other. I try not to think about color in isolation but like notes in a chord. The first color I put down is very important — it is the key to the whole painting since every other color I will choose will be in relationship to this first color. As I add each stroke, I evaluate the impact of each new color note, asking myself if it is redder, bluer or yellower, and so forth. I also ask if it is lighter or darker, and if it is brighter or duller than the strokes nearby. I try to cover the whole canvas quickly because the accuracy of my color cannot be determined until the entire canvas is covered. I make sure all my sunlit areas are light enough to stay within the sunlight and my shadow areas dark enough to stay within the shadow. The flesh notes of this figure were challenging because I had to make them cool and dark enough to stay in the shadow, but at the same time warm enough to show the color of her skin tone.

HOT TIP

Rather than work from photos, I prefer to rely on my painting memory. When I see a figure I want to paint, instead of grabbing my camera, I spend my time just looking and trying to remember the stance of the figure and as much as I can about the color and light. I then paint the figure quickly from memory. I find the more I do this, the better I get at it.

what the artist used

support	brushes	medium
Linen canvas	Variety of brushes; palette knife	Liquin

oil colors

Titanium White	Permanent Rose	Cobalt Green
Cadmium Lemon	Cadmium Red	Cadmium Green
Cadmium Yellow	Permanent Alizarin Crimson	Oxide of Chromium
Indian Yellow	Permanent Magenta	Ultramarine Blue
Yellow Ochre Pale	Permanent Green Light	Sevres Blue
Cadmium Orange	Viridian	Dioxazine Purple
Burnt Sienna	Emerald Green	

Camille Przewodek lives in Petaluma, California, USA → www.przewodek.com

A rhythmic value pattern and harmonious color relationships created visual music in this painting.

Togetherness, oil, 10 x 8" (26 x 20cm)

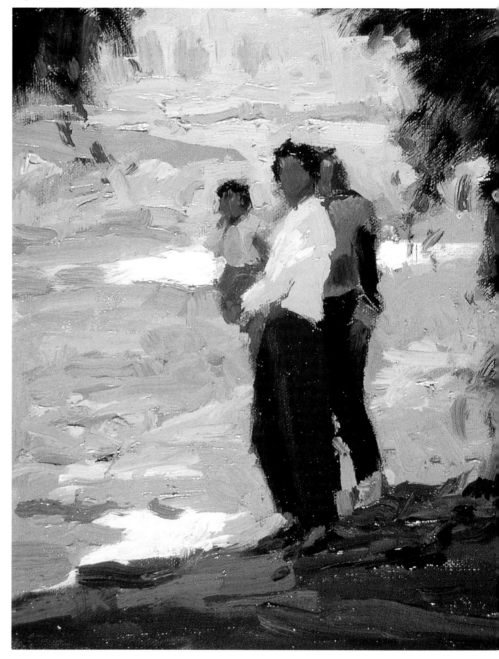

ARTIST
48

Barry John Raybould

my philosophy

I believe successful paintings combine visual music and visual poetry. The poetry is the emotion or feeling I communicate via my choice of subject matter and focus. The music derives from the abstract design of the painting: the rhythm of the large value masses and the harmonic relationship of the color spots, both of which are completely independent of subject matter. Brushwork further enhances this abstract musical quality. If I put too much detail in the painting, I leave nothing to the imagination of the viewer. By suggesting, rather than describing, the detail, I involve the imagination of the viewer so they become an active participant in the painting.

what I wanted to say

I was struck by the togetherness of this family group as they wandered through a rural area in China and by the design possibilities of the scene. I was intrigued by the contrast of the saturated colors on the figures against the muted grays of the surrounding landscape, as well as the light/dark pattern formed by the family group, the nearby trees and the sky reflections in the stream.

the main challenges in painting this picture

My design strategy was to focus on the two visual aspects of the scene that attracted me. I needed to design the arrangement of the basic three values in the scene to achieve balance and harmony, and to find a color harmony in the grays of the landscape that would set off the figures.

try these tactics yourself

- To explore the "notan" or light/dark patterns, I used black and middle gray brush ink pens on paper, keeping the studies small. I have found that this process of notan study contributes more to the success of the final painting than anything else I do.

- To develop the color harmony, I used a large palette with about 20 colors, plus a series of "muds" that I make when painting. I explore color harmonies on the palette before applying the paint. This give me a beautiful set of harmonious grays that I can apply to the canvas in a free and loose way to enhance the abstract quality of the painting.

- For the last 15 minutes of painting, I turn every picture upside down. If it does not look very interesting, I know I need to work on developing the visual music side of the image.

what the artist used

support
Canvas

brushes
Filberts #4, #6, #8

oil colors

Titanium White	Cadmium Red Light	Ultramarine Blue
Hansa Yellow	Quinacridone Red	Cobalt Blue
Cadmium Yellow Medium	Alizarin Crimson	Cerulean Blue
Hansa Yellow Orange	Burnt Umber	Phthalo Blue
Cadmium Orange	Phthalo Green	Platinum Violet
Raw Sienna	Viridian Green	Mars Black
Venetian Red	Permanent Green Light	

Barry John Raybould lives in Pacific Grove, California, USA → www.bjrgallery.com

Bringing in the wooden crate as a prop improved both the pose and my composition.

Katie, oil, 18 x 24" (46 x 61cm)

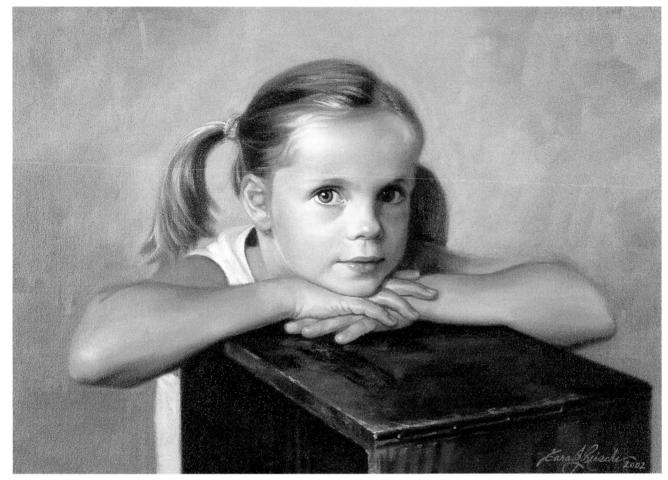

a special commission

Painting portraits is how I make my living. With each commissioned work, I try to capture the likeness of my subject, as well as the personality. This one was extra special, as it was commissioned by a high school classmate of mine. It is both challenging and satisfying to work for a dear friend. In this particular piece, I was inspired to illustrate Katie's wisdom. Though she is young, her eyes are exceptionally expressive and soulful. It was my hope that "Katie" would speak to the viewer with her eyes.

my design strategy

Because it was for someone close to me, I wanted Katie's portrait to be perfect. Simplicity was my main focus. I wanted this portrait to feel clean and uncluttered by eliminating anything unnecessary. The wooden crate was needed as

a prop, as well as a design element. I liked having Katie's hands close to her face, and the crate allowed me a natural pose, while adding lines to the composition that led your eye back to the subject. The background — a soft, medium-value gray — was chosen to enhance the warmth of the skin tones, and to compliment Katie's eye color. It was important to me that the painting feel well balanced and engaging.

my working process

- At a scheduled photo shoot, I took more than 75 photos from which to work, and ultimately combined five or six to get the final composition and expression.

- The composition dictated the proportion of the canvas I prepared. I stretched the canvas, primed it with gesso, then toned

it with an acrylic Raw Umber wash in a medium value so as to not paint on stark white.

- I began laying out the composition with general shapes and color. I built the entire painting as a whole, making sure to keep my layers of paint thin.

- Once I felt I had captured Katie's likeness and expression, I focused on details.

- Finally, I added thicker strokes of lighter values for highlights.

HOT TIP!

A rhythm I have found crucial to the development process of any portrait is to walk back 10 to 15 feet from the painting every few minutes. It is easy to get lost in rendering specific features (like eyes), only to throw off overall proportion. Walking back from the easel helps me see the portrait as a whole.

what the artist used

support
Heavyweight canvas with acrylic gesso primer

brushes
Various, including #7 flat, #4 flat, #5 round, #1 bright and #0 round

varnish
Damar Varnish

oil colors

Naples Yellow
Cadmium Lemon
Yellow Ochre
Cadmium Red Medium
Alizarin Crimson
Raw Sienna

Burnt Sienna
Raw Umber
Sap Green
Cerulean Blue
Ivory Black

Cara J Reische lives in Spencer, North Carolina, USA → www.carareische.com

To liven up a typically static triangular structure, I added horizontal and vertical lines to the background.

Final Inspection, oil, 20 x 24" (51 x 61cm)

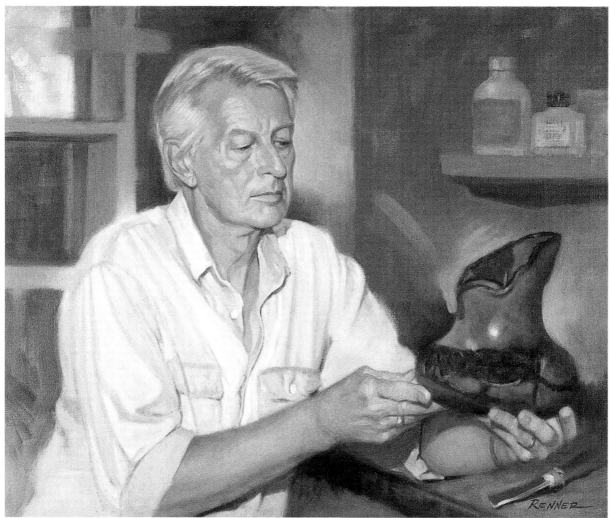

something different

I wanted to do a portrait of a friend of mine, who is a jeweler and sportsman but also works with his hands to create these beautiful wood pieces.

my design strategy

I did not want to do the same old static pose. So even though the basic design is a triangle, I contrasted it with horizontal and vertical lines in the background. Your eye follows the arm to the wooden object, up to the head and back to the arm.

my working process

- First I photographed the subject in his workshop as he used different tools. While relaxing, he looked at one of his pieces — that was the pose.

- I then made some pencil sketches to simplify the background and improve the composition. For example, I moved the window closer to the figure.

- Starting with a toned canvas, I blocked in all of the value colors. To make sure they were right, I pre-mixed four tones of light flesh colors, two halftones and two shadow colors. I started with the lighter shadows to give me the form of the head. Putting in the darks established my range of values. I then put in the halftone colors between the lights and shadows to give volume and depth to the form of the head, as well as the individual features.

- Over this block-in, I then re-painted in the face and hands, refining the values and colors to give the figure dimension.

- I went through basically the same steps for the other elements in the painting.

- Finally, I finished up with the details.

HOT TIP!

Pre-mixing your colors will guarantee you have the right values. Together with shapes and measuring, it will be easier to get a likeness.

what the artist used

support
Linen canvas

brushes
Bristle filberts and flats various sizes

oil colors

Cadmium Yellow Light	Alizarin Crimson	Ultramarine Blue
Yellow Ochre	Burnt Sienna	Cobalt Blue
Cadmium Orange	Raw Sienna	Cerulean Blue
Cadmium Red Light	Burnt Umber	Ivory Black
Venetian Red	Viridian	Permalba White

Donald Renner lives in Ormond Beach, Florida, USA → dgrenner@bellsouth.net

I used light and shadow to advance my concept.

Out of the Door, oil, 44 x 43" (112 x 109cm)

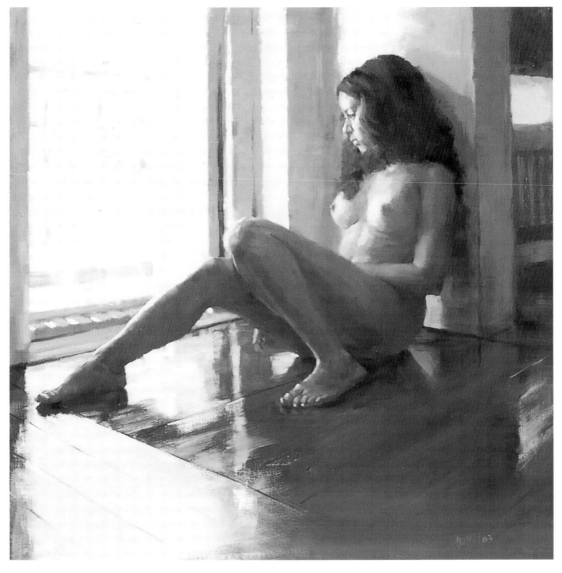

Tae Rhea

ARTIST
51

my inspiration

I was inspired by the bright light coming through a door one day. This light produced an incredible life energy source in the surrounding shadows. It gave me the idea to show and capture an innocent young woman, looking out into the world. It is the moment right before she steps out into her future. She is not sure how that future will look, but the bright light warms her, encouraging her to be part of the outside world.

follow my eye-path

My main subject is the bright light that starts near the woman's eyes and face. Your eyes then travel a circular path, following the lights and shadows. Although some elements break out of the frame of the painting, your eyes come back to the main focal point because of the contrast there.

my working process

- Because my model for this painting was not a professional and I knew I would need long hours for my process, it was mandatory to take photos. I also did life sketches and took detailed notes.
- I then arranged my composition on a large canvas.
- I started painting the shadow, using Burnt Sienna and Burnt Umber and large #20 and #30 flat brushes. To capture the overall big shapes and the movement of the light, I focused on using only three values.
- Next, I put in the local colors. I started painting the darkest area in the shadow and worked up to the highlights in the light.
- Throughout the painting process, I stepped back and checked the overall mood of the painting.

what the artist used

support
Canvas

brushes
Flats in #6, #10, #20, #30, #40

oil colors
Cadmium Lemon
Cadmium Yellow Light
Yellow Ochre
Cadmium Red
Alizarin Crimson
Burnt Sienna

Burnt Umber
Viridian
Olive Green
Ultramarine Blue
Prussian Blue

Tae Rhea lives in San Francisco, California, USA → www.taefineart.com

The elongated format of this portrait was my way of sharing vital information about the model.

Urban Warrior, pastel, 44 x 22" (112 x 56cm)

what I wanted to say

My inspiration for this piece is the individuality of the model, his strength of character, his spirituality and his deep awareness for his compatibility with nature. I've done a series of portraits of him, and he is always willing to participate in the creative process by choosing clothes and dying his hair to bring out different aspects of his personality. My objective in any painting is to make the viewer feel what I feel. Sharing information in symbolic form helps to convey emotion.

my design strategy

By choosing an elongated format, I was able to convey a sense of his power through his full stature. I used high contrast to bring out the intensity of the individual and, because of his spirituality, I stayed with earth and air coloring.

my working process

- After figuring out my composition, I put in a limited grid on my sanded pastel paper that divided it into quarters. With a white charcoal pencil, I loosely transferred the subject from my reference photo. I then completed a very tight drawing in black charcoal.

- Using hard pastel sticks, I blocked in lights and darks, using primary colors at this point, as well as a lot of black to make him stand out. I continually corrected my drawing as I moved along, turning my paper full circle, looking for inaccurate lines.

- I continued working up layers of hard pastel, trying to get closer to my exact colors. I used my fingertips in varying degrees of pressure to blend and mix colors.

- Once the color direction had been pretty well set, I started using soft pastels to intensify the color. Blending was like finger-painting and was the most enjoyable point of the structure.

- To finish, I blurred out or defined some edges and cleaned up some areas. I included details such as the ash on his face and his anarchy tattoo. I then added accents, working from dark to light to final highlights.

my advice to you

What I have learned from portrait painting is to understand what the light is doing before you paint it, build your structure solidly, but most of all, be excited about your subject and continuously look for the hidden.

what the artist used

support
Sanded papers

media
Soft and hard pastels
White charcoal pencil

Candice Rivard

ARTIST
52

Candice Rivard lives in Shelby Township, Michigan, USA → crivard_6@yahoo.com

Interesting positive and negative shapes supported the quiet strength of this sitter.

Mercedes, oil, 14 x 18" (36 x 46cm)

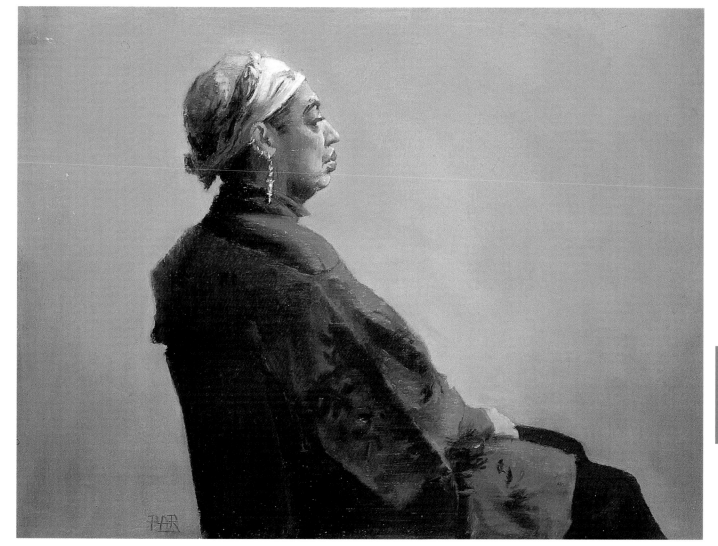

my inspiration

This model, Mercedes, has a look of strength and serenity that I found very interesting.

about light and color

Under natural lighting, I positioned the model under strong rim lighting. This brought out the dark, abstract shapes of the figure, which I felt supported the atmospheric quality of the negative shapes.

My primary focal point was the rich color in the head that cascades out and down through the turban and the rest of the figure. To harmonize the background with the figure, I repeated the same colors used in the cool skin tones.

my working process

- I started with a size and placement drawing directly on the toned surface, using Raw Umber and mineral spirits to keep the paint very thin.

- I then proceeded to mass in the shadows and the background, developing everything simultaneously to create cohesion.

- Now using thicker, heavier paints, I put in the light areas.

- After the initial layers had dried, I went in and scumbled dry color as needed, especially in the shadows.

- Notice how I used vague strokes to suggest the intricate pattern in the silk caftan so that it wouldn't detract from the powerful focal point of the head.

my advice to you

To develop your drawing skills while finding your personal style, keep a sketchbook and draw whatever interests you every day.

what the artist used

support

Tempered Masonite panel, primed with gesso and sealed with a mixture of stand oil and turpentine to make the panel less absorbent

oil colors

Cadmium Yellow
Naples Yellow
Yellow Ochre
Cadmium Orange
Cadmium Red
Venetian Red

Alizarin Crimson
Raw Umber
Ultramarine Blue
Cobalt Blue
Mars Black
Titanium White

Patricia A Rohrbacher lives in Copley, Ohio, USA → rohrbacher@adelphia.net

Minimal embellishment and powerful body language resulted in a confronting portrait.

Mario Robinson

ARTIST 54

Blue Daze, pastel, 40 x 28" (102 x 71cm)

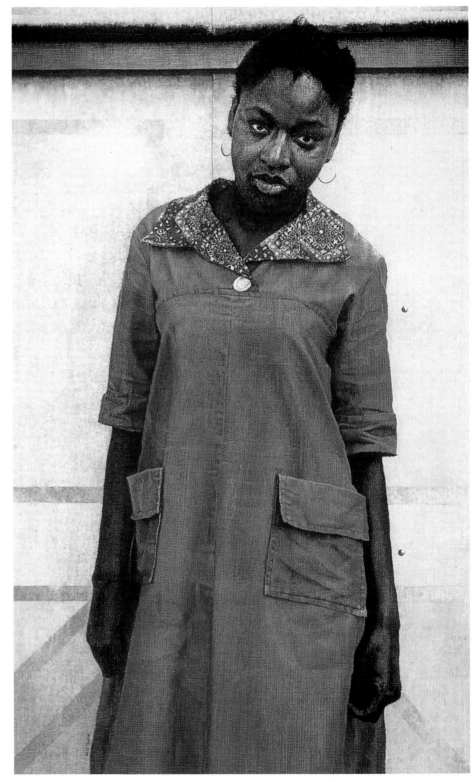

what I wanted to say

With this painting, I wanted to highlight the maturity of a model I have painted for several years. My goal was to show the complex disposition of an aging teenager, as opposed to the patient pre-teen I had once known.

my design strategy

In order to convey the tension between an impatient model and the ever intrusive artist, I employed a frontal pose. My intention was to place the viewer directly in the path of the model's disarming gaze, therefore forcing an intimate interaction. I also posed her in a blue dress purchased from the Salvation Army, which was indicative of the model's rural setting (Alabama). I noticed a shed in her backyard that would compliment the blues in her dress and define her surroundings. To create a sense of harmony, I used Prussian Blue as a major factor in the dress, skin tone and background.

my working process

- I began by cutting my pastels down to the size of small breath mints and sharpening them with a sheet of rough sandpaper.
- Then I blocked in the focal point with vertical and horizontal lines. As I worked from dark to light, the painting took on a plaid appearance.
- After I had used a tortillion to fill in any remaining "holes" showing through the cross-hatched areas, I sprayed a thin layer of fixative to prepare the working surface for subsequent layers of pastel.
- In the final stages, I minimized the size of my pastel strokes in order to add details and highlight certain areas.

try these tactics yourself

Creating a subtext for a portrait makes it far more interesting. To do this, find ways to explain what the circumstances are concerning the moment you've captured. However, I also recommend staying true to your subject's personality with a minimal amount of embellishment.

what the artist used

support
140lb cold-pressed watercolor paper

media
Soft pastels, primarily blues, violets and earth colors

Tortillions

Fixative

Mario Robinson lives in Lakewood, New Jersey, USA → absolutearts.com/portfolios/r/robinson

I defined the shapes with color temperature rather than line.

Sonita, oil, 11 x 14" (28 x 36cm)

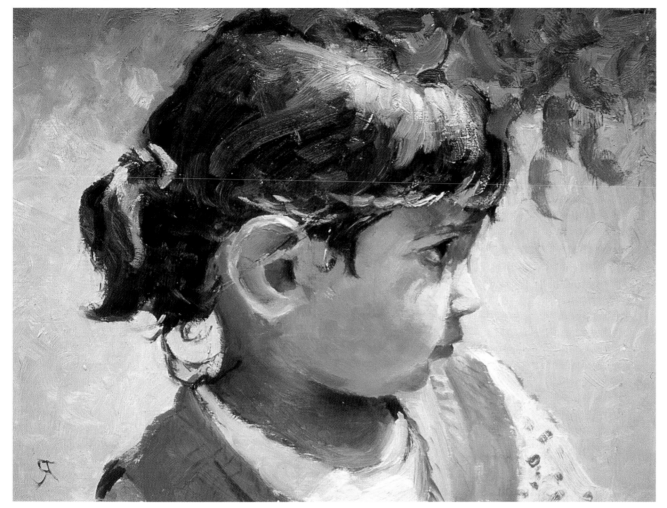

the main challenges in painting this picture

Sonita, the subject in my painting, is the daughter of a friend of mine from India, whom I have known from birth. Young children have a sense of wonder, and I endeavored to paint that facial expression in "Sonita". Thus, my challenge was to go beyond a likeness or portrait into a painting that could stand by itself and be universal in nature. Another challenge was to keep the painting from becoming too sentimental or sweet, which is a fine line one has to walk in painting children.

my design strategy

I used the foliage, as a shape, to soften and break up the edges along the top of her hair and to provide a variety of edges. The diffused light out in the garden allowed me to keep the edges soft and define the shapes with temperature rather than line. This helped me paint the emotion I wanted to convey.

my working process

- Children don't pose, so a photographic reference was helpful. I then started with sketches to get the best design to convey the message.

- Next, I toned my primed canvas with a color and value that approximated the skin tone in the light.

- After locating the eye placement, I used it as a reference to locate and measure distance to the nose, chin, top of skull and so on, until I had developed a complete drawing on the canvas.

- Next, I carefully placed the correct values in the right places, keeping the color muted in almost a monochromatic fashion.

- Once the painting's structure of tonal values was established, I painted rapidly in color, using as large a brush as possible and alternating with a palette knife to refrain from becoming too tight.

- The last thing was to add the highlights and place the accent darks.

why I work with oil

Oil paint has a historic lineage and is a time-tested medium for portrait paintings. In addition, it allows me to express myself freely and spontaneously.

my advice to you

My advice is to work from life and learn anatomy well before using photographs, especially with portrait-type paintings.

what the artist used

support
Primed, stretched linen canvas

brushes
Variety of styles and sizes; palette knife

oil colors
Cadmium Yellow Light
Cadmium Orange
Cadmium Red Light
Transparent Oxide Red

Alizarin Crimson
Viridian
Cobalt Blue
Ultramarine Blue

Tom Ross can be contacted at 3124 Kings Lake Blvd., Naples FL 34112 USA

Contrast and light patterns allowed me to suggest the warmth of the early morning sun.

Paul Saindon

Morning Reading, acrylic, 28 x 18" (71 x 46cm)

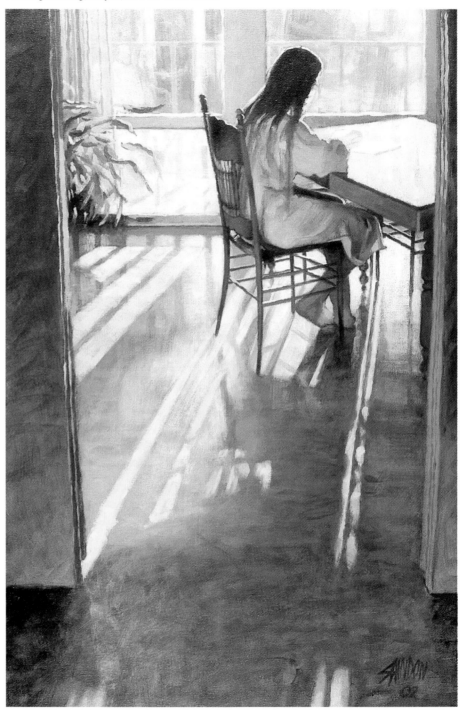

my inspiration

In our daily lives, we are sometimes too busy to notice what fantastic displays are constantly offered to us. I was captivated here by this simple scene: the cast shadows and how they lead the viewer`s eye quite directly to the figure.

my design strategy

The scene was stretched vertically to amplify the effect of the shadows in perspective. I reduced the size of the figure, chair and table and placed them higher in the painting than was seen in real life. As all lines still had to converge to the same area, everything was made to fit by using curves instead of straight lines (mostly for non-horizontal lines).

about light and color

The hardwood floor, orange-colored walls and sunlight generated too much warmth for what I had in mind. In order to capture the sunlight, everything else had to be cooled down. I did this by initially covering the canvas with a cool mid-tone (greenish brown).

my working process

- Since the pattern of the sun was integral to my concept, I had to work from a photograph. However, I treated it as if painting from life, leaving out the details and focusing on the main idea. I also had my model pose twice for me.

- Foregoing a drawing, I roughly blocked in the scene, focusing on value and not worrying about actual colors or details. As I do not like even layers of color when blocking-in, I laid down rough, random brush strokes. Note that I allowed these haphazard, interesting patterns to remain evident in the shadows on the floor.

- Once the lightest light and the darkest dark were established, I started using smaller brushes and more accurate colors. I worked all over the painting, gradually refining each "block".

- I also stepped back from my easel occasionally to check proportions and color relationships (12 feet ... down the hall!). To encourage this, I placed my palette in front of my easel so as not to work too closely to the painting.

- I adjusted areas of color as required by glazing, then added highlights.

HOT TIP!

If you're interested in painting figures, as opposed to portraits, it can be helpful to work with familiar models. I have painted this model (my daughter) many times, so I feel comfortable enough to focus on the composition, not on her likeness.

what the artist used

support
Stretched cotton canvas, primed with acrylic gesso

other materials
Hair dryer

brushes
Flats # 4, 5, 6, 7, 8, 10 and 2-inch; old #14 and 12 flats for blocking in

medium
Matte medium
Flow additive

acrylic colors
Cadmium Yellow Light
Cadmium Yellow Medium
Yellow Ochre
Cadmium Red

Permanent Rose
Raw Umber
Burnt Umber
Ultramarine Blue
Phthalo Blue

Paul Saindon can be contacted at 2006 Gatineau View Crescent, Gloucester, Ontario K1J 7X1 Canada

Here a strong pose and indirect lighting accentuates the story.

Prodigal, oil, 60 x 36" (153 x 92cm)

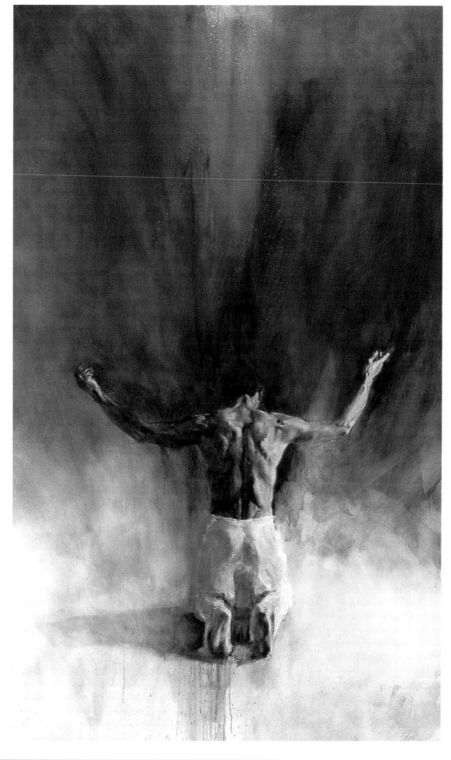

my inspiration

A friend of mine was doing a CD project called "Lessons From Prodigal Living" and wanted artwork for the cover. I had been working on another painting with a model in his warehouse studio. I liked the way the light shafted into such a big space and surrounded the figure. I decided for "Prodigal" to work with the same model in the same space. He did a number of different poses based on the story of the prodigal son in the Bible, and I selected this one to work from. I wanted to explore the mystery between God's wrath and mercy — that moment when the prodigal son turned back, not knowing which he would receive.

my design strategy

I wanted the figure to be the central focus, so I used indirect side light coming in through an open door. This showed more of the subtleties of form and color in the model, keeping the focus on him.

my working process

- I hired a model, explained the concept to him and did a photo shoot. He tried several poses, and we went with this one. I worked from several photos — one showing the whole figure and background, others showing details.

- I started with a freehand drawing of the figure with paint, and then moved out to develop the rest of the figure.

- When I worked on the background, I mixed the paint with a lot of Turpenoid and let it run in loose washes. I then went over parts of it with more opaque layers. I wanted some areas that were very detailed and others that were more gestural.

- I kept going back and working on the right hand, arm and back, adding little dashes of color, deepening darks, lightening lights.

- As I painted, I realized that I wanted to draw attention to the hands, so I darkened what was a light background around them. The background was then too distracting, being a mixture of light and dark, so I darkened the whole background, simplifying it and drawing more attention to the figure.

- Going back to it over a period of days, weeks, I continued to see things to add or change. I saw proportional problems and have to repaint areas.

HOT TIP!

Get down your drawing before you start to paint. As you do, paint/draw what you see, not what you think you see.

Suzy Schultz

ARTIST 57

what the artist used

support
Gallery-wrap canvas

medium
Turpenoid

brushes
Synthetic blend filberts and flats, from small to large

oil colors
Naples Yellow
Cadmium Yellow Medium
Yellow Ochre
Cadmium Red Light

Alizarin Crimson
Raw Sienna
Burnt Sienna
Raw Umber

Burnt Umber
Sap Green
Prussian Blue
Ivory Black

Suzy Schultz lives in Atlanta, Georgia, USA → www.suzyschultz.net

Contrasts, body language and reflections contribute to the feeling of movement and depth.

Cart Brigade, oil, 24 x 36" (61 x 92cm)

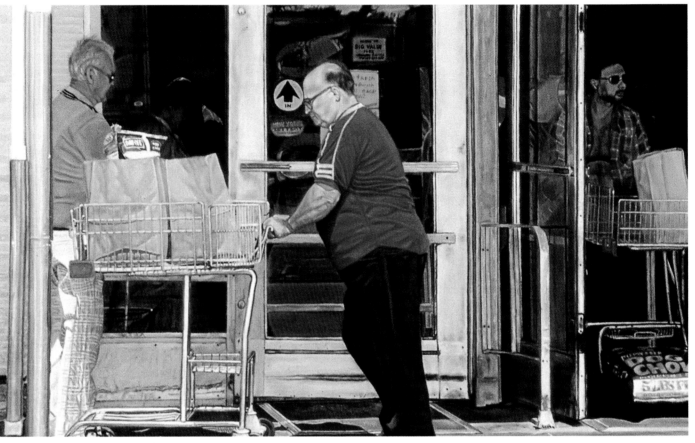

what I wanted to say

I wanted to express a sharp focus view of suburbia, highlighting both people and architecture but not at the expense of each other. Most of all, I wanted the reflections in the glass doors to give an illusion of depth so that we see forms located outside the canvas, forms which really are not there at all.

try these tactics yourself

- No other subject but people interests me, and I will take hundreds of photos to get the best composition of the scene.

- When I decide on the scene I want to paint, I enlarge the photo and choose a proportionately larger canvas, usually double the size of my enlarged photo.

- I will then cover the enlarged photo with acetate and apply an appropriate sized grid with

a non-smearing black pen. On the canvas, I sketch the image with a #2 pencil.

- Over the pencil drawing, I apply light washes of color, sticking to the general local color of the various elements.

- As I build up more layers of oils, I constantly look for ways to enhance contrasts and make the body language more dramatic.

- When I am satisfied with the depth of the colors, I will start unifying the image with glazes. For this, I use paint mixed with linseed oil and apply with a soft brush and cloth.

my advice to you

Many of the great "people artists" have used the camera, the brush and their natural creativity to paint wonderful works of art. So by all means, use your paintbrush, the camera and your unique talent to create your own masterpieces.

what the artist used

support
Canvas

brushes
Sable and bristle brushes of all sizes; 3" paint rollers

other materials
Artist's drafting tape for making straight lines

oil colors

CADMIUM YELLOW LIGHT	FLESH TINT	PERMANENT RED	RAW UMBER
COBALT BLUE	PAYNES GRAY	IVORY BLACK	SILVER
TITANIUM WHITE			

Maurice Spector can be contacted at 183 Liston Rd, Buffalo NY 14223 USA

Contrasting shapes add drama to my story.

Child of the Middle, watercolor, 33 x 40" (82 x 102cm)

what I wanted to say

I was doing an Art Festival in Connecticut with my granddaughter, Anastasia. On Saturday night at the artist's party, I noticed the glass jars filled with roses used as centerpieces. They were so full and beautiful that I asked to borrow them for a photo shoot the next morning. I shot several photos and asked Anastasia to step in on one. I did two paintings of this still life, one with her and one without. She is my middle grandchild and the glass jars are symbolic of my three, hence the name, "Child of the Middle".

my design strategy

Many portraits are pyramidal in shape, and I set this up with that in mind. I like the contrast of curves and straights, so I used this to give drama to the various elements. I also love interesting negative areas and set them up in the shadows.

my working process

- Along with shooting the film of the still life, I did black/white value sketches of the design.

- I then painted the painting, following my photograph with a photo realistic style. I built up the image with multiple glazes.

- I took special care in creating the rich shadows on the table and the side of Anastasia's face.

the main challenge in painting this picture

My main challenge is that I had never painted a portrait in watercolor, only acrylic. I thoroughly enjoyed how different the two media respond.

what the artist used

support
300lb watercolor paper, torn to get deckled edges all around

brushes
Very small sable brushes

watercolors

Cadmium Orange
Indian Yellow
Cadmium Lemon
Winsor Yellow
Gold Ochre
Yellow Ochre
Burnt Sienna

Rose Carthame
Cadmium Scarlet
Winsor Red
Permanent Rose
Permanent Magenta
Sap Green
Cobalt Violet

Winsor Violet
Ultramarine Turquoise
Cerulean Blue
Antwerp Blue
Paynes Gray

Susanna Spann lives in Bradenton, Florida, USA → www.susannaspann.com

A gloss gel medium undercoat allowed me to lift out color and create a glowing sense of light.

Kids, watercolor, 14 x 20" (36 x 51cm)

Kim Stenberg

what I wanted to say

I was at a petting zoo in Oregon during a family summer vacation when I came across a group of "kids". They were totally engrossed in the act of giving and taking food. The scene was both whimsical and moving. This intense, yet tender, coming-togetherness was what I wanted to convey.

my design strategy

The painting has a classical triangular design of stability. The boy is the high point, with the other animals flanking him. All eyes are focused on his feeding hand. creating an implied movement and expectation. This polarity of rest and restlessness is repeated in the classical brown/blue color scheme — two colors implying heat and serenity at the same time. Another contrast is the four dark-colored figures balanced by the pony, the largest and only light-colored figure.

my working process

- After editing my photo's composition in sketches and doing a quarter-sheet color study, I was ready to start.

- I first treated the support with a mixture of one part gloss gel medium and one part water, and let it dry.

- I then randomly applied a thin wash of Rose Madder Genuine, Aureolin and Cobalt Blue, and let the wash dry.

- Over a careful drawing, I applied another, slightly thicker wash of French Ultramarine, Brown Madder and New Gamboge. I used a 1-inch sable brush so that I would disturb the first wash as little as possible.

- When I let the painting dry overnight, the paints puddled, creating interesting textures. However, I had to re-state the drawing before I could continue.

- Next came the fun part of lifting paint from sunlit areas and reflected light areas of the figures, a technique made possible by the gloss gel medium undercoating.

- Finally, I introduced strong darks (mixtures of browns and blues). Although I used a gentle touch with sable brushes, in some spots the initial washes came off. But I persevered, and as the paint dried, the disturbed underpainting of Cobalt Blue on the boy's shirt created a pleasing texture.

please notice

The painting has a flatness for a reason. I intentionally downplayed the noise and excitement — what you'd normally find in a place for children — because, for this brief moment, five young creatures came together to share food. The rest of the world did not exist as far as they were concerned in their total self-absorption.

what the artist used

support
Watercolor paper

brushes
1" flat and Nos. 6, 8 and 12

watercolors
Aureolin
New Gamboge
Rose Madder Genuine
Burnt Sienna
Cobalt Blue
Ultramarine Blue
Brown Madder

Kim Stenberg lives in Alexandria, Virginia, USA → youngstenberg@aol.com

Through gesture and design, I accentuated a curious contrast between the two main figures.

Cathedral Steps, Sienna, watercolor, 24 x 20" (61 x 51cm)

what I wanted to say

In the crowd sitting on the steps of the Sienna cathedral, I saw a couple reading a newspaper. Even though they appeared to be opposite personality types — the man uptight and the woman relaxed — they looked like they belonged together. I wanted to capture their contrasts, their preoccupation and their curious aura of compatibility.

my design strategy

Their body language spoke of contrast. To emphasize this, I used complementary colors on the shirts they were wearing. The overlapping newspapers unified the figures, allowing me to present them as one design element. I eliminated the other figures that were around them, except one. The third figure at the top left provided balance and tied the cathedral and steps together.

my working process

- From several candid photos, I made quick thumbnails to work out the basic composition. Then I made a more detailed, black-and-white sketch to develop the design and establish values, as well as a ⅓ size color sketch.

- Using the sketches and photos, I made a full-size drawing on tracing paper, which I transferred to cold-pressed watercolor paper by using a graphite transfer sheet.

- To help see my values correctly, I started with dark areas of the cathedral at the top. I then used Burnt Sienna, Yellow Ochre and a mixture of Indigo and Black to do the warm areas.

- With the cathedral almost complete, I started on the figures, painting the light and medium skin tones. After the basic colors of the clothing were painted, I completed the shadows and details on the figures.

- On the steps, I laid down a light neutral wash and finished with drybrushing.

- After the balance of the painting was finished, I darkened some areas of the cathedral and figures.

try these tactics yourself

- Preliminary steps on a watercolor take the guess work out of the painting. Try making design roughs, black-and-white value sketches, full-size drawings and color sketches to ensure better results.

- Make your own graphite sheets for transferring your drawings to watercolor paper. Cover a piece of tracing paper with 4B or 6B graphite. Then lightly wet the sheet with lighter fluid to liquefy the graphite and rub softly with a cotton ball to even out the graphite. The sheet can be used over and over.

Paul Sullivan

ARTIST
61

what the artist used

support
300lb cold-pressed watercolor paper

brushes
Larger synthetics, #8, 6; small sables, #4, 2, 1, 0, 00

watercolors

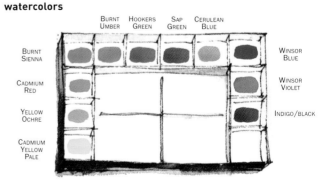

Paul Sullivan lives in Scottsdale, Arizona, USA → sully1251@cox.net

I used a careful tonal plan for this figure from a poem.

my inspiration

My inspiration for this painting was an ancient Chinese poem. It's about a very skillful wife in the south of China, who embroidered every day to express her longing for her husband who was away in the army.

my design strategy

I'd rather use my brain than a computer or other types of preliminary steps to plan my design — it is more accurate for me. I spend a lot of time thinking, forming the image in my mind and setting the tone. In this case, I decided to block the light in a small area around the head and hands so they catch the viewer's eye and hold their interest. The darker background suggests that the needs of an ordinary woman were not as important as those of the entire society at that time.

my working process

- After doing a fairly detailed pencil drawing, I used a No. 12 clean damp brush to wet the background. Waiting until it was half dry, I used a variety of colors to paint the dark area of background. For the middle tone I used water mixed with Burnt Sienna and Viridian, and for the light part I used Yellow and Viridian.

- Still using a big brush, I built up the color of the overall background. To finish this area, I put in detail with a small Chinese round brush.

- Next, I worked on the dress. I put in the darkest areas with Indian Red, Burnt Sienna and Alizarin Crimson, leaving the pattern of the dress blank. For the middle and light tones, I used a soft brush with transparent reds to finish the dress.

- For the head and hands, I used a No. 5 soft brush and a mixture of a little Viridian, a little Cobalt Blue, some Burnt Sienna, Primary Red and Vermilion with water to paint the dark area. I painted in the features as accurately as possible, then put in the middle tones and the light areas.

- Initially, the result was not what I had in my mind. I washed it out, waited until it was dry and repainted with close attention to detail.

- To refine my image, I made sure the light tone of the head and highlight area were correct and softened some edges. I made sure each adjustment fit within the entire design.

Green Moonlight, watercolor, 38 x 25" (97 x 64cm)

what the artist used

support
140lb hot-pressed watercolor paper

brushes
Nos. 14, 12 and 5 rounds; small Chinese round brushes

watercolors

Lemon Yellow	Alizarin Crimson
Yellow Ochre	Burnt Sienna
Vermilion	Raw Umber
Primary Red	Viridian
Indian Red	Cobalt Blue

Dashuai Sun can be contacted at 86 — 18 Elmhurst Ave., Elmhurst NY 11373 USA

The main players here are color and light.

Ghirardelli Music Man, oil, 36 x 30" (92 x 76cm)

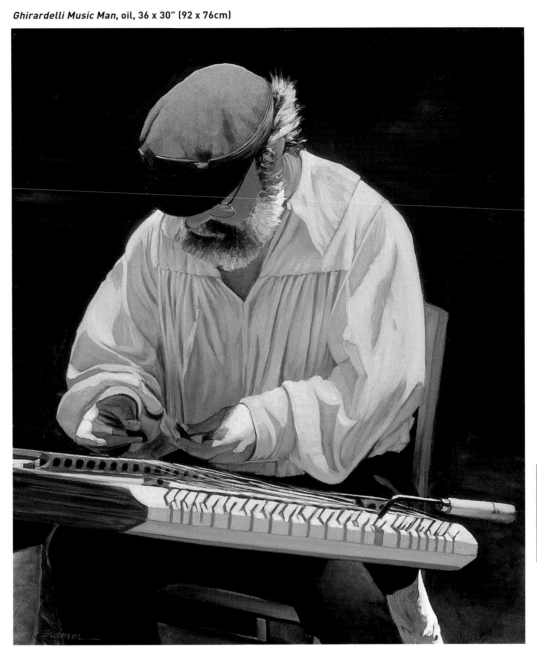

my inspiration

As I watched and listened to this dulcimer player in San Francisco, I was inspired by the color intensity and contrast of his bright yellow shirt. I wanted to capture a moment that was both musically and visually exciting. It was my hope that my painting would evoke the same emotions in the viewer, that perhaps you would almost hear the music and feel the warmth of the sun.

my design strategy

The play of light on the shirt and the geometry of the dulcimer held the most visual interest, so after taking a few photographs, I cropped in close to let them fill the composition. My main objective was to capture the sharp contrast in the light and shadow areas and to arrange the elements in a way that would make the image artistically dramatic. I wanted the viewer to first be drawn to the light and then to the musician's hands.

my working process

- Using the cropped photo for reference, I began by drawing a rough sketch of the large shapes with a fine point marker.

- Working from dark to light and thin to thick, I began to establish the basic tonal values with a thin transparent oil wash. I worked very loosely with a large brush, using only a few colors and keeping the paint thin with Oil Painting Medium #2.

- Over this wash, I began to define the darkest colors and values with more clarity. Once these were finished, I blocked in the middle values and light tones. As the painting progressed, I used the flat edge of the brush loaded with thicker paint to "draw" many of the details. I also added a little Paynes Gray to each so that the pigments appeared more natural.

- After letting the painting dry a little overnight, I added the brightest highlights, sometimes using pure color for vibrancy and drama. I never use white alone for highlights, but rather always add a little color to vary the hue.

- The biggest challenge in this painting was to capture the mood and intensity of the moment, not just the details. As with most painting, it was important to know how to balance detail with expression, and to know when to stop.

Tom Swimm

ARTIST
63

what the artist used

support
Standard stretched canvas

brushes
Flat sable brushes, #8 to #14

medium
Oil Painting Medium #2

oil colors

CADMIUM YELLOW	YELLOW OCHRE	FLESH	CADMIUM RED
ALIZARIN CRIMSON	BURNT SIENNA	PHTHALO GREEN	PHTHALO BLUE
CERULEAN BLUE	PAYNES GRAY	WHITE	

Tom Swimm lives in San Clemente, California, USA → tomswimmfineart.com

Interesting patterns of light and careful tone enhance the sense of mystery.

Private Conversation, oil, 12 x 16" (31 x 41cm)

Nancy Tankersley

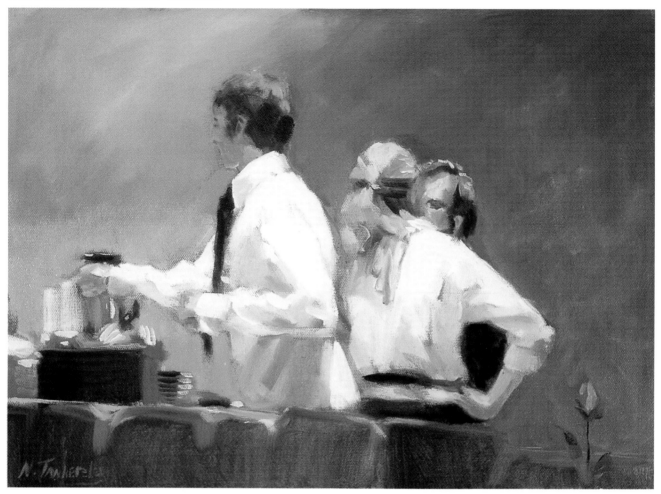

my inspiration

Interesting patterns of light are what first attracted me, but the arrangement of the elements and the gestures of the figures also suggested an interesting story.

my design strategy

I built this painting through the use of shapes and tonality. I placed the three figures squarely in the middle of the canvas to emphasize their importance, and kept the background and other objects in the painting very simple and loosely painted. The tension of the middle figure (the woman) and the placement of the largest figure on the left (the waiter) suggests that he is hearing a conversation between the middle figure and the partially obscured third figure. The rose suggests that the conversation is between two lovers, and its placement and color further explain the story.

follow my eye-path

I wanted the viewer to enter the painting from the left. From there, the top lighting on the shirts, hair and bar objects create a path to the rose in the lower right-hand corner. Subdued lighting elsewhere also serves to move the viewer toward that same object.

my working process

• When I viewed my reference photo, taken in a restaurant, the design was so readily apparent to me that I just started right in on the canvas. However, the rose was added from my imagination.

• On a medium-toned canvas, I blocked in the large shapes with Burnt Umber thinned with solvent. I then used a paper towel to lift out the paint in areas of medium value, and went back in with a dry brush and white paint to pick out the highlights.

• When I was happy with the composition, I mixed up my background color and started to define that large shape. Then I started with the next largest area and filled in with the desired color, continuing on through progressively smaller shapes.

• The final step was to bring out the highlights with heavy impasto.

• When the painting was dry, I applied a light layer of spray varnish.

HOT TIP!

After joining a plein air painters group, my figures and portraits improved. With the quickly changing conditions found in nature, I had to learn to simplify and say what I wanted to say with economy.

what the artist used

support
Stretched cotton canvas, smoothed out with one coat of oil ground

brushes
Filbert bristle brushes

medium
Mineral spirits — solvent
Commercial product similar to Maroger medium

oil colors
Hansa Yellow Light
Hansa Yellow Deep
Yellow Ochre
Napthol Scarlet
Alizarin Crimson
Burnt Umber
Indanthrone Blue
Cobalt Blue

Nancy Tankersley lives in Lusby, Maryland, USA → www.nancytankersley.com

L-shapes and diagonals are crucial in my self-portrait.

Temperament, oil, 24 x 30" (61 x 76cm)

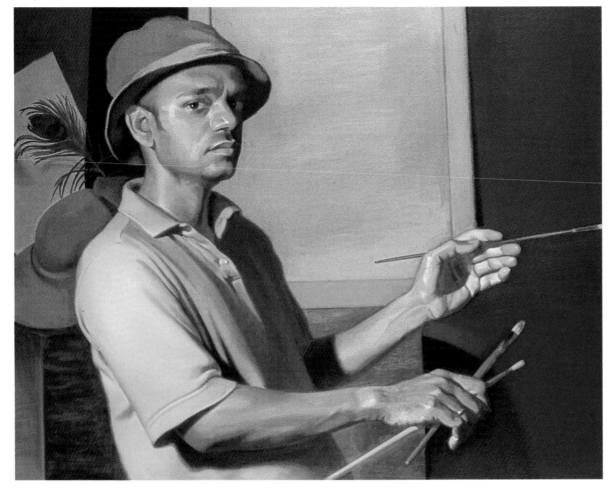

what I wanted to say

I challenged myself to make a self-portrait that was both the act and the product of my painting. For this I needed to have both my hands visible in the painting to "exhibit" the process of making my art. Since I define myself as a visual artist, I also wanted to capture my own temperament in the act of painting, an activity that consumes more time than anything else in my life.

my design strategy

Compositionally, I chose the dynamism of an L-shape, thus the tilt in the body and the hands that encourages your eye to travel from the subject to the action. The brushes provide contrasting diagonals, especially the single brush about halfway down the right side that holds the composition together.

The canvas in the background was necessary to create the dark relief of the figure. Using a canvas rather than a plain background was also more meaningful for the theme. In fact, all of the edges of various elements breaking out of the painting are significant. This conveys that the subject is part of a larger universe.

my working process

• I used a canvas toned with medium gray gesso, which provides a reference point for establishing color relationships.

• First I made a thin drawing, using Burnt Umber paint.

• I then separated dark areas and filled them with paint in different degrees of dark. At this point, my drawing was almost chaotic.

• Next, I established key points within the drawing for orientation — the dark line of the hat above the ear, the dark linear patch under the elbow

and wrist in the foreground, the dark shape of the shirt on the far shoulder.

• As I progressed, I addressed each definitive segment and its composite basic light. Of primary importance was establishing the multiple planes at varying depths in the painting. I found the solution in being very accurate in the color and values among the planes.

• I kept resolving and fine-tuning, going from larger shapes to

smaller, less defined ones, while simultaneously refining the drawing. Colors were adjusted in relationship to each other.

HOT TIP!

While painting what you see, my advice would be to look for shapes and colors, without identifying what you see as "eyes," "nose," objects or scenes. Paint the shapes in light and dark that you see, and don't pursue "likeness of the figure" as a goal.

what the artist used

support
Stretched canvas

brushes
Only filbert brushes, Nos. 1, 2, 4, 6, 8, 10, 12

medium
Occasionally use stand oil to thin the paint

oil colors
Cadmium Yellow
Yellow Ochre
Cadmium Orange
Cadmium Red Deep
Cadmium Green Pale
Burnt Umber

Viridian
Cerulean
Ultramarine Blue
Dioxazine Purple
Ivory Black
White

Vilas Tonape lives in Sarasota, Florida, USA tonape@yahoo.com

Minimal detail and glowing color were my focus.

Sheryl Thornton

my inspiration

My inspiration was this elegant dancer warmed by sunlight and caught in a moment of thoughtful repose with my digital camera. My intent was to convey those feelings of warmth and solitude by using transparent, glowing colors and emphasizing the shapes of the figure bathed in light.

my design strategy

I have found value planning to be a critical step in the success of the final painting. Not laborious, technical planning, but a simple plan of lights and darks can guide me through the painting and remind me of my intent. Therefore, I do a quick value sketch in watercolor, often using a gray mixture of Burnt Sienna and Ultramarine. I lay in a middle value gray area, painting around the lights that I want to reserve. I then follow with the mid-dark and dark values used for contrast and accent. The value plan also helps in planning an eye-path for the viewer.

I tried to direct the viewer through this painting by planning a pattern of light shapes starting at the lower left side and continuing counter-clockwise around the painting. The dancer's shoe served as a focal point, thus I painted a dark value next to the lights for optimal contrast.

my working process

- When I was comfortable with a solid value plan, I translated the value sketch into a quick color sketch to determine the most expressive combination of colors — New Gamboge, Permanent Rose, Manganese Blue and Ultramarine Blue.

- Next, I transferred the drawing to watercolor paper.

- Using a 2" flat brush, I then wet the entire surface with clear water. When the sheen was gone from the paper, I used a large, flat brush to lay in washes of color, letting the pigment mix on the paper while reserving the areas I wanted to be left white. I concentrated on achieving warm against cool color temperatures while trying to keep the tonal values within a middle to mid-light range. This stage is the most critical in the process because it is where the wonderful granulation and color is found. I wasn't too concerned if I overlapped colors because I knew I could later "lift" and correct by re-wetting it and gently scrubbing.

- After allowing the painting to dry, I added depth with shadow patterns, some minimal detail and dark accents. For this I again referred to my value pattern for guidance.

Interlude, watercolor, 29 x 21" (74 x 54cm)

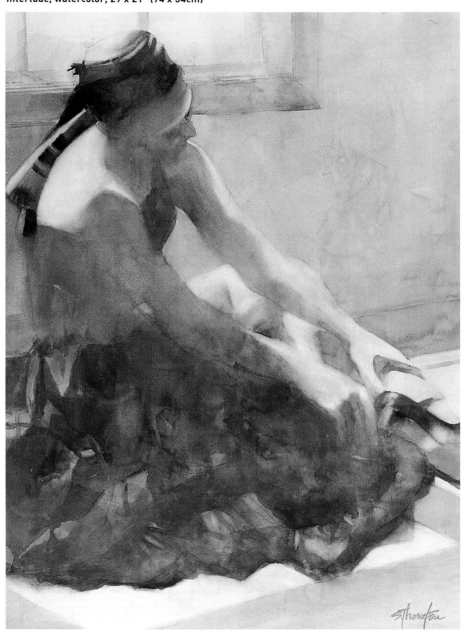

what the artist used

support
140lb cold-pressed watercolor paper

brushes
Round No. 14; mop brushes Nos. 8, 10; 2" flat wash brush

watercolors

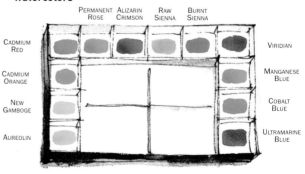

Sheryl Thornton lives in Salt Lake City, Utah, USA → www.sherylthorntonfineart.com

Reducing interest in the landscape background kept the focus where I wanted it — on the figure.

Sarah, oil, 18 x 24" (46 x 61cm)

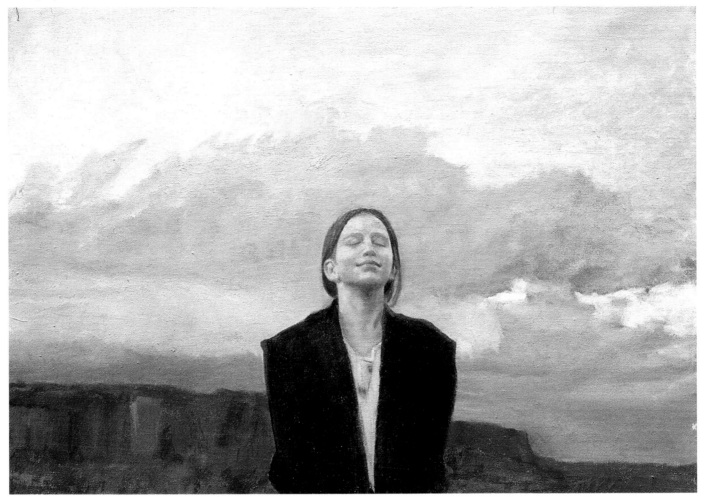

my inspiration

My inspiration for this painting was a moment in time shared with my daughter Sarah. We were chasing the last rays of sunlight up a mountain slope to take some pictures. When we got to the top, she closed her eyes and breathed deeply. I took the picture. I was inspired by her self-contained attitude and the way the colors of the sunset reflected in the flesh tones.

my design strategy

I was interested compositionally in the low skyline and the way the background was a varied gradation from light at the top to dark at the bottom. I was interested in the way the same thing happened on the figure. At the most fundamental level, this painting has the design issues associated with a figure or portrait painting; it all stems from

the gesture, and the focal point is the face.

my working process

- It started with a digital photo, so different prints of the image were used as reference in the process.

- I did a small painting first. The figure was always a little ahead of the rest of the painting. The face changed many times over the course of the process.

- When I turned to the final painting, I used all kinds of glazing and scumbling on the figure. The rest of the painting was done with larger brushes and was more like the "weather" and atmosphere for the figure.

- The face was almost like a small painting within a larger painting. I used a tiny range of brushes and a much more controlled

attitude. Capturing an expression on a particular face in a particular light can be a very subtle thing.

the main challenge in painting this picture

The main challenge of the painting, like any portrait, was to balance the figure and its environment in a meaningful way. In part this had to do with maintaining one focal point and

reducing interest in the landscape/background.

HOT TIP!

Find an artist-friend who can give you objective observations at that crucial juncture when you could use a critique of your work. But don't overwork things; painting is about balancing the moment of painting with the moment you are painting in terms of subject matter.

what the artist used

support
Canvas

medium
Liquin

brushes
Wide range, from small stiff bristle brushes to large soft brushes

oil colors
Cadmium Yellow Pale
Cadmium Yellow
Cadmium Yellow Deep
Cadmium Orange
Cadmium Red Light

Acra Red
Manganese Blue
Cobalt Blue
Prussian Blue
Ivory Black

Vincent Fazio lives in Sedona, Arizona, USA → www.SedonaArtEscape.com

Notice how the mahl stick provides a nice diagonal that adds movement to my otherwise static composition.

John with Artist's Mahl Stick, oil, 24 x 36" (61 x 92cm)

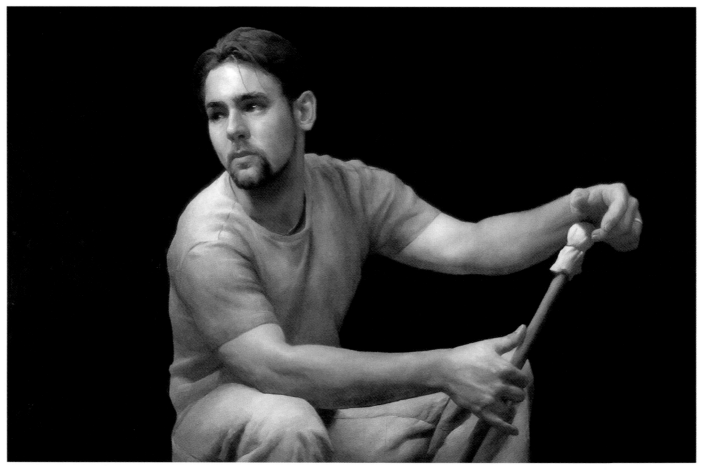

Douglas Flynt

my inspiration

Over the years, I've painted many small works of this lifelong friend. When he had a large block of time available, we decided to do something more ambitious. I really wanted to get a likeness of him while also showing an aspect of his character.

my design strategy

The subject and I wanted a pose that, despite being static, contained the suggestion of movement. For this, I tried to get a few basic curves and rhythms to dominate, and I also pushed for diagonals, such as the mahl stick. This prop allowed for a visual loop to form between the arms, helping to keep the viewer's eye moving. We both agreed that a simple dark background was appropriate for his character and would allow the highest contrast in relation to his mid-value skin tone.

my working process

- After setting the pose, I made a relatively small pencil drawing on paper to determine the composition, proportions and cropping.

- With this done, I enlarged the drawing to the desired size on a photocopier. To transfer the image, I drybrushed Raw Umber oil paint on the back of the enlarged drawing. Placing the drawing painted side down on my stretched linen, I traced over the lines with a sharp pencil.

- After this fully dried, I began a thin underpainting in Raw Umber to gain an understanding of the overall tonal scheme. Midway through doing this, I decided to switch to color so I could also get a sense of the overall color scheme.

- With this dry, working in full color, I started at the head and moved from region to region, deliberately placing each stroke of paint with the aim of finishing as I went. In my mind, I tried to imagine each stroke of paint as representing the surface form in relation to the light source angle. I proceeded in this way until I had covered the surface of the linen.

something you could try

I find working from life more satisfying because of the interaction with the model. Additionally, you can pick and choose facial expressions and take advantage of subtle changes that may occur. There is also a clearer sense of the three-dimensional form and structure when working from life.

what the artist used

support
Fine woven linen with oil-based ground

brushes
Natural hog hair bristle "rounds"; synthetic mongoose hair "rounds"

oil colors

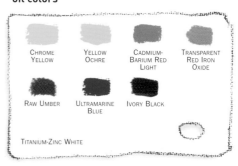

CHROME YELLOW · YELLOW OCHRE · CADMIUM-BARIUM RED LIGHT · TRANSPARENT RED IRON OXIDE

RAW UMBER · ULTRAMARINE BLUE · IVORY BLACK

TITANIUM-ZINC WHITE

Douglas Flynt lives in Sanibel, Florida, USA → www.douglasflynt.com

With the theme of dignity in mind, I relied on line and tonal value to evoke emotion.

Introspection, pastel, 22 x 16" (56 x 41cm)

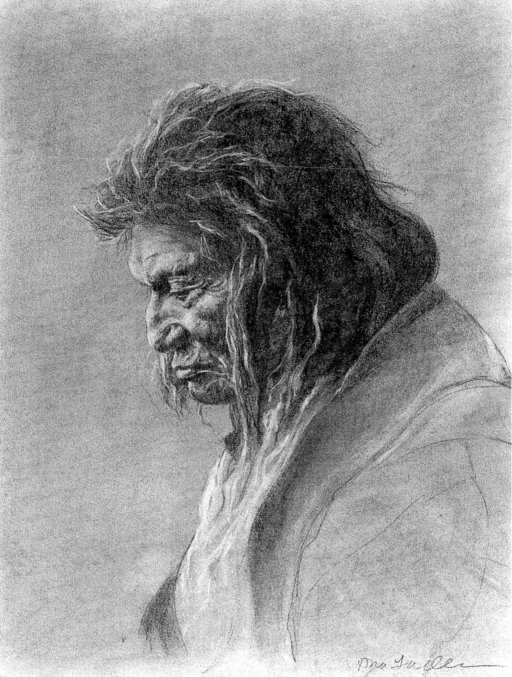

what I wanted to say

I wanted to capture the dignity of the displaced. The strength of his profile revealing his age, pride and sadness, juxtaposed with a touch of spiritual light, made this man look beautiful to me.

my design strategy

I am constantly observing poses, lines and contrasts — in real life, photos or while browsing through museums and galleries. When a composition strikes me, I will retain it and later set the model of choice into the pose that will help me express my feelings.

my working process

- Before working with the model, I prepared a ground on a heavyweight drawing paper. To do this, I overlapped layers of vine charcoal and sepia-colored pastel, rubbing each layer into the paper with a soft cloth. I repeated this process six times to create an ethereal atmosphere in the background.

- Later, I set up the model under artificial lighting. Although I planned to work from life, I first took photos to work from later as needed.

- I began by drawing with vine charcoal (it's easy to brush away mistakes), placing the elements and measuring and analyzing the accuracy of my work until I was satisfied.

- Next, I placed the dark tones with heavy charcoal and a black pastel, lightly at first and then becoming more dark, blending all the while with fingertips.

- I then began the process of "lifting" away the darks to create medium to lighter tones with a kneaded eraser. By squishing the eraser into any shape I wanted for the area I needed to lift, I had full control over my lights.

- I continued to work back and forth between the lights and darks until I had achieved the contrast needed to convey the polarity of emotions.

try these tactics yourself

- Study the master classical and impressionist artists to see what makes a drawing create an emotional response within you.

- Draw from life as often as you can, any time, anywhere. Draw your hands or feet if no model is available.

- Warm up your drawing skills by giving yourself 15-second challenges to grab the obvious movement in a gesture drawing.

what the artist used

support
Heavyweight, white drawing paper with a fine tooth

other materials
Vine charcoal

Sepia pastel

Blackest heavyweight charcoal

Soft cloth

Kneadable eraser

Anna J Farawell lives in Honolulu, Hawaii, USA → www.annafg.com

Anna J Farawell

ARTIST
69

My image contained three competing focal points, which I resolved through value and color.

Brass Taps, pastel, 16 x 21" (41 x 54cm)

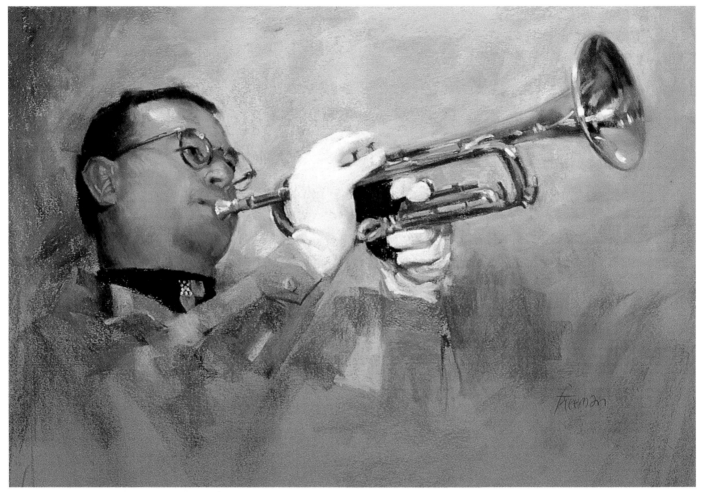

my inspiration

This is essentially a portrait of a family friend who was practising his routine while in his national guard unit. I liked the interplay between the gloved hands and the horn — a sort of symbiosis between man and a mechanical creation bringing forth a third element, sound.

about light and color

Since the reference photo was sent to me from afar, I was limited to the lighting and color found in it. I worked with the greenish cast of the light by choosing a greenish-gray surface and bringing umbers into the color scheme. However, I livened up the image with a few discords of red and violet and some blue highlights.

my design strategy

Since the composition and pose in the photo were suitable to work from, I turned my attention to resolving a focal point problem. I had three subjects — the head, the hands and the horn — competing equally for attention. I decided to push back the head by treating it with similar colors and values as the surrounding area. I also downplayed the busy camouflage uniform so it wouldn't detract from the focal point — the hands and horn, which I wanted to make fairly equal in importance. To do this, I simplified the horn and surrounded the bright white gloves with cool tones to connect the shapes.

my working process

- Using a version of the ground color, I started to lay out the drawing. I made light marks, using plumb lines, projection lines and angles of positive and negative shapes for accuracy. I lined up the horizontals of the glasses and the horn so they would read in proper perspective.
- When satisfied with the drawing, I began blocking in mid-tones of color, letting them spill over from the positive and negative areas. Next came the darks, then some lighter tones on top of the mediums (but not over darks — this causes yucky grays).
- I built up layers in the light and kept shadows thinner. Periodically, I blew off or brushed off the loose pigment because I like to avoid using fixative.
- When I thought it was done, I left it for a while, coming back to check it in a mirror and make final corrections.

a word on drawing

Unplanned color combinations and accidents can be interesting, but accuracy in perspective and proportion is essential. Small flaws in the details can pass if the major components are intact.

what the artist used

support
Sand-colored pastel drawing paper

materials
About 40 soft pastels, mostly umbers, earth reds, olive greens, pinks and violets

Bristle brushes for removing layers of pastel

A puffer for blowing off the dust

Soft cotton diapers for cleaning the pastel sticks

A wallpaper tray attached to the easel to catch falling sticks and dust

An air purifier

Brian Freeman lives in Tucson, Arizona, USA → bpfreeman@copper.net

I kept this complex concept well organized through the careful use of design, value control and color.

Juggler, oil, 40 x 30" (102 x 76cm)

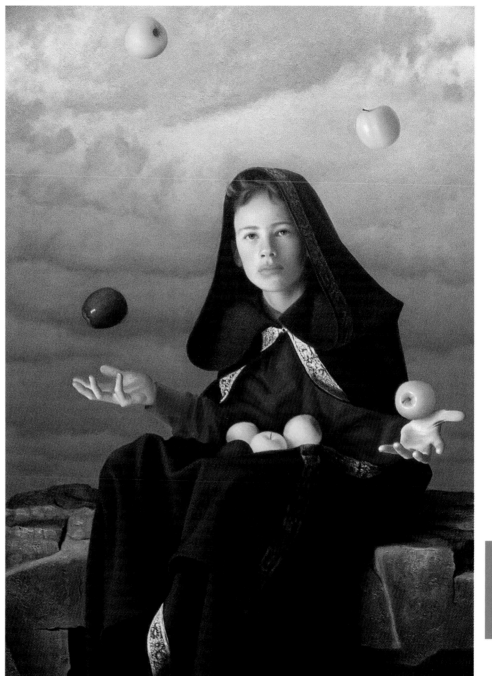

what I wanted to say

This image was conceived in my mind. I wanted to paint a young boy in a timeless attire, busy doing a difficult task. I wanted him to look resigned to his fate, calm. I wanted to create irony and contradiction. I also wished the work to resemble renaissance religious paintings in the overall feel.

my design strategy

Design is always important to me. For example, the colors of the apples were carefully considered. I kept the red ones close to the figure and placed the green ones higher in orbit. The value of the green apples is almost exactly the value of the sky. Therefore the green apples, very crisply painted, don't distract from the figure. A line drawn from each orbiting apple and the apple opposite it will intersect at the boy's face. Each hand is doing something very different. The folds of the cloak are not redundant. All of these aspects and more have to do with the overall composition process.

about the light

I lit this work from above and to the subject's right (viewer's left). This was done for several reasons. This is how da Vinci did many of his, and I wanted that feel. The light used is soft so I could paint both form and light.

my working process

- I drew out a full-size pencil cartoon, then altered placements and drawing until I was pleased. This allowed me to make many minor changes and adjustments before going to the canvas.

- I started by thinly placing in my darks. I really like the contrast of thin darks and thick lights.

- I established the figure early, and it was the first thing brought to near finish.

- I painted the sky four times, adjusting the color to enhance the skin tones and to minimize the presence of the green apples. The sky is very impasto, while the apples are very thin.

my advice to you

Even if a painting has a glowing sense of light, or is well drawn, or has a captivating subject, or great edges and color, all paintings have compositions. Design is the single, most important thing I keep to the fore in my mind as I work. With that, I know the other stuff will be fine.

Timothy C Tyler

ARTIST
71

what the artist used

support
Painting surface glued to a rigid panel

brushes
A wide range of bristles, sables and badger hair in rounds, filberts, flats, mops and fans; palette knife

oil colors
Cadmium Yellow Light
Yellow Ochre Light
Mars Orange
Cadmium Red
Alizarin Crimson
Raw Sienna

Olive Green
Green Umber
Ultramarine Blue
Transparent Brown
Ivory Black

Timothy C Tyler lives in Siloam Springs, Arkansas, USA → www.timothyctyler.com

I achieved both motion and emotion by using a range of colors and temperatures in my freeze-frames.

Listen, oil, 28 x 28" (71 x 71cm)

C J Weber

**ARTIST
72**

what I wanted to say

Whether it is dance, music, theater, or even mime, my "freeze frame" portraiture style lends itself well to capturing the dynamics and emotion of performance art. My objective in "Listen" was to speak in paint the way a mime speaks in gesture.

my design strategy

In this quad piece, I wanted to establish a general balance throughout, without losing the movement within. Joy and Surprise bracket Anger and Anguish. Line and color rule the day with the line work of the mime's exaggerated hand gestures bringing flow and movement to the work. This is not a sedentary work, but a human hyperbole. The exaggerated colors needed to be as strong, emotional and immediate as the performance of the mime.

a digital design process

- After researching in reference and anatomy books, I shot tons of photos while a friend posed for me.

- Pencil roughs were the next step, where I combined numerous individual photos to arrive at these four images.

- Next, I scanned the roughs into my computer and skewed, rotated and flipped until I found a satisfying composition that had the requisite energy I was looking for.

- Still working digitally, I experimented to find a stimulating balance of value and color that would not detract from the line flow. Working with the computer allowed me to easily test various hues, saturations, chromas, color balances and levels. My monitor has been so carefully calibrated that it can tell me the color make-up of every area in my digital image.

my working process

- After re-drawing the image on a rough-sanded hardwood panel, I draw over the primary lines with a black waterproof marker and primed with a watered-down, blue-violet mixture of acrylic paint and gesso.

- I painted predominantly with small synthetic soft filberts, using larger brushes as I pulled out from the detail.

- As an impressionist, I painted "around" the true colors I wanted to be seen from a distance. For instance, instead of painting a pre-mixed flesh color, I applied strokes of the various colors that would make up the flesh color. Also, instead of lightening with white or darkening with black, I adjusted value with a "sister" color or side-by-side strokes of color.

- I spent the same amount of time on the research stage and the digital design stage as I did on rendering the painting.

what the artist used

support
Rough-sanded hardwood panel, toned with a mix of acrylic paint and gesso

brushes
Synthetic soft filberts, starting with a #2 or 4

colors
Approximately 45 tube colors, but no blacks, browns, sepias or umbers

C J Weber lives in Waukesha, Wisconsin, USA → weberportraits.com

I minimized the detail to keep the focus on the mood.

On Call, oil, 54 x 75" (137 x 191cm)

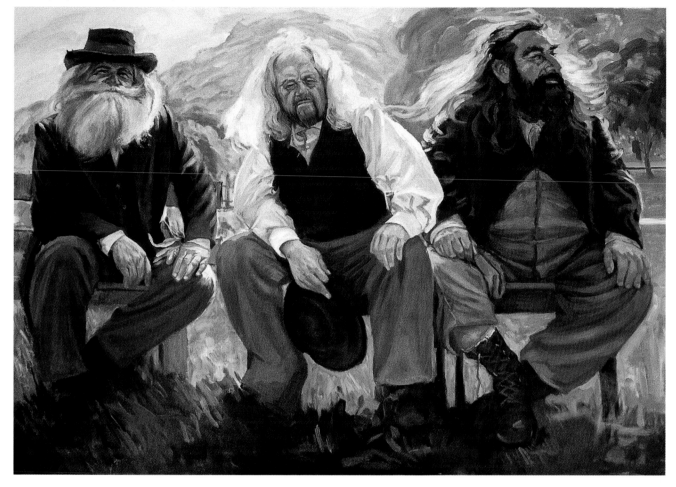

my inspiration

I was on location for a western television series when I happened upon these three actors awaiting their shooting turn. As I walked by, I came to a screeching halt. The composition seemed perfect — three totally different, beautiful characters, backlit, in costume but all expressing boredom by their particular body language. I just couldn't pass up this trio in a ready-made pose for this lucky painter.

my design strategy

My one contribution to the composition was to ask the person on the right to look out of the picture, which improved the entire tenor of the composition. It gives the painting a certain whimsy and makes you wonder what piqued the subject's interest while the other two were so static.

my working process

• Since actors love to be photographed, I was encouraged to take many pictures. I took several photographs of each individual for local color, as well as the three of them sitting together. I also made several notes pertaining to the general color and special characteristics of each individual.

• Since I couldn't improve on the composition, I started right in on the painting, roughly drawing the figures on a large canvas with vine charcoal.

• To lay in the darks, I used a #12 filbert brush and a thin, nearly black mixture of Turpenoid, Phthalo Blue and Cadmium Red Light.

• I then finished blocking in the painting with the appropriate colors from my notes and the photographs. Cool temperatures unified the two left figures with the background, and contrasted the warm attire of the figure on

the right, adding to his mystique. I had to keep reminding myself to stay loose and general.

• When I did reach the finishing stage, I found I did not need as much detail as I had thought, especially in the faces. The bulk of their bodies demanded an exceptional amount of attention — excessive facial features would have competed with that. As I added the final details, I took

great care with every brush stroke so as not to break up the painting's big shapes.

please notice

By avoiding too much detail, I was able to keep the focus on the mood and light effects of the scene. As Sergei Bongart, my first art instructor, said, "In painting one must convey mood, not story. You don't paint an apple; you paint its essence".

what the artist used

brushes
Nos. 20, 12, 10, 8 and 6 filberts; 2" house painting brush

medium
Poppy seed oil
Turpenoid for cleaning

oil colors

Zinc Yellow Pale	Terra Rosa	Cerulean Blue
Cadmium Yellow Medium	Alizarin Crimson	Ultramarine Blue
Cadmium Yellow Deep	Burnt Sienna	Cobalt Blue
Yellow Ochre	Burnt Umber	Black
Cadmium Orange	Phthalo Green	White
Cadmium Red Light	Viridian	
Grumbacher Red	Phthalo Blue	

Joseph M Yuhasz lives in Malibu, California, USA → jmy1art@aol.com

The rich, luminous color scheme and poetic pose create a classic look.

Amber Breeze, oil, 30 x 24" (76 x 61cm)

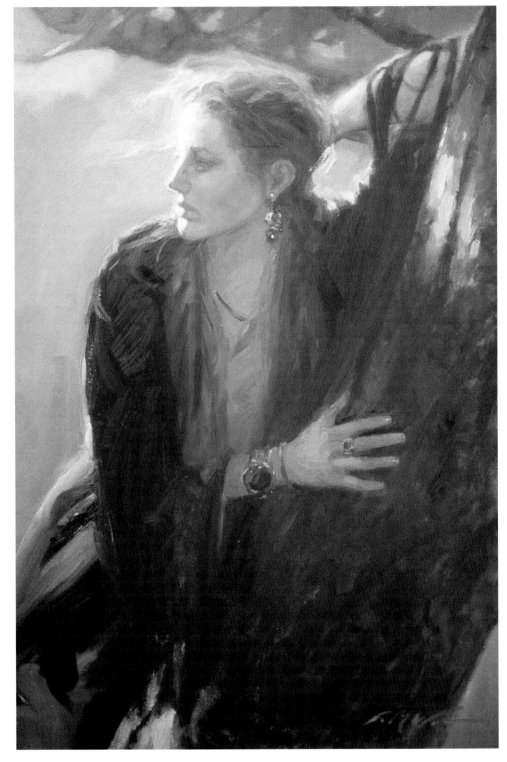

Michael Wood

ARTIST
74

my inspiration

My model, Elise Hunt, is an actress reminiscent of the heroines depicted by Pre-Raphaelite artist John W Waterhouse. She projects a classic myth and legend persona, which inspired my imagination to create something like the semi-allegorical works I am fond of. It suggests a story beyond the present here and now.

my design strategy

This painting is the result of working with the model along the nearby ocean cliffs of Half Moon Bay, a favorite setting of mine. The pose she assumed against the twisted cypress tree was poetic. I condensed the view to eliminate the sea and create a more intimate profile with uncertain origins. The composition is simply an "X", which always serves to create a dynamic tension around the focal point. Notice how the wind and light in her hair tease the eye away.

my working process

- I toned the canvas initially with a wash of Yellow Ochre.

- While still wet, I began to establish the basic shapes and values with a large flat brush, using Burnt Sienna and Ultramarine Blue. Greenish hues emerged from this mix to form a nice balance in the underpainting, which at this point was quite abstract.

- Over these abstract forms, I began to impose heavier layers, developing the shapes, light and shadow. I painted the lightest areas heavily and intensely, then refined and defined them with deeper tones. I used a full spectrum of colors, not just earth colors, to enrich her skin tones.

- Throughout this process, I refined the image while always trying to refrain from obliterating the sparkle of the underpainting, which — if not extinguished — will glow like embers beneath the surface.

HOT TIP!

Don't try to create a photo. Keep the paint and brushwork lively and fresh or the results will look as stiff as the technique.

what the artist used

support
Canvas

brushes
Synthetic flat brushes,
Nos. 2-12; liner No. 4.

oil colors

Azo Yellow	Napthol Red	Phthalo Green
Cadmium Yellow	Quinacridone Red	Phthalo Blue
Yellow Ochre	Burnt Sienna	Ultramarine Violet
Mondazo Orange	Burnt Umber	Titanium White

Michael Wood lives in San Mateo, California, USA → fmwood@msn.com

Shadow shapes bring rhythm and movement to this figure painting.

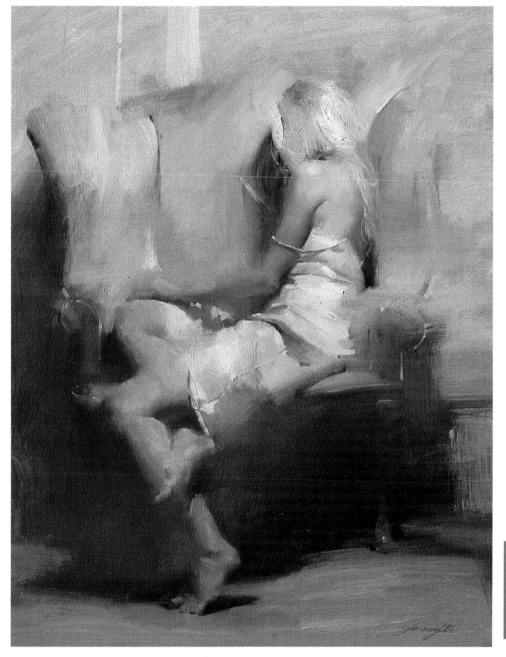

Quiet Moment, oil, 20 x 16" (51 x 41cm)

my inspiration

To express the graceful rhythm of the female figure in a sentimental atmosphere, it seemed right to emphasize the shadows. The shadow shapes were dancing across the composition.

my design strategy

In the upper portion of the painting, high-key shadow shapes describe a rhythm along the figure's torso. The legs then provide a light shape that breaks into the large, low-key shadow shape in the lower portion of the painting. Together, the dark and light shapes unite to create a flowing movement from the top to the bottom of the painting.

Notice also that there are large, empty areas with loose edges that contrast against the detailed parts of hair, shoulder, dress and legs. This creates a sophisticated design with a "lost and found" atmosphere in the painting.

my working process

- To begin, I used Burnt Umber mixed with only turpentine to help the paint dry fast. I kept the line drawing rather simple.

- With thin, quickly applied washes of my Burnt Umber/turpentine mix, I established two values in the painting — light and dark. This was just to unify the big shapes of the painting, not to define the objects.

- Once I had the values well established, I continued the quick block-in with more color and heavier paint (pigment mixed with a 50-50 combination of turpentine and linseed oil). I worked very spontaneously, relying on my intuition and sensitive feelings.

- To finish the painting, I had to become more logical and controlled. I began to think about the edges and to consider the form in terms of the structure and drawing. I used a fan brush to blend and soften some of the transitions within the figure to make it turn in space and to help the viewer's eye move over the figure more quickly.

- As I suggested detail and added interest near the focal point, I used different paint applications to provide some textural contrast against the generally smooth, simplified passages I had put in up until then.

- Finally, I revisited my initial idea for the painting. I stopped to evaluate how well I was achieving that and what I could do to improve it.

what the artist used

support
Canvas

brushes
House painting brush; fan brush

medium
50-50 combination of turpentine and linseed oil

oil colors
Cadmium Yellow
Cadmium Orange
Cadmium Red
Carmine Red
Terra Rosa
Permanent Alizarin Crimson
Burnt Sienna

Burnt Umber
Permanent Green
Phthalo Green
Cobalt Blue
Ultramarine Blue
Phthalo Blue
Magenta

Zhaoming Wu

ARTIST 75

Zhaoming Wu lives in Piedmont, California, USA → zhaomingw@hotmail.com

I built my color scheme around the passionate color of red.

Zingara Rosa, oil, 38 x 24" (97 x 61cm)

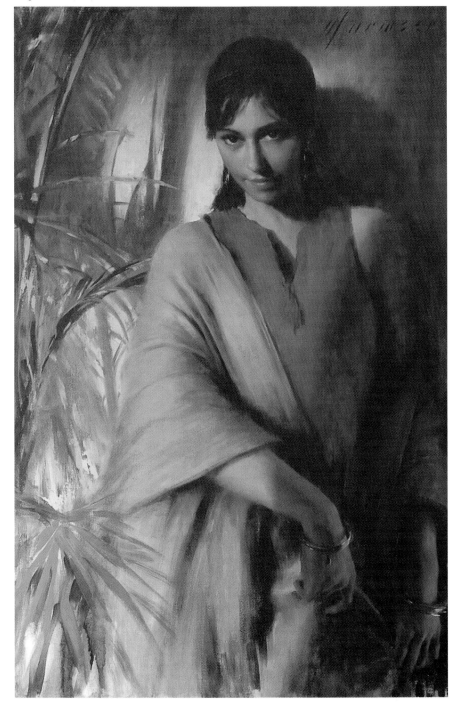

my inspiration

Though it appears at first sight to be a romantic image, there is more to this painting. The seductive nature of Felicia's expression is what really drew me and inspired the work. Whether real or imagined, validated or not, I wanted to convey the synergistic energy between me and the model.

follow my eye-path

I used very strategic tonal and linear arrangements to maintain a circular flow that takes you from the head, down her left side, across her right arm and to the palm fronds, which lead you back towards the face. Her seductive eyes should pull you right in, and everything else should keep you coming back to her face.

about color

The intensity of the bright red blouse adds a psychological element of passion and intensity to Felicia's gaze that would not exist otherwise. You'll also notice that the placement of this intense red is strategic, as it is surrounded by linear and tonal arrangements that lead you to the center of interest. The greens are very muted by comparison, naturally accentuating the pure color of the red blouse.

try these tactics yourself

- Before I ever lay paint to canvas, I completely think through where I am headed. I have a feel for the value range, the color system and the extremes in shape, value, edge and color. These bits of information put me on the right track.

- My technical approach to this painting was extremely traditional. I worked lean to fat, and built the painting up with a series of layers over a period of time. Some passages remain loosely indicated and rather transparent, contrasted by strategically placed opaque passages of paint. I usually do this to enhance the relief and appearance of detail.

- I also try to implement a number of techniques with paint application, such as manipulating paint with a palette knife, to create a variety of textures. However, I try to subordinate the techniques, leaving no residue of technical mannerisms to stand between my expression and the observer.

HOT TIP!

The best paintings, in my opinion, reveal not only the objective qualities of the subject depicted, but even more so, the subjective nature of the artist. It may be egoistic, but this egoism is necessary to saying anything substantial, so embrace it.

Ryan Wurmser

ARTIST
76

what the artist used

brushes
Bristle flats and filberts Nos. 2 to 20; softer badger-hair flats, filberts and rounds Nos. 2 to 20; palette knives

support
Portrait grade, double oil-primed linen

oil colors
Cadmium Yellow
Yellow Ochre
Cadmium Orange
Terra Rosa
Transparent Oxide Red
Cadmium Red

Alizarin Crimson
Viridian
Ultramarine Blue
Cobalt Blue
Titanium White

Ryan Wurmser lives in Westlake Village, California, USA → www.ryanwurmser.com

I wanted to emphasize the contrast between human form and static shapes.

Cora, oil, 22 x 30" (56 x 76cm)

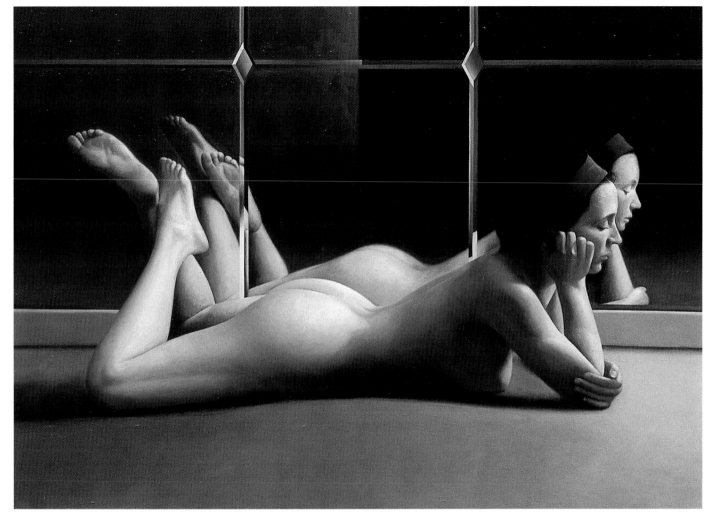

my inspiration

Willem de Kooning's painting "Pink Lady" has always haunted my mind. I am especially interested in the chaotic relationship between the human figure line and the straight line of the door and the window found in this painting. Because of this, I wanted to paint something that showed a relationship between an organic human figure line and a primary form with sharp edges (the glass wall).

about light

In my set-up, the light came from the upper right side, lighting up the face and hip area and making shadows on the upper body, shoulder and hands. Painting this flow of light and shadow was interesting.

my working process

- I coated my plywood board with about 20 coats of gesso, sanding between each coat to make it smooth.

- I used regular oil paint and brushes, starting with very thin oil paint and getting increasingly thicker and thicker during my painting process.

what the artist used

support
¾" plywood, with about 20 coats of gesso, sanded

brushes
Bristle flats and sable rounds

oil colors

medium
Spike lavender oil, Maroger medium

Kenju Urakubo lives in Jackson Heights, New York, USA → www.urakubo.com

I spent time setting up the perfect pose.

Hair, oil, 28 x 22" (71 x 56cm)

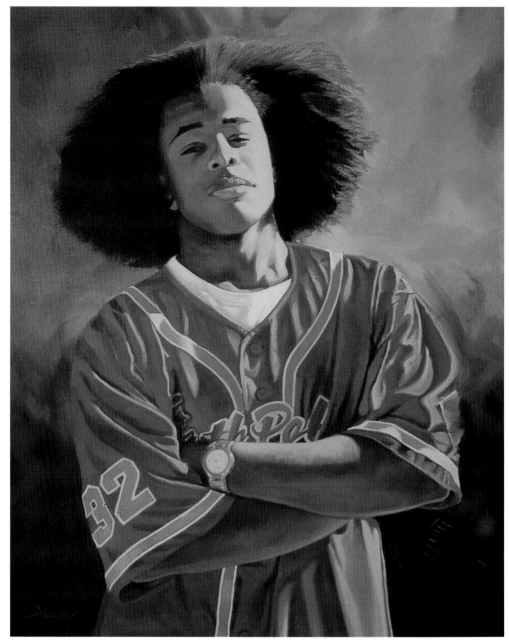

what I wanted to say

In many societies, hair has always been a symbol of confidence and pride. How we wear our hair has a lot to do with how we view ourselves. In "Hair", I was inspired by the amount of hair worn by my son. I was moved to capture the beauty and innocence of youth and to portray a sense of strength and pride.

my design strategy

Giving prominence to the portrait depended on several factors, mainly setting up just the right pose. I felt the folded arms and slightly tilted back head created a more interesting subject, lending strength to the pose. The red baseball jersey complimented the subject's dark skin tones, while the white collar created a nice frame for the head. The subtle addition of the comb helped to complete the overall attitude of the figure.

my working process

- First, I created a quick pencil sketch to familiarize myself with the subject. I then made a quick color sketch to work out the values, lighting, background and overall mood.
- On the canvas, a few gesture strokes established proportions and composition. Using very thin paint, I then laid in a tone over the entire surface.
- Mixing large quantities of a variety of color-values, predominantly warm darks and medium tones, I started the painting. I focused on creating large, abstract shapes in the background, obscuring any detail.
- Continuing with warm reds and red-oranges, I refined the jersey's edges, folds and details. I also put in the comb and watch.
- I then moved to the hair, still using warm darks but adding some cooler violet for the shadows and Cadmium Orange mixes for the highlights.
- Finally, I turned to the skin tones of the subject, mixing a variety of skin tone colors from Burnt Sienna, Burnt Umber and Cadmium Orange. I paid close attention to the light source affecting the forms, and spent a great deal of time focusing on the details of the face and head.
- Once the painting was complete, I set it out of sight for a few days before a final review and some necessary changes.

my advice to you

Take some time to study your subject beforehand, then pick something of interest to include in your representation. Conveying a message above and beyond the likeness of the subject is a challenge, but the end results are worth all the effort.

what the artist used

support
Cotton canvas with smooth gesso primer

brushes
Flats Nos. 6, 8, 9; rounds Nos. 2, 3

medium
Equal parts linseed oil, varnish and turpentine

oil colors

Dennis E Lewis

ARTIST 78

Dennis E Lewis lives in Clovis, California, USA → www.dlewisart.com

Try my simple, technology-based method for working up a thorough preliminary drawing.

A Dream of Castles, transparent watercolor, 16½ x 14½" (42 x 37cm)

my inspiration

The back of the chair seemed to symbolize the boundaries of reality in this bittersweet image. The well-read Emili wears practical sandals and socks, but from her headdress, we can see she is also a princess far, far away.

my design strategy

A soft breeze blew the plastic, multi-colored streamers in a sunlight that was almost spiritual. Happily, a camera was close by. When I snapped the picture, I had a good feeling. The repetition of the table structure with the position of the arms and foot gave the design movement. Adding the shadow in the right foreground stabilized the design and softened the contrast to lead your eye into the painting. A selective focus, as well as subtle adjustments in value and texture, were also crucial in the final image.

try these tactics yourself

- First, I had the reference photo greatly enlarged. After sealing the surface with a coat of clear acrylic, I used acrylic paints to adjust the design.

- When satisfied with my composition, I used a photocopier to enlarge it to the desired size of the painting. Of course, this meant dividing it up over several sheets of paper, but I simply taped them together.

- I then applied graphite to the back of the assembled enlargement, which I smoothed with a touch of rubber cement thinner applied with a tissue.

- After taping the blow-up to a traditionally stretched 140lb sheet of watercolor paper, I used a 6H pencil to lightly transfer the image.

my working process

- Using masking fluid, I masked off the railing and the edge of the figure. I then used a wet-in-wet approach to bring the background to about 80 percent completion.

- After lifting off the first mask and re-applying some masking fluid as needed, I completed the railing, wall and porch, repeating colors for harmony. To establish a dark point of reference, I painted the table area in a direct, deliberate manner.

- Having established a warm light, I then used warm tones for her sunlit skin and cooler tones for the shadows.

- Up to this point, I had kept everything very soft. Now, as I completed the head, hair, flowered headdress and white garment, I started each area wet-in-wet but completed them with drybrushing to create crisper, more deliberate edges.

- Finally, I refined and tied together the whole painting by utilizing glazes of all colors.

what the artist used

support
140lb hot-pressed watercolor paper

brushes
Red sable #20; synthetic blends #6, 4, 2, 1, 0, 00

other materials
Masking fluid
Craft knife
Drawing pencils

watercolors
Aureolin
Winsor Yellow
Cadmium Orange
Rose Madder
Winsor Red
Burnt Sienna
Winsor Green
Cerulean Blue
Winsor Blue (red shade)
Winsor Blue (green shade)
Cobalt Blue
Thioindigo Violet
Winsor Violet
Sepia
Paynes Gray

David Neil Mack lives in Toledo, Ohio, USA → www.davidnmack.com

Instead of blending I poured on my pigments to get a fresh look.

Southwest Jockey, acrylic, 16 x 30" (41 x 76cm)

Larry Smitherman

what I wanted to say

This is number three in a trilogy of jockey paintings. The first two paintings portrayed the figure up close in a portrait-type pose. In this, the third painting, I chose to present the figure in a landscape setting.

my design strategy

My original sketch included the complete figure standing with Southwestern flowers and cactus in front of a training track. The foreground seemed too busy, so I eliminated the plants and flowers but kept the fields and trees so that the jockey could dominate the scene.

my working process

- Initially, I shot approximately 200 photos of the model. Some were close-up shots of details or certain props, as well as the scenic views around the model. From this, I found enough material for several paintings. This is just one of many compositions I developed.
- I began by creating a detailed pencil drawing on heavy watercolor paper.
- I then blocked in the color areas and established the light source. I mixed my paints with acrylic medium to keep the layers thin at this stage.
- Then, laying the painting flat, I poured the acrylic very heavily on clothing and some of the foreground. I added definition and shape by manipulating the paint with a variety of tools while it was still wet.
- Once the paint was dry, I used fine brushes and pure acrylic paint to add detail.

HOT TIP!

I find that heavy 300lb watercolor paper works better for my pouring technique than canvas. On canvas, the acrylic tends to flatten out in the heavier areas, whereas on watercolor paper, the pigment retains the look I desire.

what the artist used

support
300lb cold-pressed watercolor paper

brushes
An assortment of brushes; other tools, such as wooden skewers and flat sticks

medium
Acrylic medium

acrylic colors

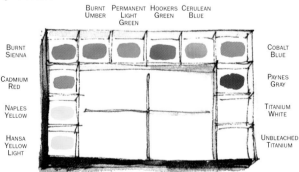

Larry Smitherman lives in Austin, Texas, USA → larry@larrysmitherman.com

I grouped my figures together and balanced them with a wide expanse of open space.

Training Day, pastel, 55 x 75" (140 x 191cm)

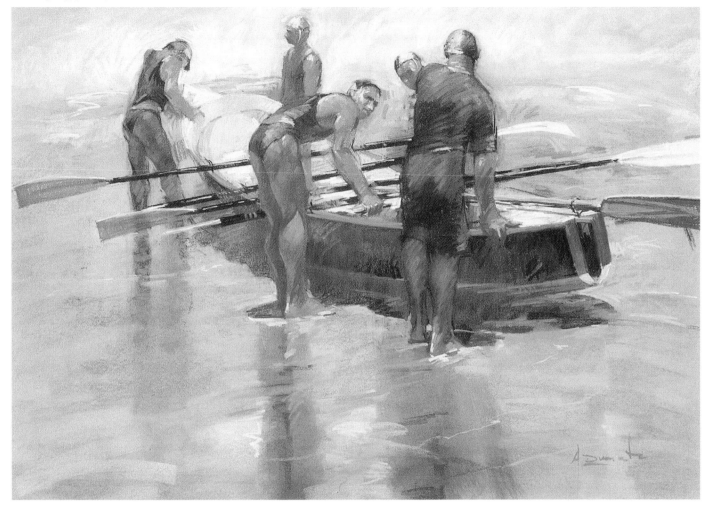

my inspiration

On Australia's Gold Coast, we're known for our insatiable appetite for the ocean and sport. The strength, harmony and athleticism of the crew and boat carving through the waves created a beautiful and uniquely Australian sight. I was particularly impressed with this crew's pragmatic approach to their training drill. It made me ponder whether I was witnessing a board room meeting — Gold Coast style!

my design strategy

One of the most challenging aspects of successfully painting figures in a group is to create a sense of the people being present in their surroundings. If this is not conveyed, the painting becomes just a picture of a bunch of figures without warmth or mystery. Thus, a cohesive, balanced design was vital to capturing and holding my viewers' attention. The placement of the crew and boat towards the top corner unifies them, while allowing me the opportunity to incorporate more color and movement in the wide stretch of wet, reflective sand.

my working process

- Using a combination of site sketches and photos, I loosely drew in the elements, very lightly in conté so they could be corrected, rubbed off or changed.

- Once satisfied with the sketch, I used hard pastels to place the darkest and lightest colors where I thought they belonged. This gave me the overall look of the painting.

- Using soft tissue paper, I blended the pastels by pulling and dragging the pigment until the drawing looked like a diffused, soft-focus photo. I then drew a more defined and permanent outline, yet with more movement. Still using hard pastels, I re-blocked in the shapes with clean, pure color.

- After giving the paper a good shake and a light spray of fixative, I was ready to render detail, contours and sharper edges with soft pastel. I overlaid pigment to create an opaque feel. I "lost" most of the edges by blending lightly with my finger to suggest the ambience of surf spray.

- Finally, to avoid fixative, I gave the painting a good whack on the back to shake the dust off, and pressed in what was left with a palette knife.

HOT TIP!

Be aware of uninformed criticism. You know when your work is not what it could be, and you know when it is good. If you have a passion that makes you happy, it will do the same for other people.

what the artist used

support
Mid-tint gray full size sheet of pastel paper

other materials
Conté sticks in black and sepia

Hard and semi-soft pastels

Stiff brush to remove excess pigment

Tony Duarte

ARTIST 81

Tony Duarte lives in Main Beach Surfers, Queensland, Australia → www.aduarte.com.au

Lighting the subject from below added even more drama to my daughter's surprising, unique costume.

Rebel, pastel, 47 x 34" (120 x 86cm)

my inspiration

This is a portrait of my daughter Meg. At the time, she was acting in a community-devised production whose theme was "wool", and they were required to make their own costumes out of raw wool. Her character was called "the Rebel", so she chose colors that reflected this (and I might add her own personality!). She dyed it, spun it, twisted it, added many beads and, many months later, ended up with this incredible creation! Seeing her was enough to instantly make me want to paint her portrait.

my design strategy

Relying on an interesting head piece and a pretty face was not enough for the kind of dramatic portrait I had in mind. Getting her position and especially the lighting just right was crucial. I blacked out my studio as completely as possible, and used a spotlight with its height lowered and angled up to create unusual up-lighting and high-contrast tonal variations. In this way, I create a moody piece that reflects the character of the model.

my working process

- I did several pencil studies to establish the main values, and then drew the composition onto white drawing paper.

- When satisfied, I transferred this to the black pastel paper with a cream pencil.

- I began with the face, working a section at a time, always finishing before moving onto the next section, like assembling a jigsaw puzzle. Although I worked from photos, the model was always available for me to check on any color or anatomical queries.

- I worked out from there, section by section, letting the black paper function as the background. I lost a lot of the edges to create the illusion of a tightly focused light source on the focal point.

- No fixative was used.

something you could try

This was actually the second painting done of the Rebel. The first answered many color problems but I was not happy with the composition and I decided to start over. I guess you could call the first painting my color study!

what the artist used

support

Black pastel paper

Soft pastels in various tones

Catherine Lidden

ARTIST 82

Catherine Lidden lives in Braidwood, New South Wales, Australia → cjlidden@yahoo.com.au

I enhanced this unusual nude-within-a-nude subject by exaggerating the contrast between the two figures.

Nude Portrait of Echo with Mirror, oil, 36 x 36" (92 x 92cm)

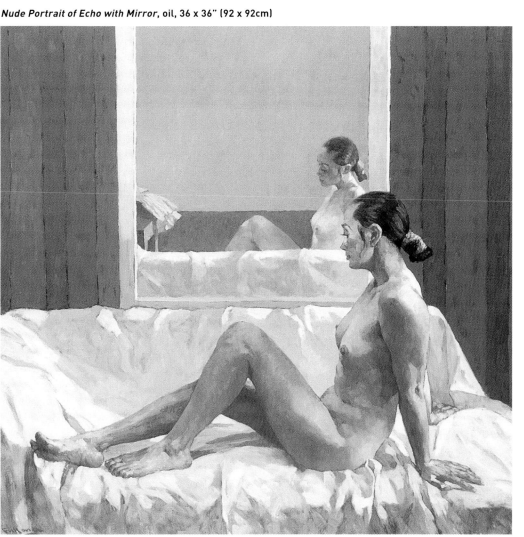

my inspiration

I chose my girlfriend Echo as my model, just because of her slender figure and smooth skin. She is much more wonderful than the models I have used before. I think this painting is quite different from the nude paintings I have done in the past.

my design strategy

Perhaps the most unusual aspect of the painting is the two nudes — one actual, one illusive. The mirror falls in the middle of the painting, catching the viewers' eyes, although the center of interest is clearly the head and shoulders of the "real" figure. This is because the warm tones of this figure are surrounded by contrasting cool tones in the white sheet as well as the cool, gray tones of the reflected figure and the mirror itself. The square format adds interest to the painting.

my working process

- On a hard wood panel primed with gesso on it, I sketched in my subject.

- Using mostly warm colors thinned with turpentine, I did an underpainting. No matter how many layers of paint cover this, it will make the whole painting look harmonious.

- To make the skin transparent, fresh and lively, I exaggerated the warmth of the colors as I blocked in the dark areas of the nude. By contrast, I blocked in the light areas with bright, cold colors, thereby showing the skin's smooth texture and resiliency. When blocking in the nude in the mirror, I reduced the pure colors and used grayed-down neutrals to strengthen the contrast and depth.

- As I applied more layers and defined the forms, I used my brushes loosely to make interesting textures. I also looked for ways to make the figure stand out, such as the streaks in the background.

- Showing the relationship between the nude and the reflected figure was the biggest challenge. They were quite different, so I needed to exaggerate the contrast between them.

my advice to you

- Challenge yourself by setting up harder and harder subjects.

- Keep your paintings fresh by using your brushes decisively and avoiding re-touching strokes.

- Don't use flesh color when you paint nudes. Fragment the colors, changing from warms to cools as you move across the skin.

- Allow your main subject to stand out, yet keep it completely under control and in harmony with the rest of the composition.

what the artist used

support
Hardboard panel primed with gesso

brushes
Oil brushes #4, 8, 12

medium
Turpentine

oil colors
Lemon Yellow Hue
Cadmium Yellow Hue
Cadmium Orange Hue
Light Red
Naples Yellow Reddish
Cadmium Red
Spectrum Red

Spectrum Crimson
Emerald Green
Viridian Hue
Cerulean Blue Hue
Ivory Black
Titanium White

Fu Hong

ARTIST
83

Fu Hong lives in Doncaster, Victoria, Australia → echo65@optusnet.com.au

Because of its design and color, this figure painting echoes classical figure paintings of the past.

Third Trimester, oil, 55 x 78" (140 x 198cm)

Steve Lopes

ARTIST
84

my inspiration

When I started painting this picture, my wife was in her third trimester of pregnancy. I wanted to document this important phase in our lives, and to create a modern figure painting that had some connection to classic poses of the past. The painting is set on the inspiring south coast of Australia — an area that my wife and I have a close connection to. In the bottom of the painting lies a prehistoric fossil, which alludes to the timeless and magical qualities of the area.

follow my eye-path

Because the three figures were seated and placed centrally, it was important that the movement in the picture be carried through the background. The diagonals created by the clouds and the triangular forms in the arms help move the eye through the picture plain. I used the negative spaces under the knees to create a balance and harmony and give weight to the design. The figure on the right looking back into the picture keeps the viewer circulating back into the image.

my working process

- Working from the model, I carefully completed an acrylic tonal sketch on my well-primed canvas. I used black and white on an orange background to warm the painting.

- I then painted in much of the painting in broad and heightened tones of color, usually the complete opposite of the final colors. In the end, this neutralizes the tones while keeping the colors fresh.

- I then began to refine the shadows and completed all of the mid-tones. I followed this up by defining the dark areas and toning down the overtly colorful areas. I ground my colors myself to get a more buttery consistency to the paint, which allows for chunkier brush strokes. In some areas, I used a painting knife or sandpaper to scrape into the paint for more texture.

- I then concentrated on warm glazes, first using a thin mixture of oil, Venice turpentine and rectified turpentine and gradually working up to thicker, oilier finishes.

- Finally, I painted in the opaque highlights. I delineated certain edges and softened other areas to create interesting focal points and tension.

HOT TIP!

Try to add something new to the dialogue between artist and sitter. For example, avoid conventional poses or images, use unexpected colors and place the figures in interesting situations or locations.

what the artist used

support
Canvas, sized and gessoed with 10 coats so the colors won't "sink" into the support

brushes
Hog hair brushes; palette knives; sandpaper

medium
Oil, Venice turpentine and rectified turpentine

oil colors, ground and mixed by hand

Naples Yellow Light	Indian Red	Prussian Blue
Cadmium Yellow	Burnt Umber	Cerulean Blue
Transparent Gold Ochre	Sap Green	Paynes Gray
		Ivory Black

Steve Lopes lives in Kogarah Bay, New South Wales, Australia → fourbits@ozemail.com.au

I used sunlight, color and body language to project a feeling of a happy occasion and a caring relationship.

The Day of the Catch, oil, 18 x 22" (46 x 56cm)

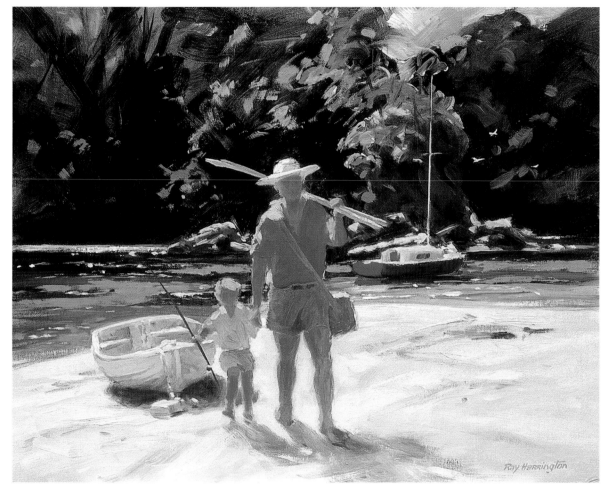

what I wanted to say

What I wanted to portray is the particular atmosphere of beach recreation so typical of the Australian way of life. Here you see the proud return of father and son from their first successful fishing trip. Dad is doing the heavy work with oars and creel while the son insists on carrying his very own precious rod. As Ratty said, "There is nothing — absolutely nothing — half so much worth doing as simply messing about in boats".

about the light

In this painting, the sun is coming from almost directly behind the figures, casting their shadows toward the viewer, which gives the feeling that they are moving forward toward someone (mum?). The viewer's eye is drawn directly to the figures by their shadows. Notice how the deep tones of the background and shadows allow the light areas, rim lights and highlights to glow. That value contrast also allows the faces to remain almost featureless without looking odd.

follow my eye-path

The design runs in a reverse "S" from the foliage highlights to the yacht, the figures, the dinghy, then to the shadows. These closely connected shapes keep the composition compact and balanced. The boats counterbalance each other and, by their relationship in size, give a sense of distance. Of course, they also lend essential atmosphere to the scene.

my working process

• This painting was completed entirely in the studio, using one of my own photographs as reference. However, the scene needed figures so I used my son and grandson as models.

• Over a thin wash of color, I sketched in the rough position of the figures and boats with paint, and then blocked in the deep shadows with a mixture of dark color.

• Once I was satisfied with the composition, I used thicker paint to build up the images, starting with dark colors first and laying progressively lighter colors and tones until the painting developed dimension and body. I repeated colors for harmony. I kept my brushstrokes to a minimum to engage the viewer's imagination.

• I finished with fine highlights — the glints on the water and the seagulls (the easiest part). The shape and size of these brush strokes were meant to create a more exciting and spontaneous effect.

HOT TIP!

Disposable paper palettes make life easier when cleaning up. One sheet per painting is all you need.

what the artist used

support
Stretched canvas

brushes
Flat bristle brushes, Nos. 12 down to 2

medium
Liquin for faster drying time

oil colors

Lemon Yellow	Burnt Sienna
Winsor Yellow	Phthalo Green
Indian Yellow	Prussian Green
Cadmium Scarlet	Cerulean Blue
Permanent Rose	Cobalt Blue
Permanent Alizarin Crimson	Ultramarine Blue
	Titanium White

Ray Harrington lives in Mount Irvine, New South Wales, Australia → raykat@lisp.com.au

Ray Harrington

ARTIST
85

The sitter's body shape is central to the painting.

Erin Eckman, acrylic, 35 x 28" (89 x 71cm)

what I wanted to say

Erin is an abstract artist and a friend of mine. I wanted to paint her in a way that captured her "statuesque" quality — she always looks so graceful. On the other hand, she's quite an "edgy" person, so I didn't want it to feel too finished and too safe. I think I captured something of her, and she thought so, too.

my design strategy

Erin's body shape is central to the painting — the long legs crumpled at angles, the vertical head, the defined arm. I wanted it to feel almost awkward, because otherwise it might look too pretty and your eye would just skim over it. So there's a pattern of angled shapes and then a large abstract area to frame it. I like to bring out certain features very realistically while allowing other areas to stay sketchy. In this case, the realism starts in her face and spills down the right-hand side of her body.

my working process

- I sketched the figure and shadows in dark, neutral browns.

- I then washed over the sketch in warmer colors, using a large decorating brush. Lots of reds and yellows brought the sketch to life and provided all the colors for the background.

- I then "roughed up" the texture of the paint right across the painting, including rubbing alcohol on it, scraping it with a dish scrubber and so on, to make the surface feel more dynamic.

- Finally, I started bringing out areas that I wanted to make more realistic by using glazes and fine brushes.

- With this kind of painting where I'm leaving some areas undefined, the hardest thing is to stop. There's such a temptation to keep working into the picture, and I always wish I'd stopped 10 minutes before I did.

please notice

It struck me recently that the things I find most visually magical are always in a state of transition — mist, smoke, sunset, atmospheric haze — things that cannot clearly be defined as one thing or the other, but are merging between the two. I heard an Irish woman say that in the past people believed that magic happened when things were in a state of transition — equinoxes, adolescence — and I think the same can be true of art. I most like the parts of this painting that are neither abstract nor realistic, but are in an undefined state of transition.

what the artist used

support
Canvas

brushes
Variety of sizes

acrylic colors

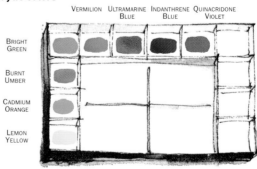

Fletcher Crossman

ARTIST
86

Fletcher Crossman lives in Mount Pleasant, South Carolina → fletchercrossman@yahoo.com

Color temperature contrasts and a compelling design did the trick here.

Rehearsal, oil, 16 x 20" (41 x 51cm)

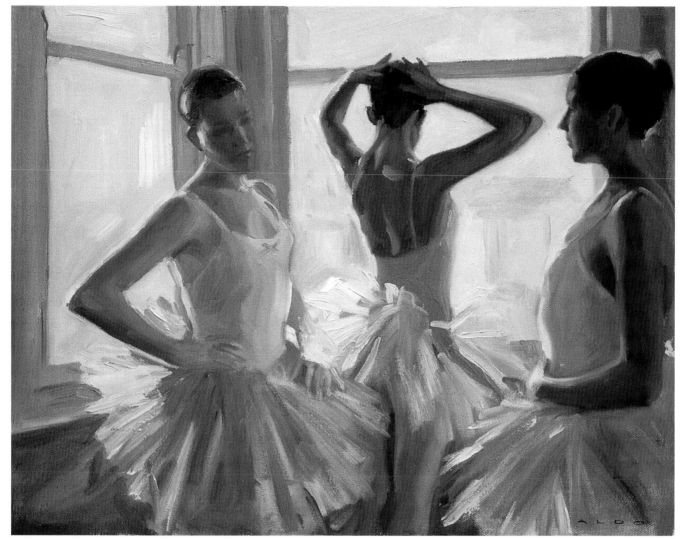

Aldo Balding

ARTIST 87

my inspiration

I hired a ballet model for an afternoon session. My intention was to portray a ballerina either stretching, dancing or warming up. But whilst photographing the girl in front of the window, it struck me how much more interesting it would be to portray a candid moment between two or three dancers. I photographed the same girl in various poses that I thought would look natural and give the painting a narrative.

my design strategy

I made a series of drawings for composition. I wanted the girl with her back to us to be the most intriguing focal point. I removed the dark buildings outside the window to simplify the background and to provide strong contrast against her head. By adjusting the poses, I could then lead the viewer to the secondary figures, although I cut back on their details. I wanted the design to be predominantly warm to contrast against the cooler sky.

my working process

• I sketched the main shapes of the composition directly onto the prepared canvas, using a soft pencil.

• I painted each figure in turn. I used Yellow Ochre, Cadmium Red, Viridian and White thinned at first with the turpentine for the flesh tones.

• In reality, the model was wearing a black tutu, but that wasn't working so I made them pink, using a little Alizarin Crimson, Ultramarine, Yellow Ochre and White.

• What I didn't want was a photographic representation for this piece so I painted more loosely and enhanced some of the flesh colors not seen in my photos.

my advice to you

Ironic as it may sound in this case, paint from life as much as you can.

Drawing is the foundation of all representational art. Painting from life also gives you the ability to determine tones and their edges accurately. All of these points are really important. There aren't any real tricks or secrets, just hard work and plenty of practice. Once you've mastered working from life, it's much easier to paint from photographs while maintaining your style and accuracy.

what the artist used

support	brushes	medium
Prepared linen canvas	Bristle filberts, sized 2, 3 and 4	Turpentine

oil colors

Cadmium Yellow	Alizarin Crimson	Titanium White
Yellow Ochre	Viridian	
Cadmium Red	Cobalt Blue	

Aldo Balding lives in Kingston, Surrey, United Kingdom → www.aldobalding.com

I chose a strong Japanese theme for this special portrait.

Francis King, oil, 59 x 39½" (150 x 100cm)

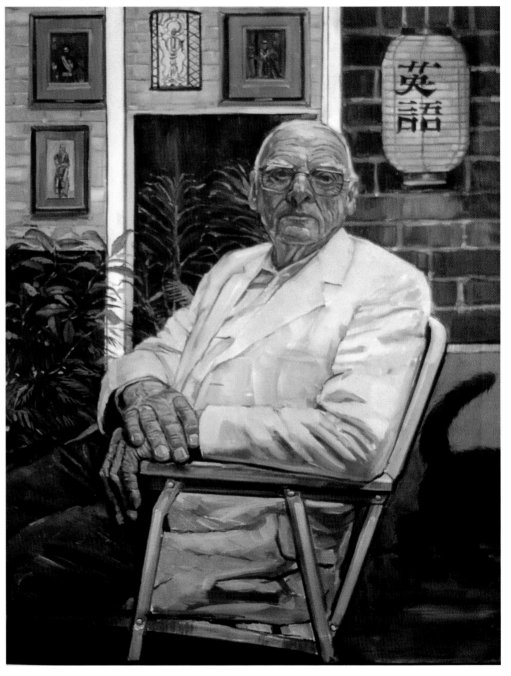

Kevin M A Cunningham

ARTIST
88

a commission story

My portrait of Francis King was commissioned by renowned biographer Jeffrey Meyers, who collects my paintings. Jeffrey wanted me to immortalize the author on canvas for his own private collection. Mr King is a very well respected author, being a contemporary of Somerset Maugham, which is why I included the Graham Sutherland portrait of Maugham in the background of my piece. He is especially regarded in Japan where there is a Francis King Society, so I chose a strong Japanese theme for the picture.

my design strategy

Reflecting the Japanese connection, I divided the background into sections in the manner of Japanese screens. The lantern may seem an obvious choice but it sets the atmosphere for the painting. (Incidentally, the Japanese symbols on the lantern translate as "English literature".) Mr King is the epitome of an old-style colonial gentleman, so the dominating white linen jacket was a must. Maybe subconsciously I was making a political point here as, ironically, the jacket competes with the subtlety of the lantern and the centrally positioned pearl patterned lamp on the wall, a gift to the writer from the people of Japan.

my working process

- Having first read Francis King's autobiography, our initial encounter was relaxed and "chatty", which gave me the opportunity to pick up on some of his eccentricities and get ideas for my composition. During our conversation, I sketched in pencil and took some photos.

- Returning to my studio, I worked from the photos and sketches to develop a full-scale charcoal drawing on paper.

- On canvas, I worked fairly quickly to develop the painting. I started with the face and hands, and constructed the rest of the piece around them. I prefer to work alone, from references, as I find I lose the rawness of the theme of the portrait with too much contact with the sitter.

please notice

If you look closely at the bottom right corner of the painting, you'll see a cat's rear end! Mr King desperately wanted his beloved "Moggi" in the painting. I was concerned that posing the cat on the sitter's lap would make him look like a "baddie" from a James Bond movie, but the cat solved the problem by "walking out" of the pose! This became a good compromise between artist and sitter, injecting some humor into the portrait.

what the artist used

support
Fine-grained canvas

brushes
Short, flat artists' brushes; house painting and decorative brushes

oil colors
Cadmium Yellow Light
Cadmium Yellow
Cadmium Yellow Deep
Cadmium Red Light
Cadmium Red
Permanent Rose

Burnt Umber
Permanent Green Light
Cobalt Blue
Ultramarine Blue

Kevin M A Cunningham lives in London, England → www.commissionaportrait.com

Gesture and color allowed me to construct a story around these imaginary characters.

Family Discussion, watercolor/gouache, 11½ x 8½" (30 x 21cm)

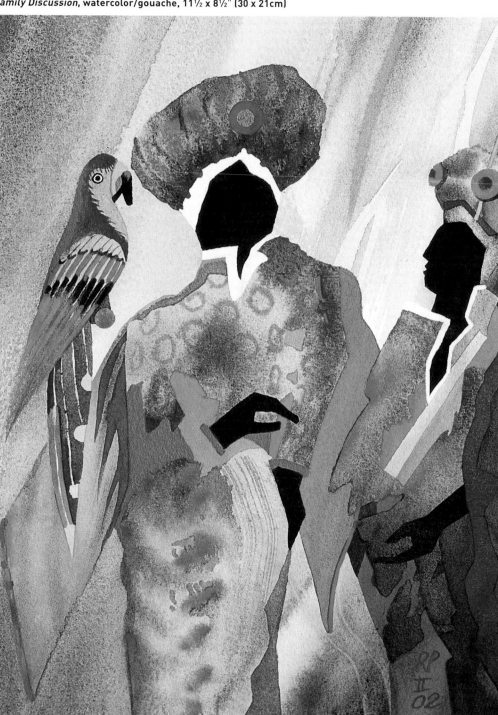

my inspiration

Inspiration was derived from a small collection of children's wooden dolls seen at the home of our friends in Maryland in the US. They are believed to be from American Civil War days or soon after. This painting, as with most of my work, was derived from a sketch in my sketchbook. I have always carried around a sketchbook, particularly on holidays or visits to special places.

my design strategy

Using the idea of, as it were, "bringing the dolls to life", two of them were imagined in conversation with each other. The make-up of the painting was largely intuitive, and a lively color rendering was felt to be important to emphasize a rich, oriental environment. The parrot was added to reinforce this effect, and perhaps partly in the maybe quizzical notion that it might be taking part in the conversation.

my working process

- The first step was a swift background wash. Immediately following that, the broad outline of the turban and the head of its wearer were laid in. It was important that these outlines suggest the wide, powerful face of the high-ranking individual.

- Robes and general details followed. Then all was finished up with a more careful application to both of the headdresses and a rather more meticulous treatment of the parrot.

- Finally, the heads and hands were put in with Lamp Black, taking care to leave small areas of white paper unpainted for the collars and headgear edging.

- I hope that it will be generally accepted that it was so very much better in this painting to leave the facial features to the imagination.

what the artist used

support
140lb handmade watercolor paper, "not" surface

brushes
Soft flats and rounds

watercolors and gouache
Naples Yellow
Raw Sienna
Cadmium Red
Crimson Alizarine
Emerald Green

Cobalt Green
Cobalt Blue
Ultramarine Blue
Lamp Black

J Richard Plincke

ARTIST
89

J Richard Plincke lives in Winchester, Hampshire, United Kingdom → roseplincke@btopenworld.com

A dynamic composition and complementary color scheme helped to convey the special quality of late afternoon light.

On the Beach, oil, 39½ x 59" (100 x 150cm)

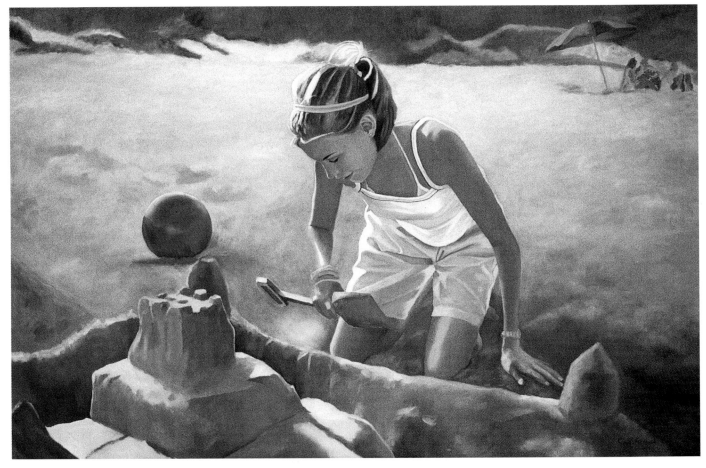

my inspiration

Light — the way it enhanced the figure and the resulting shadow — inspired this painting. The sun was low, highlighting the girl and the sandcastle only in specific places. This contrasted with the light falling quite evenly on the sand behind the model, giving a strong, brightly lit background area. With these, I wanted to depict the mood of the late afternoon light on the beach and the feeling one gets at that time of day.

my design strategy

I chose this composition because it has a basic triangular composition formed by the figure's head (as the apex of the triangle), the orange sandcastle on the left and the smaller sandcastle on the right that connects with the figure because of its proximity to the hand. This primary triangle is offset by the secondary triangle that is created by the figure's head,

the ball and the spade. There is an element of tension here, which is further heightened by the suggestion of movement in the spade. Other visually linked shapes give a sense of depth and connect the figure to the background.

digital design

Because I use my photographs as a source of inspiration, my camera and photographs are an intrinsic part of the process. In this instance, I took my own children to the beach and asked them to build a sandcastle. I photographed them with a painting in mind.

I then studied and analyzed the photographs to find the most pleasing composition. As I work digitally, I then turned to my computer to crop them, manipulate the colors and adjust the contrast as needed.

my working process

- When satisfied with my design, I projected the image onto the

canvas. Seeing that projected image at full size instilled in me the confidence to tackle a project of such magnitude.

- After drawing up the image with water-soluble crayons, I quickly filled in as much as I could with acrylic paints. I did this in about three hours, working very quickly and roughly. Color values were approximate.

- The next step was to go into oils. I love this part. I had endless patience to fine tune and mix colors, and change and adapt colors until I had what I thought was absolutely right. I tried to capture the feeling of sunlight through the use of complementaries, especially through the use of yellows, oranges, purples and blues.

what the artist used

support
Cotton duck canvas, primed with three coats of gesso mixed with a peachy-grey acrylic

brushes
Soft brushes, Nos. 2 to 24

other materials
Watercolor pencil crayons to draw the subject
Acrylics for underpainting

oil colors
Naples Yellow Deep
Yellow Ochre Light
Yellow Ochre
Cadmium Yellow Deep
Cadmium Orange
Naples Yellow Red
Cadmium Red Light
Scarlet
Alizarin Crimson
Permanent Rose
Burnt Sienna
Burnt Umber

Phthalo Yellow Green
Chromium Oxide Green
Sap Green
Terre Verte
Ultramarine Blue Light
King's Blue
Ultramarine Violet
Permanent Red Violet
Mars Brown
Davy's Gray
Paynes Gray

Ginny Fletcher

ARTIST
90

Ginny Fletcher lives in Johannesburg, South Africa → ginnyfletcher@tanjo.co.za

I made my figures believable without being overly detailed, and concentrated on suggesting movement.

What's the Catch, oil, 22 x 26" (56 x 66cm)

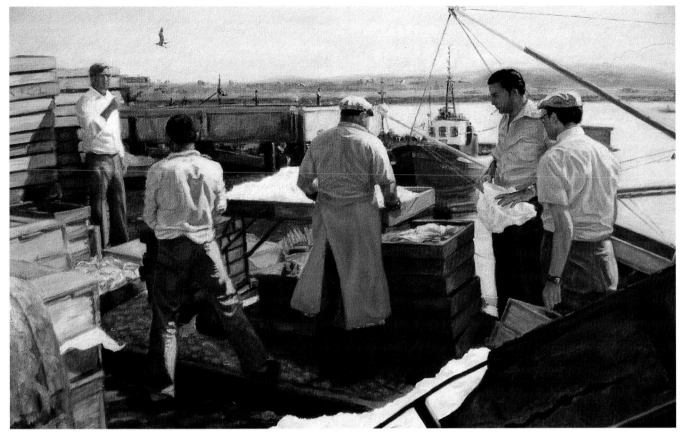

my inspiration

As I walked the cobbled quayside in southern Portugal, I was thoroughly drawn into the bustling hive of activity around me. I was inspired to convey some of the atmosphere and sensations experienced at the port. Although the image itself is static, I hoped to capture a feeling of continuous activity that would entice and embrace the viewer.

follow my eye-path

There is a distinct and meandering path for the viewer's eye to follow created by simplifying some areas and accentuating others. The direction runs from the lower border of the picture via the line of the ice-cart up through the figure on the extreme right and is held in by the structure of the boat immediately behind. It then moves through to the central figure, whose significant role is communicated by his bright orange apron. Finally, the progression is down and up through the men on the left and back into the scene via the seagulls.

about light and color

The vivid sunlight and the implied movement are used to give the scene a "spark". While employing contrast of sunlight and shade, the prime aim was to achieve a powerful sense of color harmony. The subject demanded at least the dimensions given, and while it would still have been convincing on a larger scale, I think the size chosen affords the scene a comfortable feel.

my working process

- On site, I made careful visual observations, drew some pencil sketches and took photographs.
- Back in the studio, I first primed the canvas with at least three coats of quick-drying acrylic primer.

- Using an HB pencil, I lightly sketched the figures, shapes of stacked boxes and basic surrounding structures on the canvas. Detail was kept to a minimum.
- Using flat bristle brushes, I lightly blocked in every main shape, using the general colors diluted with turpentine.
- When this had dried, using mainly filbert brushes, I had the enjoyable task of working across the scene, intensifying colors, adding basic details and refining shapes. I devoted the most attention to the men and their clothing. Proportion, posture and cast shadows all helped to make the figures believable.
- I then used No. 1 brushes to delineate certain parts — such as struts, lines between boxes and seagulls — and to correct some edges, suggest textures and add tonal variations.
- After about six months, I applied two coats of high gloss varnish.

what the artist used

support
Medium grain cotton canvas primed with quick drying acrylic white

oil colors
Lemon Yellow
Cadmium Yellow
Yellow Ochre
Cadmium Red

brushes
Long flat hog bristle No. 12; short flat hog bristle No. 8; sable filbert Nos. 4, 6 and 10; synthetic round No. 1

Alizarin Crimson
Raw Umber
Burnt Umber
Cerulean Blue

other materials
Turpentine
High gloss varnish

Cobalt Blue
Titanium White

Tom Kelly

Tom Kelly lives in Bournemouth, Dorset, United Kingdom → kelly169@freeserve.co.uk

Composition and cropping were my keys to suggesting a bustling, "carnival" atmosphere.

my inspiration

My wife and I have always loved Paris and are fortunate to be able to go once or twice a year. I spend hours meandering through the small streets, taking photographs that I can use in my compositions. This particular painting came about from a photograph I took one rainy, late Paris afternoon in March. My wife and I were looking for somewhere new to eat and were struggling through the hurly-burly of people doing the same as us! I wanted to capture the "carnival of people in a carnival of buildings". To my mind, the people and the buildings filter into one living entity, and the post-rainstorm feel adds to the quality of the people "melting" into the surroundings.

my design strategy

To get the height of the buildings, I used a classic U-shaped composition, with a superimposed "V" to draw the viewer's eye down the street. Limiting the amount of sky added to the bustling feeling. I made the greater part of the painting a lower tonal value to bring a more pronounced contrast with the on-street lighting.

my working process

- First, I sketched the scene on 140lb hot-pressed paper with a 4B pencil. I masked the lightest elements and peoples' faces.

- I then wet the whole paper and flooded in color in one big, juicy wash, quickly using various pre-mixed color s. Working from the top of a tilted board, I let the color s blend into each other and run off the bottom of the board. This first overall wash created a foundation to work from and got rid of that intimidating white.

- When the paper was completely dry, I removed the masking and worked wet-on-dry. As I established my darker values, it was important to vary the color s in each wash.

- I then softened some of the hard edges by scrubbing with a clean bristle brush and water.

- It was now time to paint in the lighter values on the lights, windows and faces. Care was taken with the light values on the crowds' faces so as not to compete with the shop lights and lanterns, therefore detracting from the inherent "V" in the composition.

- Finally, I painted the detail in the lanterns and signs.

- After seeing the overall work, I decided to add a little drybrush work to the shop fronts and street to create a little more texture and interest.

People of Paris, watercolor, 13½ x 9½" (35 x 25cm)

what the artist used

support
140lb hot-pressed watercolor paper

brushes
Squirrel mop No. 10; round sables Nos. 12, 8 and 6; rigger

watercolors
Indian Yellow
Raw Sienna
Permanent Rose
Permanent Magenta
Cobalt Blue
French Ultramarine
Burnt Sienna

Gez Cox

Gez Cox lives in Warwickshire, United Kingdom → www.gezcoxfineart.com

The placement of the figures was essential in describing the interaction between these people.

The Waiter, Montmartre, oil, 30 x 40" (76 x 102cm)

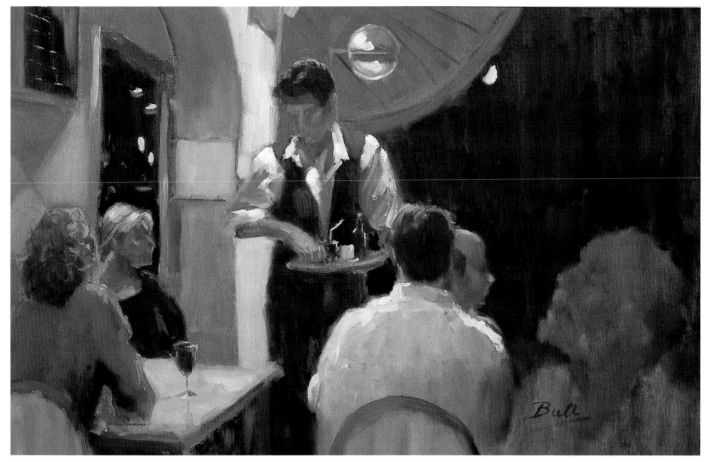

my inspiration

The vast majority of my paintings involve people going about everyday life, so this scene for me couldn't have been more perfect. It involved a warm evening, the aromas, sounds and magic of Montmartre and the waiter quietly and calmly going about his business. The overhead lighting made him glow and cast shadows as he moved, rendering him the "ballerina" in the chorus line and therefore the focus of the painting. I wanted to invite the viewer in to share the warmth and atmosphere of the evening.

my design strategy

My response to a visual moment is spontaneous so I don't plan or do a preliminary design. I'm impatient and just can't wait to get to the easel to put the experience down. The analysis comes later. The colors used were chosen to convey the warmth and atmosphere of the evening.

The highlights on the shoulders of the shirts automatically drew the viewer's eye up from the seated male to the waiter, making him the focus of attention.

my working process

- With no art materials to hand, I took photographs, memorized the scene and made rudimentary sketches and notes on serviettes.

- On a canvas board coated with a mixture of Cadmium Red and Yellow Ochre acrylic, which gives a lovely warm, mid-tone base to begin work on, I used a fairly small brush and Raw Umber to roughly establish the placement of the figures.

- Then I used a large No. 20 fine hog hair brush and a mixture of Ultramarine Blue and Raw Umber to establish the dark areas.

- The medium tone and warm tones on the people and

restaurant were next, using smaller brushes and Indian Red, Cadmium Red, Rose Madder, Yellow Ochre and Naples Yellow.

- Finally, the fun part that I can never wait to get to — the highlights — using Lemon Yellow and Titanium White.

what the artist used

support
Pre-primed canvas board

brushes
Hog hair brushes, Nos. 8 to 20

oil colors

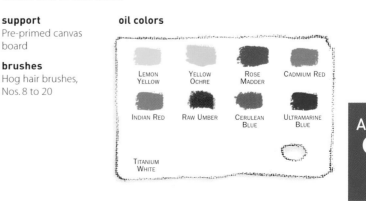

LEMON YELLOW • YELLOW OCHRE • ROSE MADDER • CADMIUM RED
INDIAN RED • RAW UMBER • CERULEAN BLUE • ULTRAMARINE BLUE
TITANIUM WHITE

HOT TIP!

When painting a group of figures, don't worry about the faces too much. You're observing the interaction, not being a portrait painter at that moment. As such, consider the spaces in and around the figures. Try to feel yourself in that pose or position.

Anne Bull

ARTIST
93

Anne Bull lives in Esher, Surrey, England → oliverbull@aol.com

A myriad of shapes in primary colors allowed me to convey the excitement of circus life.

Roll Up, oil, 14 x 18" (36 x 46cm)

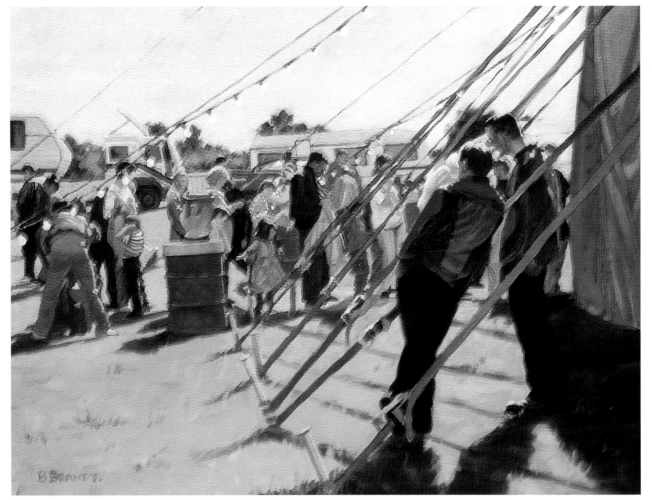

my inspiration

Some years ago, the Cottle Sisters' Circus came to Bristol, where we then lived. I got permission to spend time with the circus and, for several days, hung around the big top and watched the performers practicing, grooming their team of horses and making their entrances. I took a large number of reference photographs, hoping to create a series of paintings catching the essence of circus life. However, only a couple of outside views seemed to work. This painting is one of them.

my design strategy

The design of "Roll Up" is simple enough. The structure for the painting hangs off the mass of the big top on the right and the foreground area of grass supported, as it were, by the diagonals of the "tent-guys" (that's ropes, not attendants). The two foreground figures represent the show-people and their aim to entertain the public, seen queuing up across the middle of the picture. The tent and foreground figures are relatively dark, providing a contrast to the light and sparkle of the crowd.

follow my eye-path

Here, the mass of the tent on the right prevents the viewer from reading along the waiting audience and out of the picture. The tent supports carry attention back towards the left, as does the angle at which the two young men are looking.

try these tactics yourself

- To start, I drew out the design with a waterproof, black pen. I then stained the canvas with a pale, warm orange glaze diluted with alkyd medium. This introduced the general lighting of the scene while making it easier for me to judge the relative values of colors added later.

- My general practice is to build up a painting through a series of sessions, working from general shapes to particular, with small touches of bright color being added last. I find that working in relatively short sessions allows me to return to my painting with fresh eyes each time. If part of the painting works, I leave it alone, even if I had thought it "not finished". This allows me to take advantage of happy accidents.

- I like to mix my colors only partially on the palette and apply them this way. This keeps them more interesting than if they were fully mixed. Here, I focused on primary colors to reflect the excitement of a circus show.

what the artist used

support
Canvas

brushes
Flat, synthetic brushes, ranging in size from 12 to 2

medium
Liquin

oil alkyd colors
Cadmium Lemon
Cadmium Yellow Medium
Yellow Ochre
Cadmium Orange
Cadmium Red
Alizarin Crimson
Burnt Sienna

Burnt Umber
Sap Green
Terre Verte
Cerulean Blue
Cobalt Blue
Ultramarine Blue

Bob Brandt

Bob Brandt lives in Norfolk, United Kingdom → www.clockhousestudio.demon.co.uk

Extreme value contrasts invite the eye through the painting in both places.

Piccole Dolomiti, acrylic, 16 x 20" (41 x 51cm)

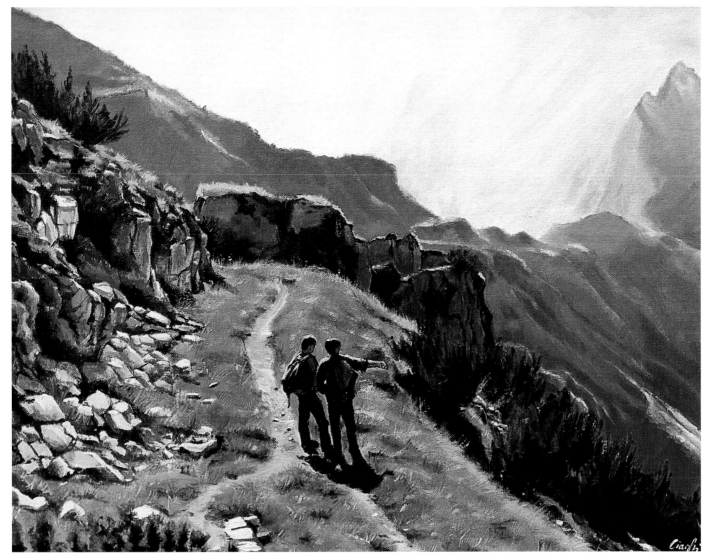

my inspiration

I live in the north of Italy (Trentino Alto Adige). This region situated at the foot of the Alps is characterized by evocative alpine landscapes, valleys, woods and majestic peaks. The people who live here identify very deeply with the mountains that surround them. Personally, it is only by immersing myself totally in these landscapes that I am able to regain a sense of peace and beauty and to wonder at the splendor of it all. Nature is a temple that holds within itself a universal language of memories, signs, traces and sensations that communicate with the observer, not through words but through deep and intimate feelings.

Tiziama Ciaghi lives in Trento, Italy → www.geocities.com/tciaghi

my design strategy

The harmony of the scene, the light and colors and the composition are most important for me. I tried to create an imaginary route for the eye of the observer that goes from the two figures at the center of the picture and follows the path up to the top of the mountains in the distance.

my working process

• I made some sketches, just to remember the essence of the scene and shapes. Then I took some photographs on location to fill in the details. My painting is a combination of elements from photos and sketches.

• After putting on the foundation coat of paint, I drew a careful pencil design on the canvas.

• I then began at the top and worked down. I used Titanium White, French Ultramarine Blue and Mars Black for the sky and mountains in the background. Acrylic colors dry very quickly and allow painting of several layers in a short time, which prevents overworking and adds continuity to the painting.

• I then painted the two figures in the center and the grass with the path, all illuminated by very bright light casting dark shadows. I covered the right side of the path in Mars Black and then added the pine tree.

• Finally I accentuated the areas in light by using successive layers of color, painting the details and shadows with great care, using fine round-tipped brushes.

• The painting took several days to complete and was finished with a coat of matte varnish.

what the artist used

support
Canvas

brushes
Synthetic brushes of varying sizes and styles

acrylic colors
Cadmium Yellow Medium
Cadmium Red Medium
Red Oxide
French Ultramarine Blue
Mars Black

Tiziama Ciaghi

ARTIST
95

Tonal painting helped me minimize the details in this busy, complicated scene.

Chesterfield Fair, pastel and gouache, 8 x 11" (20 x 28cm)

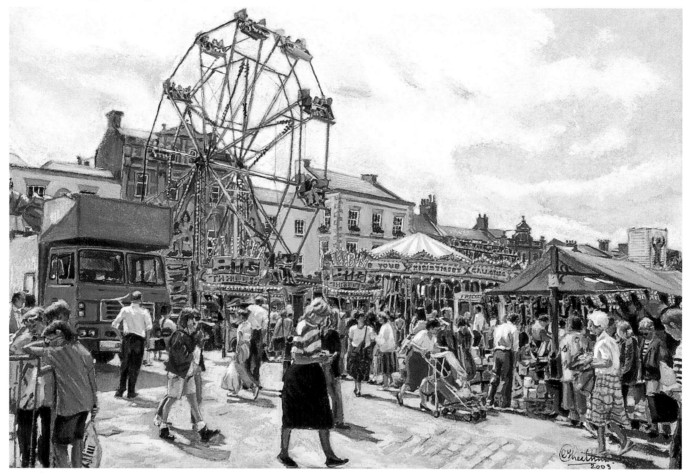

Chris Cheetham

ARTIST
96

what I wanted to say

Good weather is such a rare experience for those of us lucky enough to live in this part of the world that this splash of color on such a bright, sunny day was well worth capturing for posterity. The multitude of people and bright colors against the dark background added interest and tonal contrast. This made the painting a real challenge, but an inspiring piece to undertake.

my design

I painted this picture to explore tonal painting and pure color. These qualities created a vibrant scene, which I hoped would make the viewer want to explorer the picture further. I planned the composition to work from right to left, leading the viewer's eye towards the big wheel and carousel in the center of the picture.

my working process

- With this subject matter being so busy and full of detail and the scene so changeable, it was essential to take photographs.
- After selecting one main photo to work from, I used the grid method to transfer the image to tracing paper. I then included details from other photos to pull the composition together in a detailed drawing. I also made a tonal sketch to work out the value pattern.
- On the opposite side of the finished drawing, I rubbed 4B pencil over the surface. The drawing was then transferred to the support, using a hard 2H pencil.
- Working first in gouache, I roughly blocked in the composition's medium tones. I followed up with Burnt Umber and Black pastel pencil for the dark areas, then White pastel for the highlights. I sprayed this

layer with fixative before adding more highlights, using a mixture of Permanent White and Yellow Ochre gouache. This completed the underpainting.

- I then began to work from dark to light, starting with the background and working towards the foreground. This included working with soft pastel, pastel pencils and gouache, respectively.
- To finish off the details of the picture, I used a magnifying lens to improve the quality of the

detail, which enhanced its appearance further.

the main challenge in painting this picture

It was very easy to get carried away while painting this picture, so I had to restrain myself when it came to finishing off the details. I had to make sure I didn't overwork the picture and lose its painterly quality, which would have defeated the objective.

what the artist used

support
Gray card primed with acrylic matte medium and pumice powder

brushes and tools
Flat brush #10; round brushes #2, 4, 6; pencils 2H, 4B; tracing paper; magnifying lens

pastels and paints
Pastels:
Blues, yellows, reds, greens, earth colors
Gouache:

Spectrum Yellow	Primary Blue
Yellow Ochre	Oxide of Chromium
Flesh Tint	Warm Gray #4
Spectrum Red	Cool Gray #4
Burnt Sienna	Permanent White
Winsor Green	

Chris Cheetham lives in Derbyshire, England → chris@cheetham652.fsnet.co.uk

Shape and scale resulted in an intimate painting.

Mary-Jane, oil, 57 x 57" (145 x 145cm)

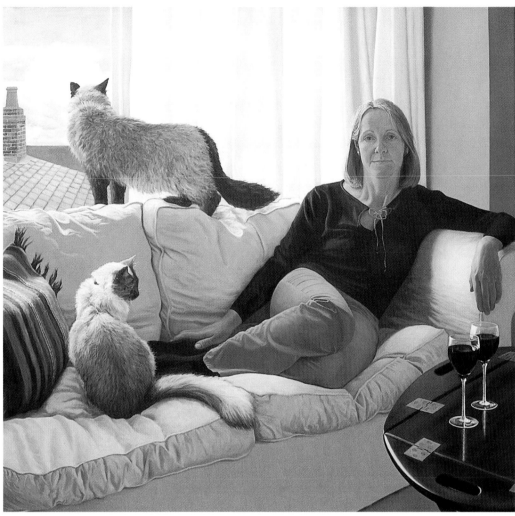

my inspiration

At the time I asked Mary-Jane to sit for her portrait, she was simply a colleague of mine at the school where I was teaching. However, since the portrait we have become partners — an unexpectedly happy consequence! I hope the portrait conveys something of my elation at meeting Mary-Jane and discovering that the meeting was reciprocal. I knew from the first sitting that her two cats Leo and Misty should also be included, though only much later did I see they played almost a symbolic role in representing two aspects of myself: Leo, the more adventurous of the two looking beyond the confines of the room, and Misty more timidly perhaps seeking attention and comfort. The two wine-glasses likewise took their place without my contriving but I later chose to overlap them out of "poetic license".

my design strategy

As with nearly all my portraits, deciding on the composition was both crucially important and a fairly passive process. At the first sitting, the composition presented itself to me through the way Mary-Jane chose to sit and where she was positioned in relation to the windows and furniture of the room. Once her pose and my viewpoint were established, the composition seemed to align itself on two diagonal axes counterbalanced by the verticals of the wall and curtain. Changing Leo's pose from curled up at Mary-Jane's shoulder to alertly looking out to the left accentuated the bottom-right to top-left diagonal. The other important element was scale: I always paint people roughly life-size to suggest an encounter with a real person.

my working process

- Initially, we had about five sittings in which I took photos to record various poses from which I made a compositional line drawing. Working from life, I also made a detailed pencil tonal study of her face.

- As for the painting itself, I prepared the canvas with rabbit-skin size and a muted ochre primer, on top of which I outlined the composition as precisely as possible in charcoal.

- Then I painted in the whole composition fairly loosely to establish the balance of tones, beginning with larger areas and working towards details.

- When this was dry, I worked into each area more methodically. Some color and compositional changes did occur at this stage to enhance the light.

- Finally, for the face, I asked Mary-Jane to sit for me about five or six times.

what the artist used

support
12oz cotton duck canvas, primed with rabbit-skin sizing

brushes
Standard range of sable and hog-bristle

medium
White spirit

oil colors

NAPLES YELLOW · YELLOW OCHRE · ALIZARIN CRIMSON · RAW SIENNA
BURNT SIENNA · RAW UMBER · BURNT UMBER · ULTRAMARINE BLUE
IVORY BLACK · TITANIUM WHITE

Andrew Paterson

ARTIST 97

Andrew Paterson lives in London, England → a_l_p_art@hotmail.com

Body language helped me suggest a pleasing, slightly mischievous moment.

Serious Discussion, pastel, 19 x 25" (49 x 64cm)

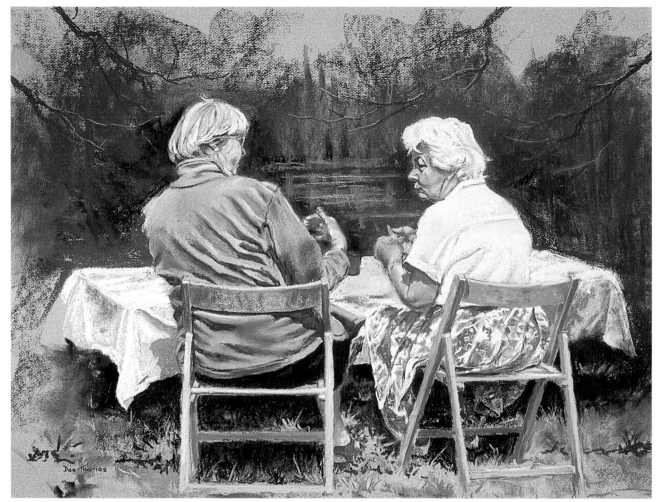

my inspiration

At a picnic during a painting holiday in France, I saw these two ladies deep in conversation, oblivious to others at the table. It was one of those "had to paint scenes" as I most enjoy portraying people in the tableau form, rather than just in a sitting or standing pose.

my design strategy

After returning home with a photograph and some quick sketches done on site, I set about making several drawings, using a 4B pencil on sheets of typing paper. I omitted the other people, concentrated on getting the proportions and poses of the two ladies correct and made sure the tonal values would portray the moment and mood. I generalized the environment so there would be no doubt about the two figures being the center of interest.

my working process

- Based on my favorite sketch, I drew in the two figures on the smooth side of my pastel paper, using a sepia pastel pencil. I very carefully drew in the outlines and details of the figures, but no shading. I indicated the background shapes only vaguely. A light spray of fixative set the drawing.

- At first, I ignored the background. To prevent smudging, I commenced with the left-hand figure with very light strokes so that the tooth of the paper was preserved as long as possible. I blended the initial marks with my fingers, ear buds, pieces of plastic — whatever seemed to work best.

- After completing most of the figure on the left, I started on the one on the right, using my wife as the model and working from life. Smudging and blending was used less and less as the picture developed.

- I then began to address their environment. Foreground grass was indicated quite clearly with broad strokes, leaving much of the paper showing through. I treated the background with even less detail, using dark tones with cooler grays to bring the two figures forward. For the sky, I left the paper blank.

- At regular intervals throughout, I viewed the picture upside down and in a mirror to reveal any errors.

- I did not finish with fixative as this tends to darken colors.

HOT TIP!

During the painting process, I use thicker pastel sticks and never break or sharpen them to obtain a hard edge. This prevents me from becoming too tight. I limit the use of pastel pencils for the same reason.

what the artist used

other materials

Pastels, primarily greens, blues, pinks and earth colors

Limited number of pastel pencils

Ear buds and pieces of plastic for blending

Fixative

support

The smooth side of medium weight pastel paper, medium gray in color

Des Thomas lives in Sedgefield, South Africa → gillyt@mweb.co.za

I achieved a romantic, old world feeling with gestural line and color.

Ava, oil, 24 x 36" (61 x 92cm)

my inspiration

The model for "Ava" is a 14-year-old painting student of mine. She bakes bread and sells it at the local farmer's market. When I saw her in this peasant dress that her mother had made for selling the bread, I knew I had to paint her. My inspiration was sensing — through this girl — the special time of early adolescence. I could see the woman that this innocent child was fast becoming, and I tried to capture that in my portrait.

my design strategy

I arranged the model on the floor so that my perspective was peering down while painting. This gave the feeling of a landscape design rather than the usual portrait style.

my working process

- I felt the model needed a warm environment, so I prepared my canvas by toning it with Cadmium Yellow Deep and Orange Red acrylic paints.

- Using a #4 filbert brush and mineral spirits, I mixed Ultramarine Blue with a little Yellow Ochre to begin. Since my paintings are more about building form than linear sketching, I simply registered the placement of the model on the canvas in a loose, gestural way. A simple curved line, for example, represented the size and direction of the shoulders. When I felt secure about my placement, I picked up a larger brush and began creating form.

- I believe in continual relating back-and-forth between model and canvas. I tried to respond as quickly as I could to the colors, values and shapes. This crucial, intuitive process was based entirely on what I saw. Immediacy was achieved by massing in the color where I saw shapes turn and shadows form.

- During this time, I paid very close attention while trying to feel the essence and the attitude of my model. I kept my painting "open" for as long as possible to give opportunity for my canvas to talk to me as I worked. There was a dialogue not only between the model and canvas but also between the canvas and me.

- Toward the end, I used line to tie things together. To keep it fresh and clean, I had to trust my instincts about when the painting was finished and not over-work it.

something you could try

I usually work from life because I love feeling the space and atmosphere along with the excitement of seeing subtle nuances. It's the visual experience that's important to me.

what the artist used

support
Stretched canvas

medium
Mineral spirits

oil colors
Cadmium Yellow Pale
Cadmium Yellow Light
Yellow Ochre
Cadmium Yellow Deep

Cadmium Red Light
Alizarin Crimson
Phthalo Red Rose
Phthalo Green

Phthalo Blue
Ultramarine Blue
Titanium White

brushes
Filbert bristles #4, 6, 8;
#14 synthetic brush
for toning the canvas;

liner brushes #1, 2;
palette knife

Sandra Bos lives in Cookeville, Tennessee, USA → www.sandrabos.net

Sandra Bos

Busy graphic elements emphasized the gentleness of the face.

what I wanted to say

My friends asked me to paint their daughter. I wanted to capture her face at a moment in which she would be unaware of my presence. So when shooting photographs of her, I waited for a moment when she would be clearly interested in something and when her childlike curiosity would appear in her eyes. Susan is a child full of energy, so patience was needed to find the perfect moment characteristic of her.

my design strategy

To emphasize the light, smooth color of her face, I contrasted it against a dark background and a graphic pattern in her dress. A tangle of lines and stains also enhanced the gentleness of her face, as did natural, overhead lighting. The pattern of her dress and the light moving across the upper part of the painting from the left to the right direct the viewer's eye to the main element of this composition at once.

my working process

- I took a series of photos and made observations of Susan. After arranging the most interesting and characteristic depiction, I drew a little sketch in pencil. I tried to study the relationships between the places of the most intense light and the deepest shadow.

- On my watercolor paper, I drew my image in pencil in a natural life size. After that, I used masking fluid to save important light and small places of her face, hair and elements of her dress.

- I started my work from the background, using a big, flat ox hair brush, water sprayer and facial tissues for mopping up excess water and for laying in some of the watercolor stains.

- Next, I painted her hair and face by using round sable brushes # 2, 7, 12. I put in the details and lines of her dress with a long hair round brush #2.

- After removing the mask, I analyzed the whole composition. As a result, I decided to use a thin glaze to "switch off" parts of the light elements. I also brightened some dark details that interfered with the logical building of my composition.

why I chose this medium

I chose watercolors for this painting because it is a very fast technique, which also makes it possible to get very subtle color effects.

Susan, watercolor, 23½ x 19" (60 x 49cm)

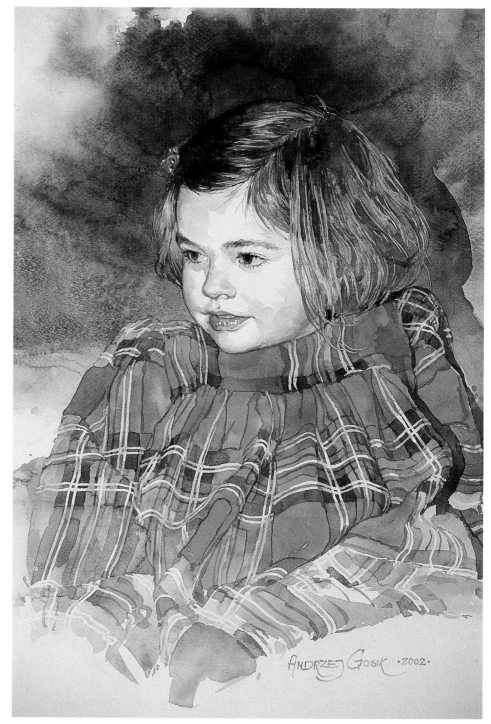

what the artist used

support
200gsm watercolor rough paper

brushes
Flat ox hair #8, 12, 19; round sable #2, 7, 12; long hair round vinyl #2

other materials
Facial tissues

Spray bottle for water

Andrzej Gosik

Terms you should know

abstracting Taking from reality, usually simplifying, to suggest a general idea. Not necessarily related to real forms or objects.

acid free For greater permanance, use an acid free paper with a pH content of less than 7.

acrylic Viewed historically, this is a fairly recent member of the color family. Waterbased, so can be diluted to create thin washes, or mixed with various mediums to make the paint thicker or textured.

aerial perspective Dust, water droplets and impurities in the atmosphere gray off color the further away it is from us. These impurities block light, filter reds and allow blues to dominate, so that in the distance we see objects as less distinct and bluer. This is an important point for landscape painters to grasp. Objects in the foreground will be sharp, more in focus and will have more color.

bleeding Applies mainly to watercolor where the pigment tends to crawl along the surface outside the area in which it was intended. Can be a good or a bad thing, depending on your intention.

blending Juxtaposing colors so that they intermix, with no sharp edges. Applies to pastel, where you blend colors by rubbing them with fingers or paper stumps, and to oil, where you would use a broad soft brush to blend colors.

body color Mainly gouache or opaque paint, as opposed to transparent paint. Can be used to create richness of color or to cover up errors. Chinese White (a zinc opaque watercolor) is often used to restore or create highlights. Many watercolor purists insist that a watercolor painting should only be created using transparent pigments, but countless leading artists use opaque paint in moderation. That is the key — only use opaque color on transparent watercolor paintings very sparingly.

brushes
Wash A wide, flat brush used for applying washes over large areas, or varnishing.

Bright A flat paintbrush with short filaments, often called a short flat.

Filbert Similar to a flat brush, with rounded edges.

Round A pointed brush used in all mediums.

Spotter A brush with a tiny, pointed head which is used for fine details.

Liner/Rigger A brush with a long brush head used for fine detailing.

Fan A crescent-shaped brush head for blending and texturing.

brush sizes The size of flat brushes is expressed in inches and fractions of an inch measured across the width of the ferrule. For instance, No.12 = 1 inch and No. 6 = ½ inch.

The size of a round brush is the diameter in millimetres of the brush head where it emerges from the ferrule. For instance No. 5 measures 5mm (¼ inch) in diameter.

Be aware that sometimes brush sizes may vary slightly between brands, even though they may both be labelled say, No. 10 round. Instead of choosing numbers, choose a quality brush in the size you prefer.

canvas Mainly for oil painting. Canvas can be bought in rolls, prestretched or already stretched with support strips or mounted on a still backing.

Canvas is fabric which comes in cotton, linen and synthetic blends.

Linen is considered better than cotton because of its strength and appealing textured surface. Newer synthetics do not rot and do not sag. You can buy canvas raw, (with no coating), or primed, (coated with gesso), which is flexible with obvious canvas texture. You can also buy canvas that has been coated twice — double primed canvas — that is stiffer with less texture.

Canvas board is canvas glued to a rigid backing such as cardboard, hardboard or wood. Note that cardboard is not suitable for serious work because cardboard is not acid free, and will not last.

Wood and hardboard must be prepared properly.

cast shadow A cast shadow is one thrown onto a surface by an object blocking the light. It is important to remember that the edges of a cast shadow are not sharp.

center of interest (focal point) This is the area in your painting that you want to emphasize. It is the main point. You can create a center of interest with color, light, tone, shape, contrast, edges, texture, or any of the major design elements. Any center of interest must by supported and balanced by other objects. And do not simply place your center of interest smack in the center of your painting! Make it your mission to learn something about the elements of design.

chiaroscuro This is an Italian word meaning light and dark. In art is means using a range of light and dark shading to give the illusion of form.

collage A work that has other materials glued on, including rice paper, paper, card, cloth, wire, shells, leaves.

color temperature This term refers to the warmness or coolness of a paint. Warm colors are those in the red, orange, yellow, brown group. Cool colors are those in the blue and green group. However, there are warm yellows and there are yellows with a cooler feel to them.

composition and design Composition refers to the whole work, while design refers to the arrangement of the elements.

counterchange When you place contrasting elements — dark against light.

drybrush Mainly for watercolor. If you use stiff paint with very little water you can drag this across the paper and produce interesting textured effects.

frisket Frisket fluid (masking fluid) can be painted over an area to protect it from subsequent washes. When dry the frisket can be rubbed off. You can also use paper frisket that you cut to fit the area to be covered.

gesso A textured, porous, absorbent acrylic paint that is used mainly as a preparatory ground for other mediums such as oil or acrylic.

glaze A thin, transparent layer of darker paint applied over the top of a lighter wash. This richens, darkens, balances, covers up or adds luminosity.

high key/low key The overall lightness (high key) or darkness (low key) of a painting.

impasto Applying paint thickly for effect.

lifting Removing pigment with a brush, sponge or tissue.

Collect all these titles in the Series

100 ways to paint
STILL LIFE & FLORALS
VOLUME 1

ISBN: 1-929834-39-X
Published February 04
AVAILABLE NOW!

100 ways to paint
PEOPLE & FIGURES
VOLUME 1

ISBN: 1-929834-40-3
Published April 04

100 ways to paint
LANDSCAPES
VOLUME 1

ISBN: 1-929834-41-1
Publication date: June 04

100 ways to paint
FLOWERS & GARDENS
VOLUME 1

ISBN: 1-929834-44-6
Publication date: August 04

100 ways to paint
SEASCAPES, RIVERS & LAKES
VOLUME 1

ISBN: 1-929834-45-4
Publication date: October 04

100 ways to paint
FAVORITE SUBJECTS
VOLUME 1

ISBN: 1-929834-46-2
Publication date: December 04

How to order these books

Available through major art stores and leading bookstores.

Distributed to the trade and art markets in North America by

F&W Publications, Inc.,
4700 East Galbraith Road
Cincinnati, Ohio, 45236
(800) 289-0963

Or visit: www.artinthemaking.com